# REDISCOVERING SOME NEW ENGLAND ARTISTS

# 1875-1900

Rolf H. Kristiansen
and
John J. Leahy, Jr.

*Biographies and memorabilia of*
*some little known and forgotten*
*master New England painters .*

Published by Gardner-O'Brien Associates
Post Office Box 321
Dedham, MA 02026

*Published by:*
GARDNER-O'BRIEN ASSOCIATES
*P.O. BOX 321*
*DEDHAM, MA 02026*
*(617)329-9107*

*Cover Design by* A THOUSAND WORDS

*Library of Congress catalog Card Number: 86-60495*
ISBN *0-9616580-0-2 Softcover*

*First Printing: 1987*

• COVER •

*MT.WASHINGTON FROM CONWAY VALLEY, N.H.*
*By William F. Paskell, Oil on Canvas, 23¼ x 36,*
*(Private Collector)*

# CONTENTS

# PREFACE

American art does not flow from tradition, but, in a specially marked sense, from the individuality of the artist. Many of the nineteenth century artists cited in this book had received their training abroad and used it in a fresh manner that was very personal. Others had to pick up their art wherever they could find it. It is in appreciation of all of these men that the following pages have been written. In 1893, the catalog of The Columbian World's Fair, gave some recognition to certain notable works by some of these Americans, a few of whom were more or less famous in their day and justly so, but who in later times were almost forgotten. The major reason why their recognition has lapsed is because the general and popular art interest has been absorbed and distracted by the works of more modern methods, though quite often, in our opinion, of less truly artistic character. The pendulum of time and taste ever swings and presently a renewed interest in the value of the art of these few artists is stirring. Their works may be seen in some of the smaller museums, a few public buildings, local auctions, so called "flea markets," or often forgotten in the dust of someone's attic.

Looking at these older works it is possible to ponder the why and how of their creation. We should accept a picture on its own merits but it may be interesting also to know something of the times and career of its painter. All the artists in this small volume had a studio at one time or another in Boston. They exhibited and sold their works at the usual Boston art shows and were all well acquainted with one another. Joining the various art clubs, that were so numerous before the turn of the century was a professional must. Their more famous brothers consti-

tuted a so called, "Boston School." However, the men whose biographies appear here, had little connection with these affluent gentlemen. They formed their own little art coteries and endeavored to have their works in the various art exhibitions, hung, "on the line and not skied." These pictures were affordable to the public at large and very rarely attracted the elitist Boston Back Bay collectors.

All the research and facts about each artist is contained, narrative style, in the artists own chapter. Some documentary proof is included and the lists of authorities consulted. Old books, some privately printed. and portions of some artists' journals have fortunately been found to bring the art scene of the 1880s to life in a contemporary sense. Remaining relatives and descendents of the artists were interviewed and their memories have proved useful primary sources. Some art dictionaries contain a great deal of misinformation and the art reference libraries in Boston, Washington, New York, and many smaller museums have supplied pertinent, and sometimes more reliable information. Criticisms from old newspaper columns and magazines as well as illustrations of 1880s catalogs have also been referred to. Listings of works and some picture sizes in these catalogs are an indication of the artists choice of subject.

One of the purposes of the book is to call attention to these artists and their works. All were dedicated people who strove for recognition in the 1880s Boston art scene. Most of them failed to gain much attention but earned some sort of living as professional artists. They came from all over New England drawn, as if by a powerful magnet, to Boston, the Hub of the Universe.

Sanderson came from a small hamlet in Vermont, Titcombe, from a town in New Hampshire, Phelps from Chesham in New Hampshire, Harlow from Cape Cod, Burdick from Connecticut, Vinton from Salem, Eldred from the South Shore of Massachusetts, Green from the North Shore, Key came from Baltimore, Claus was from Germany; and, among the native Bostonians were Santry, Griggs, Gerry, Wagner, Paskell, White, Parkhurst, and Billings.

There undoubtedly were others who would fit well within this same framework of time and locale as this group of artists but the authors, who freely admit to a certain bias, restricted this small volume to these few artists on the basis of personal knowledge, preference and the limits of time and space. A few of them were known personally by co-author Rolf H. Kristiansen, and co-author John J. Leahy is a grandson of artist William F. Paskell. Each and every one of these artists caught our eye first with their paintings and then our curiosity and respect when their stories were revealed.

We acknowledge, with gratitude, the help and assistance of many people including those cited in our Bibliography and Other Sources as well as others too numerous to mention individually. Special thanks are extended to our wives, Charlotte Kristiansen and Dorothy Leahy, without whose support our meager efforts would not have seen the light of day. At the same time we retain exclusive responsibility for any errors or mistatements of fact, albeit unintentional.

We also acknowledge, with sincere thanks, two individuals to whom this publication is dedicated; to Janice Chadbourne, Acting Curator, Fine Arts Department, Boston Public Library who gave generously of her research capabilities and encouragement, and to John J. O'Brien, who as an avid art historian and collector, provided much of the in-depth research and kept us pointed in the right direction.

Dedham and Boston,
Massachusetts, 1987

# INTRODUCTION

The American painters of the last quarter of the 19th Century were some of America's finest, such as Thomas Eakins and Winslow Homer. Today, our Libraries abound in books regarding such artists. During the same period there were lesser painters working who achieved artistic excellence but never found a large appreciative audience during their lifetime. Their work was observant, reportorial, honest, and frequently poetic - often reflecting the grandeur of the American continent. If you wish to know more about many highly competent artists, whose lives, in many instances, are but dimly remembered, this book will be an infinite delight.

The material is fresh and the biographies are comprehensive, detailing the daily lives of 25 artists during the 1880's. The artist's aims will be revealed and his character understood. Numerous anecdotes and a personal background have been provided by many descendants who kindly granted interviews. All artists' lives are highlighted by selections taken from various private diaries, hitherto seen only by each artist and his family.

Each artist's affiliation with clubs, associations, and other artists is noted. Well over one hundred artists are mentioned, all of whom were working artists, mostly with studios in Boston. Throughout the book, many of each artist's works are listed, mostly the period 1875-1900, and their present whereabouts noted. There are descriptions of many art exhibits of the period and an inclusion of a rare document: The 1884 *Massachusetts Charitable Mechanic Association* Fine Arts Catalog (American section).

The reading is easy, narrative, and non-technical. Each

biographical survey is of a fine painter, either forgotten or comparatively unknown today. Ten years of research were necessary to complete this text - an effort from which every connoisseur of fine art will benefit. Most important to the beginning collector is that most of these artists are still "affordable."

The co-author, John J.Leahy,Jr., whose grandfather is William Paskell, one of the 25 artists, comes from a family solidly entrenched in New England art. His experience qualifies him to understand the travails and philosophies of the many artist friends of his grandfather. The other co-author, Rolf H. Kristiansen, already has one other title to his credit. He co-authored the biography of John Joseph Enneking (first edition, 1972). Mr. Kristiansen worked for many years with several fine Boston art dealers - an experience which dates back to 1925. Many of the paintings mentioned and described herein have passed through his hands and today add the color and flavor of nineteenth century New England to many otherwise drab walls.

Robert C. Vose, Jr. once said that, "Thirty years is the average span before artists of merit are *discovered* again." If this is true, then the 25 artists represented herein are certainly overdue. We all owe a debt of thanks to both Mr. Leahy and Mr. Kristiansen for bringing these forgotten artists to our attention, allowing us better to understand and appreciate the struggle necessary to survive as an aspiring artist during *any* era.

*William T. Currier*
*President*
**Currier's Fine Art**

**Author of:**
*Currier's Price Guide to AMERICAN ARTISTS AT AUCTION (1645-1945)(Second Edition)*
and the forthcoming
*Currier's Price Guide to EUROPEAN ARTISTS AT AUCTION (1545-1945)*

# LIST OF ILLUSTRATIONS

# Chapter One

## CHARLES WESLEY SANDERSON

The White Mountains of New Hampshire have lured hundreds of artists attracted by the unique hills, valleys, and its rugged mountains. Their beauty is undeniable. The neighboring state of Vermont with its pastoral rounded hills and high mountainous pastures, has hardly any nineteenth century artists that can be considered, "Green Mountain" painters. One such artist who has left a heritage of Vermont landscapes was Charles Sanderson, who curiously enough had his studio in Boston and exhibited year after year with the Boston artists.

Sanderson was born in Brandon, Vermont in 1838. Brandon is a small village set in a pleasant, flat valley surrounded by low mountain ranges far in the distance. Otter Creek flows through these meadows for many twisting miles. Excellent farmland circles the village. As a boy, Sanderson had a natural talent for drawing and sketching but was raised to be a music teacher. He did indeed teach music to the villagers for a number of years. When a Scotch artist, James Hope, settled in the valley, Sanderson was the first to study with him and learn the rudiments of oil painting. Hope recognized the young man's talent and helped to send him to Boston to study with Samuel Gerry, who in 1858 was president of the Boston Art Club.

The music training stood him in good stead and he had many pupils from the Boston gentry. Eventually Gerry encouraged him to go to Paris as befitted all good American art students (or so held the wisdom of the times).

Sanderson did manage to set out for Paris and arrived there in 1864. There is a record of his practicing drawing from life in the atelier of Julien. He was awarded two prizes for his nude sketches and was admitted to the l'Ecole des Beaux Arts for excellence in drawing. When his Paris studies were, he felt, ample, he went to England and turned his attention to water color painting. He employed this media throughout his long career. Returning to the continent he made the grand tour and painted landscapes in Italy and Switzerland. One of his better known pictures, a product of this trip, was created in the Alps and titled, "The Afterglow on the Wetterhorn."

Sanderson returned to Boston with two loves, many of his European paintings and sheaves of piano music. While in Italy he had heard the great Liszt perform in Rome. The master not only played his fiery music but also a gentle and dreamy pianoforte of a certain Frederick Chopin. Sanderson opened a studio on Franklin Street and installed a piano as well as his paints, brushes, and easels.

People coming into the building could hear the soft Chopin music echo through the halls and staircases. It may have been the first occasion that the turbulent Revolutionary Etude was heard in Boston. He had both art and music pupils, one of whom was one of S. D. Warren's children. It was not long before Mrs. S. D. Warren purchased his, "Afterglow on the Wetterhorn" painting. The Beacon Hill dowagers had a new artist to lionize, and one who could perform the latest music from Europe.

Sanderson spent his summers in Vermont painting the familiar landscapes of his youth. The pictures attracted much attention and received good prices. He entered several of these works in the 1874 Williams and Everett annual Boston Artist's Exhibition. They were watercolors and one was entitled, "Lana

Cascade near Lake Dunmore, Vermont." It was bought by a collector from Brooklyn, N.Y. by the name of Turner. Another watercolor, "Otter Creek Meadows, Vermont," was purchased by a Mr. Wright of Boston. Downes, the art critic of the Boston Daily Advertiser, wrote of the exhibit:

> In the same gallery there is a watercolor by Mr. C.W. Sanderson, whose paintings should be more frequently exhibited. The painting is a study of the "Lana Cascade near Lake Dunmore, Vermont," and is in most respects an excellent picture. There is nothing at all conventional about it, and one can easily see that the artist has attempted to make an accurate, careful,and truthful interpretation of the scene before him. The handling of the colors is a clear indication that the artist has skill in manipulating the brush, and it is this disclosure of reserved strength that arouses the desire to know the artist better through his paintings. The scene itself is a charming one, very familiar to be sure, but of that sort which one is never tired of seeing.

Sanderson was one of many artists that frequented the art shop at 8 Bromfield Street in Boston. There was a picture framer and gilder working there by the name of Paskell who had emigrated from England some years before. He had a little boy that came in after school by the name of Bill. All the artists made much of the lad and soon had him sketching between his chores. This went on for a number of years and soon the boy fancied himself an artist. He graduated from high school and was painting in this style and that, quite confused by trying to assimilate all the styles of too many mentors. Sanderson took Bill in hand when he was seventeen, and gave him watercolor lessons at his Franklin Street studio. What the artist did not know was that young William kept a day to day journal of all his daily efforts,

his impressions of the various artists that he had met, and all the Boston art events. It is through this journal that we can get an inside and an overall contemporary view of the 1883 through 1885 art scene of Boston.

Judging from the journal, Bill was a brash young man, with all the confidence of youth. Despite his young age he had a long acquaintanceship and last name familiarity with many successful Boston artists and the journal contains opinions as well as descriptions that are remarkable even today. Selected entries during January of 1884 include the following:

> In the morning I went to take a lesson in watercolor from Mr. Sanderson...At Mr. Sandersons, in the morning painting...My pictures at the Art Club are accepted...Went to Sandersons to paint in watercolors. In the afternoon I went to a private view at the Art Club. Over 450 works were sent to it but only 162 were taken...[Repeating H.O. Walker's admonition to him] Place no dependence on the jury as influence, not merit, is the greatest factor in getting your work in [the Art Club exhibition]. Do not be discouraged if they are returned, but be assured there will be fifty worse ones there.

The journal contains an excellent description of the show but more importantly speaks of Sanderson introducing and renewing acquaintances with such men as George Fuller, J.F. Murphy, J.J. Enneking, Eaton, Dickinson, and the younger artists, E.B. Stewart, Reynolds, and C.H. Woodbury. They all invited Paskell to their studios and he availed himself of every opportunity.

Paskell praised his teacher's entries in the Art Club exhibit as having, "a sense of beauty, quality of execution, more practical, yet poetical in conception." Sanderson could teach him painting but not to be a little less brash.

The Massachusetts Charitable Mechanic Association held an annual fair and contained a large display of fine arts. Artists from all over the country came to Mechanics Building on Huntington Avenue and the public filled the many halls to capacity. Sanderson considered it a feather in his cap when his pupil's watercolors were accepted along with his own works. It is interesting to note the prices asked for these paintings. Paskell's entry No. 40, "Mountain Brook: is marked $20. and his No. 97, "Road to Pasture" could be had for $18. Close to Paskell's works were hanging two Venetian scenes painted by another young artist by the name of J.H. Twachtman. The price of his "Venice" was $35. and his "Venetian Scene" was marked at $25. It is not recorded if they sold.

Sanderson's watercolors were entitled, "Young and Old Growth," at $75. and an Adirondack Mountain scene, "Moss Glen," priced at $90. The artist whose works were hanging beside them was Homer Martin who at that time had been voted a full member of the National Academy. His painting "Coast Meadows" was priced at $40.

The above seems typical of the Boston art scene of the early 1880s, plenty of opportunities to exhibit, lots of crowds, but very little and selective buying taking place. Some of the names that were selling for higher prices included J.J. Enneking, Mrs. F.B. Chadwick, C.D. Gibson, G.H. Smillie, P. Little, and C.Y. Turner. Paskell's comments of Turner's work was terse and to the point "studio pictures that have no particular value as works of art."

Sanderson exhibited regularly at the popular gallery of Doll and Richards and induced the manager, Mr. Hatfield, to allow some of his pupils to show their works along with his own. Sanderson bore the expense.

As he grew older Sanderson yearned for the peace of pastoral Vermont. He spent a year in Brandon, completing many paintings. When he returned to Boston he opened a new studio and resumed not only his art career but became involved again in many of the Boston musical events. The entire world

had been impressed when in 1872 the city staged a great Peace Jubilee. The idea was to commemorate a whole world practically at peace. Wars were a thing of the past and it was celebrated with massed melodic hosannas. The musical events were stupendous. Sanderson sang with a representation from the Ruggles Street Church in a chorus of over 17,000 voices and an orchestra of 1600 selected musicians from all parts of the country. A hymn was sung slowly by the great chorus with the support of the great organ, orchestra and thundering cannon. People trembled and cried throughout the vast hall and felt transported into the very presence Divine.

During the 1880s, Sanderson frequented the music stores almost as much as the art supply houses. Two of his favorite musical emporiums were Oliver Ditsons on Washington Street and Russels on Tremont Street. The environment was quiet and dignified. The gentlemen customers usually wore frock coats, high hats, and all carried canes. Tremont Street was the strolling place for all types of exponents of the finer arts. They gathered at the three clubs that had become Boston institutions for painters, literary persons, and musicians. They were the St. Botolph, the Boston Art Club, and the Harvard Musical Association which was then on Beacon Hill. Artists were prompt in attendance when the bar opened at four o'clock daily to discuss the events of the day and prepare for the salon's command appearances of the Beacon Hill and Back Bay dowagers. Those who did not receive that type of invitation were hard put to make sales and sometimes had to resort to auctions to ease their financial burdens. Leonard's Auction Rooms staged weekly sales for better or worse. One such auction is recorded and the account reads:

| | | |
|---|---:|---:|
| *50 Pictures sold* | | $500.00 |
| *Advertising, per bills* | $49.90 | |
| *Commission 11 per cent* | 55.00 | |
| *200 fancy linen catalogs* | 66.28 | |
| | ———— | |

|  | 171.18 | -171.18 |
|---|---|---|

*Net profit:*                                                        $328.82

Lo, the poor artist!

Sanderson, however, had no need of auctions or over exhibiting. His works and subjects never dried up. He was active until his 67th year and died during the bad winter of 1905. Most of his works had been sold and evidently are still held in high regard by the families that possess them. Very few are seen today at auctions.

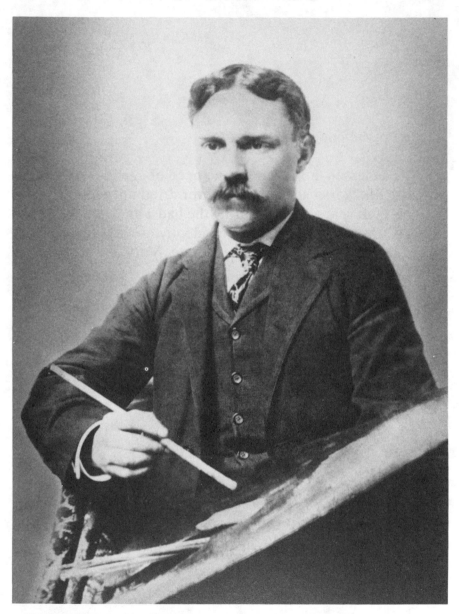

**WILLIAM F. PASKELL (1866-1951)** [photograph]
*Circa: Boston, Massachusetts 1895*

# Chapter Two

## WILLIAM FREDERICK PASKELL

The artist from Boston was in his eightieth year and on his annual trek to New Hampshire where, many years before, he had fallen in love with Mount Chocorua. As a boy of eighteen he had made his first trip to the Chocorua region to which he returned, again and again, to paint and gain inspiration. He was among those young artists in the rear guard of that group of painters whose work was known as the White Mountain School of Art; a junior associate of artists B. Champney, J.J. Enneking, S.L. Gerry, F. Shapleigh, and others.

The trip, in his eightieth year, his "last hurrah", was to Chocorua, N.H. In 1946 on October 5, his birthday, the artist wrote a poignant letter to his wife, Mary, back in Boston.

> Since my arrival here it has been very cold and it was raining hard...the thermometer never went above forty until this morning. It is warming up now and the weather is fine today. I hope to do some sketching by this afternoon...The color on the mountain and forest is getting to be very brilliant and Chocorua Mountain seems to look finer

than ever...Nearly all the people I knew years ago
in the Tamworth neighborhood are gone and that
seems to have changed the place so much. I am
going to the Lake Chocorua tomorrow.

His last letter from Chocorua, dated October 11, 1946,
alerting his beloved wife, Mary of his impending return to
Boston says it all. "The weather has been very fine and the color
of the foliage has been very good. I know that these few days in
the mountains have done me much good in every way and that I
will benefit by it."

Less than three and one half years later, on a cold, blus-
tery day in February, 1951 after spending most of the day work-
ing at his studio in Boston, he collapsed and died. True to his
youthful ideals, he had persevered in his chosen profession most
of seven decades. William Frederick Paskell, who was born on
October 5, 1866, in Brompton, Kensington, England, arrived in
America at the Port of Boston on November 15 of 1872 five days
after the great fire which destroyed a large portion of the central
city. His father, William E., was a gilder and framer of pictures
and, in England, his grandfather, Samuel W. Paskell, was a pic-
ture restorer. According to English census records, his paternal
aunt, Ellen, was also an artist.

The father sought to support his three children by setting
up shop near many of the art stores on Bromfield Street. There
were nine children eventually, two of whom, died in infancy.
William's first home in the new world was in nearby Roxbury at
50 Heath Place. Bromfield Street was one of Boston's principal
art centers. The street housed art supply shops, gilders and
framers, auction rooms, galleries, and studios. Most of the time
one store could contain the majority of the above. Such a place
was 8 Bromfield Street where young Bill, as the oldest son, came
after school to help his father by doing any chore that he was
able to do. His father's gilding and framing shop was a few doors
away from Benjamin Champney's studio located at 21 Brom-
field St.

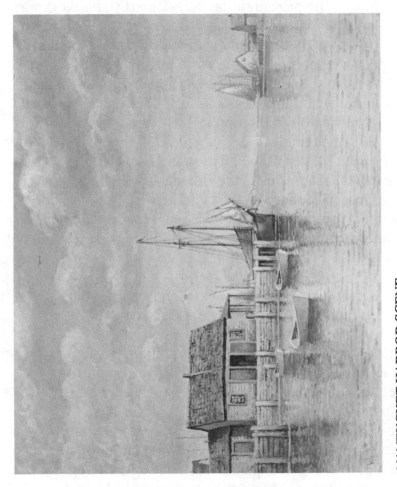

NANTUCKET HARBOR SCENE
*By WILLIAM F. PASKELL - Oil on Canvas, 25"x30"*
(Courtesy of Richard A. Bourne Co. Inc., Hyannisport, Ma.)

Young Paskell, then, was born and raised to be a painter. He was sketching at an early age and painting by the age of sixteen. His association with works of art and artists in his father's shop, in Boston, undoubtedly inspired him to develop and master the skills of painting, which was to become his sole, life-long vocation. As he proved his talent as an artist, his work was chosen by a jury of his peers for exhibition by the Boston Art Club. His paintings, both oil and watercolor, were exhibited in eleven separate exhibitions by the Art Club, from 1884 to 1906. His work was also selected for exhibits at the Boston Museum of Fine Arts in 1885, and the Massachusetts Charitable Mechanic Association's Fifteenth Exhibition in 1884 where his work hung alongside, J.J. Enneking, J.F. Murphy, J.A. Weir, and G. Fuller. Fuller died shortly after this exhibition in 1884.

Paskell's first entries in the Boston Art Club appeared in the exhibit held in January of 1884 and he was, perhaps, one of the youngest artists, at age 17, so honored. He received remarkable acclaim such as the item in the Boston Morning Journal of January 19, 1884:

An interesting feature of the landscapes exhibited is the work our younger painters have sent to it. First among them is at once the newest and one of the most promising, is Mr. William Paskell, who has never exhibited any of his work before, yet both of whose contributions to the present display were accepted and hung. They are Nos. 87 and 98, both modest in their intentions and unaffected in their execution, yet showing an unusual talent, and a great quality of handling that suggests much that is admired in the works of Michel and Rousseau. The painter is but 17 years of age and had little or no instruction in art, but the sign of genius is unmistakably upon him, and he shows unusual promise. One of his pictures was sold at once at yesterday's private view, and the other ought, by its merit, also to find a purchaser.

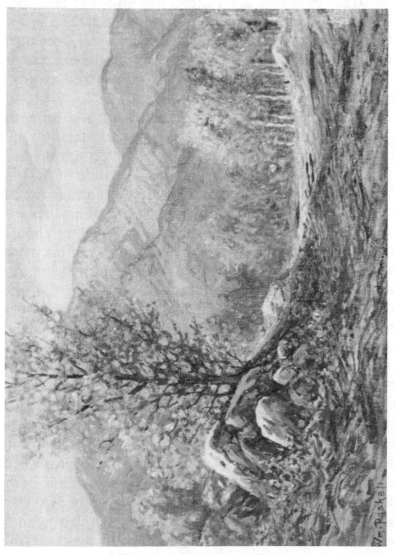

AUTUMN, MT. WASHINGTON - JACKSON, N.H.
*By WILLIAM F. PASKELL - (1885) Oil on Canvas, 12"x16"*
(Private collector)

His career as an artist was marked by diligence and hard work, confident that his talent was equal to his peers. All in all he had great expectations. The decision on his place in Boston Art is yet to come but we are grateful to him for at least one good reason. He kept a journal covering his activities in the world of art in Boston and New Hampshire between December 1883 and October 1885. It gives us insights into the era and its artists that we might not have had otherwise. Selected excerpts are reprinted in Appendix B.

Paskell kept meticulous track of his artistic progress through these journals and many sketch books detailing his thoughts, movements, associations, and work in art through the years. These records were kept in an old desk, one of his few possessions, since for most of his adult life he and his family rented "furnished" apartments. Toward the end of his life, and at one period of time, this desk remained at his daughter's house in Dedham, - perhaps the most permanent locale of his many residences. Shortly before his death his one unmarried son, Alfred, who lived with his parents until their deaths in 1951 and 1958 took possession of the desk. Three of the sketch books remained with Paskell's daughter Ruth. Alfred, the beloved uncle to all of his many nieces and nephews, gave to one of his favorite nieces, Olive, nine other sketches, apparently torn from three other sketch books. The other journals and sketch books eventually were given away or bartered in exchange for past due rent and an occasional round of drinks at local taverns. Alfred, who eventually buried his parents in an unmarked grave, was in no position to protect what was left of his father's records when he also died, alone and somewhat derelict in 1969 - his body unclaimed for two weeks in the city morgue. One of Paskell's journals, probably his second, surfaced and found its way into the hands of a present day collector of Paskell's works. This journal was missing over thirty of its pages, perhaps torn out by a Paskell progeny, for whatever reason. The time frame and several specific references in this journal relate well to several of the pencil sketches still owned by the family. The search con-

tinues, however, and is slowly turning up more documentary insights into the era of Paskell's artistic career.

There were several annual opportunities to exhibit and an important one was The Massachusetts Charitable Mechanic's Association (Department of Fine Arts) on the occasion of their Fifteenth Exhibition in 1884. This great exhibition filled the large Mechanic's Building on Huntington Avenue. The first two floors were full of the latest in machinery, the new electric railway models, all sorts of inventions, jewelry and furniture. The third floor was divided into fine art galleries and each year attracted artists and sculptors from all over America. The first gallery was devoted to foreign works, mostly owned by Boston collectors and art establishments. Then came the American Gallery, the Watercolor Gallery, the Prang Lithograph Gallery, the Heliotype Gallery, and various schools of design, photographs, and art school exhibits. Paskell's journal has a fine description of this event. A portion of the catalog of this exhibition is included in the Appendix A of this book. Most of the records of this organization were unfortunately lost in a great warehouse fire several years ago so this information is rare and hard to come by.

The journal notes, "Two of my pictures [watercolors] are hung here, [No.40] The Mountain Brook, and [No.97] The Road To Pasture." One of them is hung on the line and the other one just below it. Nearby a work that attracts much attention is young [P.W.] Bartlett's [1865-1925] statuette of John Brown." Paskell also had a small oil painting at this exhibit which he described as a "Small Sunset Sketch," No.186.

The Boston Museum of Fine Arts had an annual Boston artists show and the various art stores who had galleries were always at the disposal of artists who were willing to sell unframed works and pay a certain premium. Paskell tried them all. Williams and Everett's Art Gallery at 508 Washington St., who advertised, "The largest and finest stock of paintings, engravings, etchings, carbons and photographs in New England, " gave him a small show. They also advertised, "Prices always reason-

able." Reasonable indeed; Paskell watercolors were selling for
$6. A Mr. Hatfield was the manager at Doll and Richards'
Gallery at 2 Park St. who also exhibited some of the young
artist's works. He advised Paskell to use brighter colors. Paskell
noted in his journal that he would pay no heed to that advice.
These aforementioned art stores were, at the time, the oldest
two such establishments in Boston and had the largest galleries
for the public viewing of paintings. Paskell's father also gave him
encouragement by providing one wall in his frame shop to ex-
hibit his son's work. Paskell was also known to exhibit his work
at other framing shops including Foster Brothers at 2 Park
Square.

The newspaper art critics were always kind to him with
rather lavish praise. However the sales that brought substantial
amounts were not of his work and he began to have doubts
about making it as an artist. The artists that he had contact with
still encouraged him not to give up. A private one man show was
decided upon. A room was hired at 13 Franklin St. in the same
building as his constant adviser, Ida Bothe, one of the few
women artists in Boston at the time. He hung about fifty pic-
tures, including a large "Chocorua Sunrise". The exhibit opened
April 10, 1885. He apparently was very pleased with the Boston
Daily Advertiser's comments of April 14th. "One of his
[Paskell's] largest pictures is a view of Mount Chocorua at sun-
rise, in which the effect of the first flush of the dawn over and
beyond the mountain peak,with the mists and shadows of the
night still hovering in the woods and valley beneath, is conveyed
with remarkable success." and The Morning Journal of the same
date "There are large landscapes with beautiful skies, and soft
toned foliage and exquisite feeling; and small pictures with just
a glimpse of sunset or twilight which are like poems in their
delicate beauty."

The Museum of Fine Arts show in 1885 as reported by
the Boston Evening Transcript of April 13, 1885 spoke very well
of his one small picture exhibited. "The small number of land-
scapes is their only point of weakness. As a whole it is marked

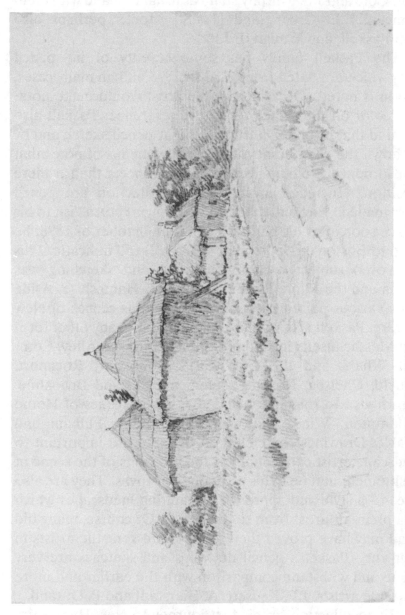

HAY STACKS, HERNE BAY, ENGLAND
*By WILLIAM F. PASKELL - (1889), Pencil sketch*
(Courtesy of Ethel Mace Thompson)

by great eveness and that of a high degree. Enneking [J.] Foxcraft Cole and J.F. Murphy,stand as usual first and with them this time, C.E.L. Green, and [J.A.S.] Monks perhaps also William Paskell, and Waugh [F.J.]"

The Paskell family has some seventy of his pencil sketches which are dated from 1883 to 1895 and, in many cases, a location is noted. Occasionally, the artist would make notations of color on the sketch for future reference. Paskell also said, "I find that by taking a true but slight pencil sketch and by noting down the chief points of a scene by means of notes that you can produce a picture better in all respects than a mere composition." Included in the family collection are pencil sketches made in England dated 1889 during a return visit to his birthplace soon after his mother's death in October of 1888; he returned to Boston on September 9, 1889. By all indications his most favored subject area for painting and sketching was Chocorua and the White Mountains of New Hampshire. Aside from the various paintings readily identified as scenes of New Hampshire, Paskell also visited and painted in many other locations in Massachusetts including Nantucket (Stone Alley, Commercial Wharf, and the Old Mill), Gloucester, Rockport, Springfield, Chelsea, Roxbury, Jamaica Plain and Brookline. His return visit to England included work on scenes of Herne Bay, Hampton, Windsor, Loughton, Bromley, Fulham and Whitstable. Drawings completed on the spot are important to the landscape artist connecting his recollections of the scene at a given moment in time to his work on the canvas. They are also evidence of a style and approach to painting landscapes which marks a plein-air artist from studio artists. Of course, many did both and may have proved themselves more versatile artists in the long run. Paskell's pencil drawings and sketches are very well done and withstand comparison with the earlier and more recognizable artists, J.F. Kensett, A. Bierstadt and P. Durand.

His recollections of his first journey to New Hampshire and the White Mountain area were recorded in his journal and the location names are still familiar to us. He recorded painting

"an oil color sketch on Swift River", a "sketch in sepia of Mount Chocorua after rain", a "watercolor of the Old Mill House", three pencil sketches, and a watercolor of Mount Chocorua from Swift River".

James Mayhew, a Civil War veteran, built a small house (known as "Carriagain House") for summer boarders in the Intervale area of New Hampshire sometime around 1870. On his first trip to the area in 1884, Paskell describes in detail his 15 mile journey by horse and carriage from Conway to Mayhews's house arriving there on Wednesday, July 2nd. Paskell apparently developed more than a passing acquaintance with Mayhew. The two of them went fishing together on several occasions and ascended Mount Chocorua together. Mayhew's house was "about one mile from the foot of the mountain."

The descriptions of the White Mountain area landscapes, in his journal of July 1884 are truly poetic. He wrote:

> The beauty of the scene was perfect. Before us lay the stretch of half a mile of water like a mirror with the exception of one place where the breeze just dimpled it, and the lily pads with their white blossoms. The woods rose on the other side of the lake. Sugar Hill lay on the left and the Green Cliffs on the right with one of the most beautiful valleys between. Away up the valley lay some distant mountains enveloped in mist. The sun was about one half hour from setting and shed a warm glowing light that pervaded all. The sky was filled with a rich golden mist and some of the most delicate sunset skies I ever saw. A few light clouds of graceful form were slowly moving across the western sky. The sky possessed none of the bright yellow or orange tints most often seen in a clear, nearly cloudless sunset, but it was glowing with a golden silvery tint that was wonderful. ... Coming across the meadows we had before us a stretch of

grassy field for half a mile and then came the long line of trees that line the bank of the Swift River. Then came some large hills and back of them rose Chocorua with its sharp peak and three domes lit by the last flowing rays of the sun and the lower parts of the mountain, a coolish bluish grey. The eastern sky was one mass of purple pink graduating to blue grey at the zenith.

In later years, Paskell's Boston Art Club entries were devoted to New Hampshire scenes. The 1899 exhibit lists Paskell's No.201, "Northern Ravines of Chocorua;" No.220, "Chocorua Mt. Tamworth, N.H.," and No.224, "Bridge at Wonalancet, N.H." In 1901, he exhibited No.156, "Summit of Mt. Chocorua," and in 1906; No.94, "A Pasture, Tamworth, N.H." and No.175, "October, Tamworth, N.H."

William F. Paskell was both a student and a teacher, as were most full time artists of his time. His teachers included Charles W. Sanderson who encouraged the young Paskell and taught him much about handling watercolor. Of Sanderson, Paskell wrote that he was "one of the most pleasant men I ever met with. He has a very entertaining way of talking." John J. Enneking, a man much admired by the young artist, gave Paskell informal instructions in the use of light and color and admonished Paskell to, "remember to keep a reserve in everything. Never make your colors so brilliant but what if you need it can be made more so." Other teachers included Francois B. De-Blois, and Tommaso Juglaris, then a professor at the Boston Academy, Juglaris , like many of the other artists mentioned, also had a studio on Bromfield Street near Paskell's father's shop. In 1866 Louis Ober of the now famous Locke-Ober's restaurant gave Juglaris a commission for $80. to paint a portrait of a nude which still hangs over the bar at this establishment. Paskell also received art instruction from Henry Oliver Walker and A.C. Fenety who had the studio next to Walkers at 23 Studio Building on Tremont St. at the corner of Bromfield.

He associated and exchanged paintings with Felix A Gendrot a boyhood friend, C.E.L. Green, Jacob Wagner and others. His students were numerous, usually on a one to one basis and included Charles E. Heil. He taught this way, individually, well into his seventies. Indeed, other artists are still identifying themselves as "a student of W.F.Paskell" or "of the school of Paskell". He wrote, as a young man, of traveling, often on foot, to Framingham, Brookline and Medford to give lessons.

In 1930 Gendrot donated a small painting by W. Hunt to the Worcester Museum of Fine Arts. Artist, and friend, and the same age as Paskell, Felix Gendrot occupied a special place in Paskell's thoughts as reflected in his journal:

4 Jan.1884, At the room in the evening and made a charcoal drawing. Gendrot has left us. Next to King I depended on him for keeping the club going. He however, prefers his social club [Boston Art Club?] to our drawing club. Poor taste for one who wants to be an artist.

15 Jan.1884, Gendrot's pictures came back from the Art Club today, not accepted. I hope mine are taken as they are the best two I have.

21 Jan.1884,Went to see the exhibition with Jones and Gendrot in the evening. Met Mr. Eaton, who congratulated me and introduced me to some of his friends.

3 April 1884,Began a 10 x 14 sunset in oils. Went to Gendrots in afternoon.

9 Nov.1885,Called on Gendrot with Knox.

19 April 1885, Went to see Gendrot tonight who sails for France on May 2nd. His father is

going to give up work and go back to his native land so that his son may study art.

2 May 1885,... went to East Boston with Mayhew to see Gendrot depart for Europe. We spent a couple of hours talking over old times and future prospects, and gave each other encouragement to study hard. The boat went at One O'clock and he ran down the gangplank five times to shake my hand just before the moment came to start. As the boat pushed off from the wharf I must confess that a suspiciously large drop of moisture was in our eyes and it was all we could do to say goodby. We could not speak any farther without breaking down, so Mayhew and I wrung hands in silence and gazed after the receding form of our friend until he was no longer to be seen, when we turned and sadly left. He will let us know how he gets on and he promised to send me a sketch once a year and I the same. Hard as it is to part from a friend how must those who feel and leave the home of their childhood, their parents and those ties dearest to the heart, to start to some unknown land, knowing that perhaps they will meet on this earth no more. And although they meet new friends they seldom find that place in their hearts that the old one did.

Gendrot went on to study at the Julien Academy in Paris under Laurens and Constant. He returned to Boston and became quite active in the various art circles of the area.

There was one other man that he admired above all and that was his neighbor on Bromfield St., Benjamin Champney. This was not strange because that pioneer White Mountain artist was without doubt the most beloved of all the New England Masters. He was a founder of the art club and one of its

presidents. When Champney died in 1907, at the age of ninety, William Paskell painted, as a tribute, a large canvas entitled, "Champney's Favorite View" [see cover illustration]. He presented it to the club and it hung in a place of honor until the organization closed its doors.

It was said by those who knew him as a painter that he was a pleasant and convivial person at play, but he was reverential, single minded and deadly serious while at work. Painting until the day of his death in 1951, spanning a sixty-eight year career, Paskell devoted all of his energies to his art. A most prolific painter, Paskell, at age 21, actually listed over one thousand paintings, oil and watercolor, in his journal and elsewhere, covering the years 1883 to 1887. In a February, 1932 interview published in several Boston papers, he acknowledged having painted over one thousand paintings, of sailing vessels alone. A conservative estimate of his life long production would run between four and six thousand paintings.

He spent little time bettering the lot of his family, marrying an Irish Catholic girl from the Roxbury section of Boston, in a ceremony before a Unitarian minister in Providence, Rhode Island in 1901, just twelve days after the death of his father. She was 30 and he was 34 years of age. Paskell met his future wife, Mary Ann Morgan, while he was a boarder in her family's home on Heath St. He quickly sired six offspring, two of whom died young.

Throughout their married life, the Paskell family hardly ever owned a stick of furniture, moving from one furnished apartment to another at fairly regular yearly intervals. Mary, wife to William Paskell, must have been the proverbial, long suffering wife, little understanding the ways of her artist husband. And yet, there was a certain affection between these seemingly disparate persons. William tended to be an intellectual, well read in the classics and the topics of the day, with an opinion about anything and ready at the drop of a hat to express that opinion to anyone who was willing to listen, except his family.

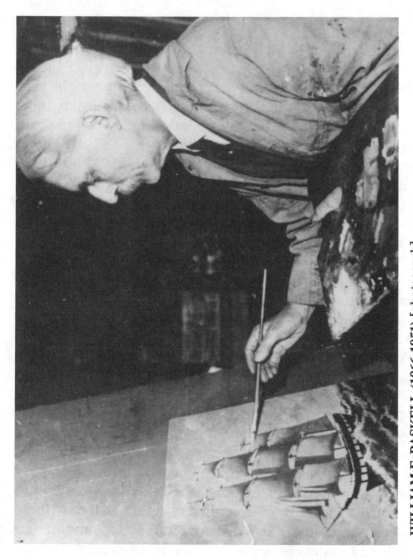

**WILLIAM F. PASKELL (1866-1951)** [photograph]
*Circa: February, 1932 - Painting in his studio at 26 LaGrange Street, Boston, Massachusetts*

Apparently, Mary, on the other hand, with her parochial, Irish Catholic background must have stood somewhat in awe of this strange creature who could create pretty pictures at will. As Mary and William grew old together, Mary's awe turned into an affectionate tolerance of her husband's artistic ways. Mary's advice to her daughters and grandaughters was that "this is the best job you'll ever find and you can't find a job better than being a wife", not the exact words of today's liberated woman! Often, almost yearly, he would be off on painting expeditions usually to his beloved White Mountains in New Hampshire, gone from his family from May to October.

We know much of these early days through official records, family remembrances, sketch books, letters and for his initial years, his journal.

Paskell usually signed his paintings with a period after "Wm." or "W.F." and "Paskell.". In a few paintings he signed with a monogram. He intertwined the capital letters "W" over "P" and again, perhaps inappropriately, placing a period beside the monogram. Paskell often dated his watercolors which he deemed particularly well done (we agree), and we have seen examples of these, mostly landscapes and shore scenes dated from 1883 through 1920. Rarely did he date his oil paintings - perhaps thinking that to do so would age them in a prospective buyers eye and lessen their saleability. One oil, a 20 x 36 panoramic view of Mt. Chocorua, was rare for the artist in two ways, first it was dated, and secondly the date was 1935; proving that he was still very active as a landscapist in addition to his more recent fling with marines.

Although Paskell is not well recognized as yet, there are a number of avid collectors of his works. In the Greater Boston area alone there are at least three hundred paintings which are owned by perhaps a half dozen collectors.

A grandson of William F. Paskell remembers visiting Paskell's studio on a regular basis in the late 1940's. Paskell then in his eighties and still regularly at work, would arrive at his studio by nine A.M. and, like clockwork, would arrive home by

six P.M. sharp each evening. Following supper and his customary cigar, it was his habit to work at his easel until bedtime each evening.

His studio was cluttered with his paintings and his desk was equally cluttered with papers and on top, numerous photographs of his many grandchildren in whom he took great delight.

When his grandson arrived at his studio he would question him briefly about his parents and siblings, after which he would work for hours without another word passing between them.

Occasionally, Paskell would instruct his grandson about this or that technique, for example, illustrating perspective by saying that as things get further away they became smaller and lighter. It should be noted that such instruction to the young teenage grandson was not received with great interest although he showed some early talent for pencil sketches. This talent for drawing by the young boy must have been a source of pride to the aging painter.

Many of Paskell's colleagues and contemporaries amongst the art community were problem drinkers and often their lives were shortened as a result of alcohol abuse. There has been some conflicting stories about Paskell's own drinking habits. The answer appears to be that he was a moderate drinker. He did live to 84 years, far beyond the average age for men of his day. His family never observed Paskell intoxicated or otherwise "under the influence". It is recalled that at most he would take one small glass of liquor with a bit of lemon after the evening meal.

Paskell was artistically aware of the glorious profusion of colors splendidly displayed in nature and particularly in the mountains and valleys of New Hampshire. The spring explosion of green in all of its shades, the emergence of hosts of wild flowers and the dramatic transformation of the fall foliage into bright oranges, reds, crimsons, and yellows marked many of Paskell's New Hampshire landscapes. His portrayals of

Chocorua, the mountains, the lake, the valleys and foot hills around that picturesque mountain were many. He painted this scene, centering on Mt. Chocorua, from every angle and in many different lights, colors and seasons in both oil and watercolor.

Paskell's love of New Hampshire's Chocorua was consistent and never failing, from the age of eighteen to eighty his heart was ever young with thoughts and impressions of that mountainous region. On the 8th of April 1885, Paskell wrote:

> Worked all afternoon on the Chocorua and succeeded in improving it, Miss [Ida] Bothe thinks it far ahead of all I have done before. It is certainly poetical as far as I can carry it and the subject is original both in composition and effect. But it still falls far, far below the great original that impressed me so much, as far below it as the wooded valleys are below its granite peak. An echo perhaps of its wonderful effect but a very faint one. Still if it stirs some of the finer feelings it has accomplished something.

Paskell's grandaughters remember the annual chore of delivering the artist to Boston's North Station on Memorial Day so that he could travel to his beloved White Mountains and, of his return in October.

Long term residents of the Conway area still recall Paskell, who often wore a white linen suit, a black string tie and a black fedora hat, in company with artists James D. Hunting and Francis E. Getty his best friends. Phyllis Greene, now of Glen, N.H., who ran a small crafts shop in Conway remembered the three as jovial and fancying themselves as gourmet cooks (and, she says, looking the part). She nicknamed the three artist chums, in a play on words as, the "Three Musty Steers." They would often come into her shop looking at the various items of craft work on display and teasingly ask her to pose for them. Mrs Henry Gagnon of North Conway recalls Paskell as a boarder at

her parent's home and remembers the artist as being an interesting conversationalist. In earlier years, these three were often visitors at B. Champney's studio and home in North Conway according to Champney's grandaughter and Paskell's own recollections related, shortly before his death, in an interview with a collector of his works.

The local Catholic priest, a Father Eugene Belford, Getty, Hunting and Paskell would spend hours together in the back room of Jim Hunting's Photographic Studio on Main Street just across from the Railroad Station. Mrs. Gagnon marvelled at how these four could talk for hours on one seemingly simplistic subject or another, be it color and its various affects and uses in art, or some other aspect of art and its implications. This period of time in Mrs. Gagnon's recollections cover the decade of 1922 through 1931. She remembers the four listening to opera on the radio and eating gourmet meals prepared by Hunting who was, by far, the best cook among them. They would also often congregate at Father Belford's rectory to play bridge. Paskell was always known by his family as one who loved to play cards, especially bridge.

Paskell's Mt. Chocorua paintings hanging in hundreds of homes provide their owners, near and far, with a constant reminder of one of New Hampshire's most scenic areas; and beckons them to return. The artist too, is constantly remembered and has attained a kind of immortality through these paintings and thousand of his other works.

The limitations under which Paskell was compelled to labor must not be forgotten. If circumstances were a shade better from those under which he had to pass his more mature years he could have ranked with the greatest and left masterpieces of the first order (although some of his works are considered by their owners to be of that quality). The material out of which great art is made was in him. His artistic powers in trying to progress through impressionism into realism were diluted somewhat by the necessity of trying to support a growing family.

His passing marks the end of a rather golden era, the

twilight of New England landscape art. He must have been the last of the many noted artists that exhibited at the two memorable 1884 Boston art shows at the Boston Art Club and the Massachusetts Charitable Mechanic Association. He left a gigantic output that curators and collectors will attempt to sort out for many years.

No memorial service has been held in his honor in the city where he lived but a fitting tribute would indeed be a memorial exhibition. In his youth Paskell was trying for great qualities, for more breadth in treating masses of light and shadow and vigorous handling of his materials. Good mechanical work is as much demanded in picture making as in any other craft. The question never arises whether a picture is finished or not. The art in them is so subtle that it evades scrutiny. It is impossible to look at a painting by Paskell without being deeply impressed that he had a highly tuned sense of organization which brought him into a close relation with nature enabling him to perceive and portray the beautiful and the picturesque.

## BOSTON ART CLUB EXHIBITIONS

*(Listing entries of William F. Paskell)*
*(watercolors, unless otherwise noted)*

| YEAR | NO. | SUBJECT |
|------|-----|---------|
| 1884(29th) | 87 | *"ROAD IN WEST ROXBURY"* (oil) |
| | 98 | *"SUNSET IN DAY'S WOOD"* (oil) |
| 1884(30TH) | 56 | *"AFTER A SUMMER SHOWER"* |
| 1887(35th) | 74 | *"JUNE DAY, DAY'S WOOD"* (oil) |
| 1889(40th) | 88 | *"TWILIGHT"* |
| | 102 | *"SUMMER DAY AT NEWTON"* |

| 1890(42nd) | 11 | *"HAYSTACKS AT BROMLEY, KENT, ENGLAND"* |
| | 13 | *"CALM DAY OFF THE MORE, KENT, ENGLAND"* |
| | 109 | *"GREY MORNING, WHITSTABLE, KENT, ENGLAND"* |
| 1892(46th) | 94 | *"BEACH AT HERNE BAY, ENGLAND"* |
| | 105 | *"WET DAY"* |
| 1893(48th) | 53 | *"GREY DAY, HAMPTON, ENGLAND"* |
| 1899(60th) | 201 | *"NORTHERN RAVINES OF CHOCORUA"* |
| | 220 | *"CHOCORUA MT. TAMWORTH, NH"* |
| | 224 | *"BRIDGE AT WONALANCET, NH"* |
| 1901(64th) | 156 | *"SUMMIT OF MT. CHOCORUA"* |
| 1906(73rd) | 94 | *"A PASTURE, TAMWORTH, NH" (oil)* |
| 1906(74th) | 175 | *"OCTOBER, TAMWORTH, NH"* |

## CHRONOLOGY

| | |
|---|---|
| Oct.5,1866 | Born Kensington, England |
| Nov.15,1872 | Arrives in U.S.A.(Port of Boston) |
| Jan.19,1884 | First Exhibited, Boston Art Club |
| April 12,1884 | Second Exhibit, (B.A.C.) |
| July 1884 | First trip to Conway/Tamworth Area,N.H.(Regularly repeats this experience between May and October) |
| Sept.1884 | First Exhibited, Mass.Mechanic Assn.Art Fair |
| April 1885 | First Private Exhibition |
| May 1885 | First Exhibited, Boston Art Museum |
| Jan.14,1887 | Third Exhibit, (B.A.C.) |
| Oct.25,1887 | Becomes U. S. Citizen |
| Oct.8,1888 | Mother dies. Visits England |
| Sept.9,1889 | Returns from England |
| Apr.5-27,1889 | Fourth Exhibit, (B.A.C.) |
| Apr.5-26,1890 | Fifth Exhibit, (B.A.C.) |
| Apr.2-23,1892 | Sixth Exhibit, (B.A.C.) |
| Apr.8-29,1893 | Seventh Exhibit, (B.A.C.) |
| Apr.1-22,1899 | Eighth Exhibit, (B.A.C.) |
| Dec.30,1900 | Father dies |
| Jan.11,1901 | Marries Mary A. Morgan |
| Mar.23,1901 | Son, William, born |
| Apr.6-27,1901 | Ninth Exhibit, (B.A.C.) |
| Nov.16,1901 | Daughter, Ruth, born |
| Aug.1,1905 | Son, Arthur, born |
| Jan.6,1906 | Tenth Exhibit, (B.A.C.) |

| | |
|---|---|
| Apr.6-28,1906 | Eleventh Exhibit, (B.A.C.) |
| Mar.24,1907 | Son, Arthur, dies (19 months old) |
| Feb.8,1908 | Daughter, Dorothy, born |
| 1910 | Son, Alfred, born |
| June 10,1913 | Son, Edward, born |
| 1915 | Moves to Dedham, Mass. from Boston. Brother Ernest A. dies |
| Feb.17,1918 | Son, Edward dies (4 yrs old) |
| 1927 | Moves back to Boston |
| Oct.1946 | Last Trip to Conway/Tamworth Area, N.H. |
| Sept.24,1949 | Sister, Florence (Dakin) dies |
| Feb.23,1951 | Died enroute to studio in Boston, Age 84 |

# Chapter Three

## JACOB WAGNER

During the early 1880s there was one young artist who resented the constrictions inherent in the crowded city, even though he had lived in one most of his life. Now that he had married he began to realize that Boston was not the best place to raise children. His ambition was to paint rural landscapes, river and brook scenes, meadows with cattle, woodland glades, and even farmyards. After much traveling about in the nearby suburbs, he discovered the town of Dedham. Here was real country, fertile and scenic, yet within commuting distance of his livelihood in the city. The young family moved to Whiting Avenue in Dedham, near the foot of Walnut Hill. Much later, the young artist W.F. Paskell lived on that same street for over ten years. Some people still called that section of town, Mill Village. Jacob Wagner spent the next sixteen years painting serene landscapes that were destined to be exhibited and sold in many of this country's leading cities.

Wagner was born in Bavaria, Germany in the year 1852. He was brought to Boston, by his emigrating parents, when he was but four years old. Similarly to many other budding artists he had a childhood talent for drawing but economic circum-

stances prevented him from taking any formal lessons. Jacob's school days were cut short, when, like many other Boston boys, he had to seek employment to help the family over hard times. Fortunately, he was able to enter the Boston art store of A.A. Childs to assist in the framing of all sorts of pictures. The opportunity to study the many oil paintings was appreciated even at the age of twelve. Walking from Bromfield Street to his Roxbury home in all sorts of weather gave him quite a bit of stamina and much needed exercise. He worked at the art store for a year and then quite suddenly his mother received passage money and an urgent summons to return to Germany to settle some family matters. Jacob accompanied her and the visit was quite prolonged. Jacob's older cousin, an art student at the Royal Academy in Munich, recognized the American boy's talent and they spent an entire summer sketching. The Bavarian forests provided his first formal art training.

The Wagners returned to Boston late in 1865 and this time Jacob was able to find a framer's position in the J.M. Lombard Art Store. Most of the art establishments were clustered together on Bromfield, Washington and Park Streets. Jacob was in and out of all of them and became friendly with all the proprietors. The largest of these stores was operated by a Mr. Doll. He was inpressed by the boy's interest in all things artistic and offered Jacob an opportunity, not only to frame but also to learn the art of restoring paintings. That was the beginning of a long and fruitful period for the aspiring artist. The framing and restoring was done in the same workroom and the pungent fumes of toxic chemicals mingled with the stifling odors of glue pots. Jacob was quite happy and after some years the store moved uptown to Newbury Street and opened under the name of Doll and Richards Gallery.

The young Wagner, with a bit of assistance from Mr Doll, entered the evening art classes of the Lowell Institute. Some months of these studies ended abruptly when the new Museum School opened its doors for evening students during the fall season of 1877. Forty-seven students registered and Jacob was one

of them. The teachers were quite distinguished. Otto Grund-
mann, brought here after a long career in Europe, was the draw-
ing teacher. The well known artist and medical figure, Dr.
William Rimmer gave lectures on Anatomy for artists. J.M.
Stone was the instructor on portraiture and Edwin Champney
taught oil painting. During 1878 some students were given the
opportunity to exhibit in the Boston Art Club's spring show.
Wagner entered a charcoal drawing showing the head of
William Morris Hunt. Drawing on his restoration experience he
had treated the charcoal work with a special liquid fixer to make
it very durable and give it a luster appearance. This raised some
favorable comment and Wagner was accepted as a full member
in the club. He also entered his first oil painting in the second
show of that year, "A Study of a Dog."

There were no evening classes at the Museum School in
1879. Wagner had joined the Zeppo Club and was able to con-
tinue his drawing for several years there. His first oil portrait was
accepted at the Boston Art Club 1879 show and was simply
marked, "A Study." The framing and restoring at Doll and
Richards brought the opportunity to study the works of many
fine contemporary artists such as George Fuller, Winslow
Homer and Henry Webster Rice. Homer came out of his Scar-
boro, Maine seclusion once a year to deposit his canvases and
complain bitterly to Mr. Doll about the low price tags placed on
his work. The water colorist Rice was Wagner's age and gener-
ated an interest in Wagner for that medium that he held for his
entire life.

Wagner in 1884 advertised himself as a portrait painter
with sittings in his Roxbury home. It was later that same year
that he married and moved to Dedham. Only one painting was
exhibited in the Art Club's 1882 show and he had entitled it
"Landscape at Roxbury." Now he applied himself to painting
out of doors in Dedham whenever the weather permitted, Sun-
days, found him, along with his wife carrying some of an artist's
trappings, trudging the banks of the twisting Charles River look-
ing for just the right perspective. The easel was generally set up

just above the Town Landing and beyond a graceful bend. This was one of his favorite painting spots and he portrayed the scene many times. There were usually a few cows munching about and one of his fall scenes shows that scene in muted colors complete with late fall russet foliage, the river bend, and two contented cattle. When the church bells rang on Sunday mornings, the church goers would cut across the meadow, stopping to peer at the artist's easel. Some would inquire if the painting would be for sale but Wagner would say that he was painting for future exhibitions. Once the owner of the land came down and offered him $35. for a sizeable work. The artist smiled and said he was thinking along the lines of $500. Practically all of his art teachers had told him, "Never sell your efforts cheaply. Painting and drawing are the results of much hard work and study."

One of the places that fascinated Wagner was the ancient Fairbank's Homestead which was just down the street from his new Dedham home. It was the large sagging roof that interested him. He painted the old house from many angles as had many artists before him. His wife remarked that it appeared that the roof might cave in at any moment. Neighbors stoutly maintained that even though the dwelling had been there since 1636, it was good for a few more centuries and it still stands today. The front of the old house is on East Street, which in the early days had been a well worn Indian path. Many traveling native Americans had spent the night wrapped in their blankets, very close to the kitchen fireplace.

Another historical, yet artistic place that the artist admired was the Church Green. Its two meeting houses at that time were called the First Unitarian and the First Congregational Churches. Few towns have more beautiful examples of colonial meeting edifices than Dedham. Wagner had read somewhere that these were the great power houses from which went forth the spiritual and moral influences that inspired the early life of the community. The farms, the meadows, the bridges and an oak forest near his home were portrayed before he felt that he was ready to exhibit again.

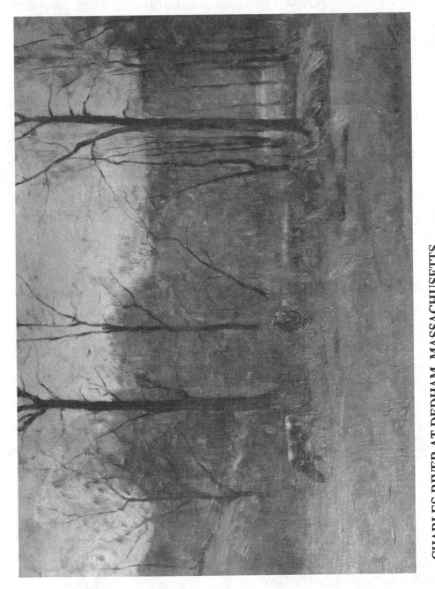

**CHARLES RIVER AT DEDHAM, MASSACHUSETTS**
*By JACOB WAGNER - Oil on Canvas, 15"X21$\frac{1}{4}$"*
(Private collector)

He always encouraged younger artists in their work. One such artist who was befriended by Wagner was William Paskell. He visited Wagner's studio on several occasions at which time he records being advised to study the figure. In 1884, Wagner flattered the younger painter by purchasing one of his small paintings.

Unfortunately, his generous employer died, and once again he changed positions. This time he went as manager of the manufacturing and restoring department in the establishment of J. Eastman Chase. He was not happy in such a large commercial enterprise and finally in 1886 endeavored to open his own studio. He hired a large room at 12 West Street in Boston. Several well known artists also worked in that building and it was close to the business center. Here were the studios of the marine painter, Marshall Johnson, Jr., the landscapist, Charles Franklin Pierce, and two portrait painters; Charles H. Turner and J. Harvey Young.

These men were an inspiration to the young artist and he learned a great deal from all of them. C.F. Pierce painted cattle, sheep, and genre landscapes. The scenes were sketched from his summer home in Peterboro, New Hampshire and finished in the Boston studio. One art critic wrote in the Boston Post, "If I wanted a picture of New England cattle, I had rather have one of his, than any artist that I ever saw or heard of, not even excepting Rosa Bonheur or Eugene Verboechoven."

J. Harvey Young was a distinguished portraitist. Boston's haughtiest brahmins sat for him and his work was considered of the highest rank. Jacob, when he heard some of these business men complain of long sittings and tiresome poses, had an idea. He advertised portraits in watercolor in which medium, he was a fast worker. He prospered. Many of these portraits went into the Beacon Hill and Commonwealth Avenue homes but the majority were for the man of moderate means in South Boston, Dorchester and Charlestown.

The artist, Turner, excelled in interiors and Wagner quickly tried his hand in recording some of the rooms he had

visited. Frederick Porter Vinton wrote after a visit to Wagner's studio, that "He is doing excellent work. I saw an interior, a parlor scene, with a lady sitting reading. It was an elaborate picture and a study of mysterious color. Several portraits, some of them [of] children, were being done. There is much power and promise in his work."

The Wagner family Sunday forays were now done by buggy and accompanied by two children who made merry while their father painted industriously. They ventured beyond the environs of Dedham and managed to cover almost the entire south eastern region of Massachusetts. The Boston Art Club exhibits record the locations of. the pictures. He painted along the Quincy Shore, Nantasket, Hull, Scituate, and inland to Wollaston, Braintree, Brockton and back to the Blue Hills. The summer vacations were spent in East Gloucester and southern New Hampshire. Many scenes portray Hookset and then to the short sea coast of Portsmouth. Jacob rarely painted boats and the beach scenes were just that, all done from the land perspective.

A listing of his Boston exhibits is at the end of this chapter. It is to be hoped that some reader will recognize their own pictures from the titles. Wagner's works are now scattered all over New England and elsewhere and it would be rewarding to see some of them hanging once again in a local museum's exhibit.

Starting in 1893 he began his exhibits at the National Academy of Design in New York. Their catalogue listed his paintings as:

| | |
|---|---|
| *"A Glimpse of the Sea, East Gloucester"* | $300. |
| *"A Grey Morning in Spring"* | $300. |
| *"An Interesting Story"* | $500. |

That same year he sent three paintings to the Chicago World's Fair. They were a Dedham landscape, a portrait and a figure painting, all oils. There were other exhibits in Philadel-

phia, Buffalo, Pittsburgh and St. Louis. Many times Wagner would bring the paintings to the distant exhibition halls. This meant making his own crates and carrying them aboard the trains and tediously changing trains. Some of the journeys required traveling all day and all night. He was usually rewarded by a favorable placement of the pictures and sometimes selling them.

Back in Boston, he continued his Art Club exhibitions. Dedham has had many fine artists but very few exhibited in as many places and so regularly as Wagner. The possible exceptions were Alvan Fisher and Phillip Hale who had earned international reputations. Some others who showed locally and in Boston were, Henry Talbot, Charles Cox, Louis Harlow, Robert Bailey, Charles Mills, and Henry Hitchings, who was a founder of the Boston Art Club and a respected director of art instruction in the Boston Public Schools for over twenty years.

The copy of Gilbert Stuart's portrait of Dedham's earliest and most distinguished statesman, Fisher Ames, was done by Wagner. He also restored the portrait of Deborah Ames for the Historical Society.

Serving on many art juries he gave himself to the cause of art but never forgetting that he was primarily a family man. Many of his portraits are of his wife and daughters reflecting their many moods and occupations. The paintings suggest that he had an innermost sense of peace with himself and his world. He was a seeker of serenity and portrayed nature in its calmer moods. The ordinary scale of things satisfied him. A hint of mysticism is contained in his works and the pictures reveal the quieter times that men still long for. It was for him a time of peace and plenty. The canvases were not exaltations of human fancy but just the simple direct moods of a gentle and pleasant nature. He felt that a "Grey Day" could be as satisfying as any sunny one.

One critic, Von Mach, wrote in a *History of American Art*; "Jacob Wagner, E. Barnard and Hayden of Boston, Shearer of Philadelphia; Taylor W. Lawson, Meteyard and W. Robinson

are some of the disciples of low keyed impressionsism." Another critic wrote in a book published in 1908 that Wagner's autumn scenes keeps all the fairy like beauty of a late October day.

A mature culture will recognize and acclaim its artists. Boston was no exception but Wagner did not live long enough for such recognition. He went once again to New York to prepare for the winter exhibition of the National Academy of Design on November 6th, 1898. After returning to his hotel room, he suddenly died from a massive stroke.

A shocked and saddened family brought him back to Dedham. He was buried at a place called Brookdale and on a knoll overlooking the "Quinobequin" (the Charles River), that he had portrayed so well.

His memorials are his paintings. They exist today and pass from hand to hand among many discriminating collectors, some local museums and a great many of the people of moderate means. So today as in the late 1880s, his woodland glades seem dreamy and haunted by pleasant memories, tinged by the mellow and subdued associations of an all too brief lifetime, and yet still glowing with the embers of a quieter time soon gone but long remembered.

Some of the locations, at this writing, of Jacob Wagner's paintings are:

"Charles River, Dedham" now in the Jetty Collection at Colby College Art Museum, (see their 1975 catalog *Rediscovered Impressionists*).

"On the Neponset," Gift of Augustus Lowell to the Boston Museum of Fine Arts.

"A Barnyard," the Brockton Art Museum, Fuller Memorial.

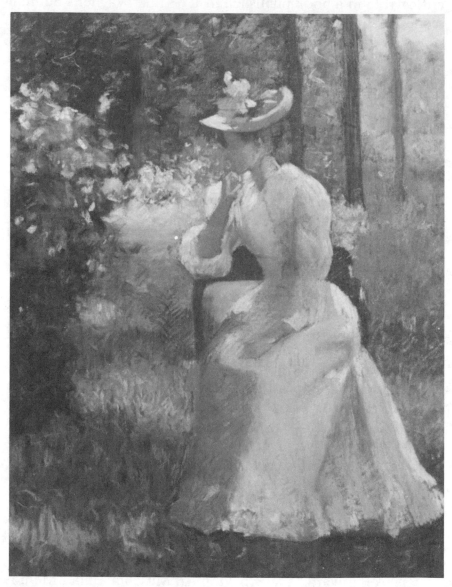

**LADY IN A CHAIR**
*By JACOB WAGNER - Pastel, 23$\frac{1}{2}$"x17"*
(Courtesy of George and Carol Downer of Needham, Ma.)

## BOSTON ART CLUB EXHIBITIONS

*(Listing entries of Jacob Wagner)*
*(watercolors, unless noted otherwise)*

| | |
|---|---|
| 1878(1st) | *Charcoal drawing of W.M. Hunt* |
| 1878(2nd) | *Study of a Dog (oil)* |
| 1879(1st) | *Study Portrait (oil)* |
| 1882(25th) | *Landscape at Roxbury (oil)* |
| 1886(33rd) | *Portrait (oil)* |
| 1886(34th) | *Nantasket Beach & Landscape Dedham* |
| 1887(35th) | *Grey Morning (oil)* |
| 1888(37th) | *Portrait (oil)* |
| 1889(40th) | *Portrait, Old Barn at Hookset, N.H. & Hookset Falls, N.H.* |
| 1890(41st) | *Portrait (oil),Landscape (oil), & Portrait (oil)* |
| 1890(42nd) | *Bit of Charles River, Watertown, King's Beach, Swampscott & Grey Day* |
| 1891(43rd) | *Portrait (oil), Portrait (oil)* |
| 1891(44th) | *Grandma's Portrait,A Study & Lost to Sight, to Memory Dear* |
| 1892(45th) | *A Bit of a Lark (oil), A Portrait of Mrs.J. (oil) & A Morning Greeting (oil)* |
| 1892(46th) | *Charles River Bridge, Dedham & Early Spring, After a Shower* |
| 1893(47th) | *Early Spring(oil) & Mother & Child(oil)* |
| 1893(48th) | *Portrait & Study Head* |
| 1894(49th) | *Portrait (oil), An Interesting Story (oil), Five O'Clock Tea (oil)* |
| 1894(50th) | *Portrait of Mrs. M. & Portraits of My Daughters* |

| | |
|---|---|
| 1895(51st) | *Priscilla (oil), Portrait of M.L. (oil) & Portrait of Mr. H. (oil)* |
| 1895(52nd) | *The Rose & Summer* |
| 1896(53rd) | *Twilight Moon (oil)* |
| 1896(54th) | *Portraits (2)* |
| 1896/1897 (55th) | *Portrait (oil)* |
| 1897(56th) | *Portraits (3)* |
| 1898(57th) | *Portrait (oil)* |

# Chapter Four

## DANIEL P. SANTRY

Boston in the 1870's was not an artistic community. Still there were enough public museums and art societies to create a surplus of artists and instill, in some young men, the desire to become painters. Such was the case of Daniel Santry whose one goal was to become a full time, professional artist. He held steadfastly to that purpose all his life.

Santry was born in the Roxbury section of Boston on August 31, 1858. His parents, Timothy Santry and Ellen Crowley had emigrated to the United States from Ireland some years before. Daniel was one of five brothers and his early years were marred by tragedy. One of his brothers drowned and two died in early childhood.

After middle school Daniel was able to secure a position as clerk in a large mercantile and specialty store, the C.F. Hovey Company at 33 Summer St., Boston. Hovey's was one of the city's first department stores and was adjacent to Eben Jordan's rapidly expanding establishment. This was in 1877 and, at the age of eighteen, Santry was already an aspiring artist. He availed himself of the many art classes held in the evenings. The Santry home on Dale Street in Roxbury was within easy walking distance of the city's downtown.

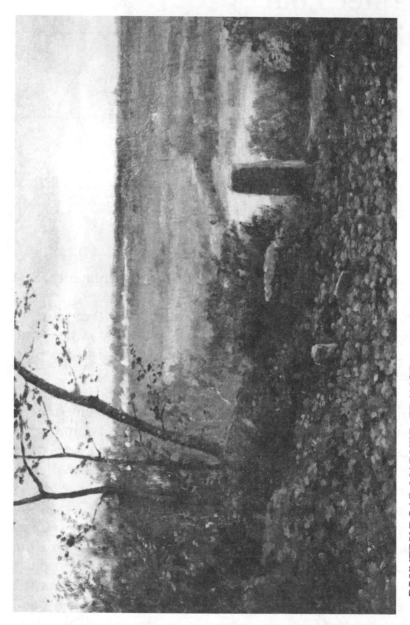

**COUNTRY ROAD MARKER, FRANCE**
*By DANIEL P. SANTRY - (1887) Oil on Canvas, 17$\frac{1}{2}$"x11$\frac{1}{4}$"*
(Private collector)

Young art students of that period had ample opportunity to study with artists who were well established. They could take lessons in oil painting from such men as G.W. Seavey, B. Champney, E.T. Billings, J.M. Stone, S.L. Gerry, S.W. Griggs, and W.H. Titcombe. These artists advertised quite regularly in the newspapers and usually at the set fee of fifty cents for an hour. Their counsel was invaluable and their dedication such as to extend an hour's lesson to considerably more than sixty minutes.

Benjamin Champney's advice to his pupils was, "Save up a few hundred dollars and go to Paris. It is and always will be the best place to study art and meet with artists of great renown." Young Daniel heeded this advice and left the Hovey store and Boston for France toward the end of 1881. When he arrived in Paris he found that amateur painters and students were everywhere. Although quite a few were Americans the many different languages spoken sounded to him like that of ancient Babylon. Finding a garret was not easy but ateliers teaching drawing and painting were plentiful provided a few francs were forthcoming each month. These schools were rough places and took some getting used to. The students could be insulting and vulgar. Some teachers were indifferent and boring. The student had to be aggressive to get a good view of the model and fights would break out at the slightest perceived insult. This clearly was not the Paris of Champney's memory.

The general talk in Paris, the notices, and the daily journal criticisms were all about what was then the newly accepted term of "Impressionism," what it was and what it was not. "Spots and blotches," said one side, and "Cleverly done, the culmination of all art," maintained the other side. Some books had already been published on the subject and they were favorable to this recent but controversial development. Most of the public had accepted this artistic trend and were supportive. However, the sales were few and far between.

Small wonder then, that Santry found himself, one March morning in 1882 at 251 Rue Saint Honore, eager to view the

seventh Impressionistic Group Exhibition. The place was the art gallery of M. Durand Ruel and there were 253 paintings on view. It was the greatest exhibit he had ever seen. The show was well advertised and well attended. The names on the canvases were Guillaumin, Caillebotte, Sisley, Vignon, Renoir, Monet, Pissarro, Gauguin, and Berthe Morisot. The Pissarro oils interested and attracted Santry greatly. There were twenty-five Pissarro oils shown, many with odd looking frames. The Pissarro landscapes were earthy with busily engaged farmers and peasants predominating. Santry was to find out later that some of the other exhibitors were young followers of Camille Pissarro. In a letter to his brother in Boston, he wrote that he had decided, then and there, that this was the Master to emulate.

The young artist found that Pissarro was represented in several French art books and magazines. He spent some time copying these illustrations. In addition Durand Ruel had, in his permanent collection, some of the early works. Santry learned that the Master lived with his family in the village of Pontoise, not too far from Paris, and that it was his custom to paint in the fields and environs of that village with whatever young followers went with him to escape the summer heat of Paris. These informal master classes lasted from late May to early October. A few of the artists were quite intimate with the Master but the majority looked, listened and painted. Santry trudged along, content to be one of the majority. Many nights they slept in the fields and depended upon the largesse of the villagers. The days were filled with sketching and painting. Some fortunate artists had umbrellas to cover their easels but most wore floppy hats to ward off the sun's direct rays. On more than one occasion Pissarro counseled his ragged group;

> Use small brush strokes. The eye should not be fixed on one point but should take in everything. Keep everything going on an equal basis, sky, branches, houses, buildings, and ground. Observe the aerial perspective well. Have only one master, Nature.

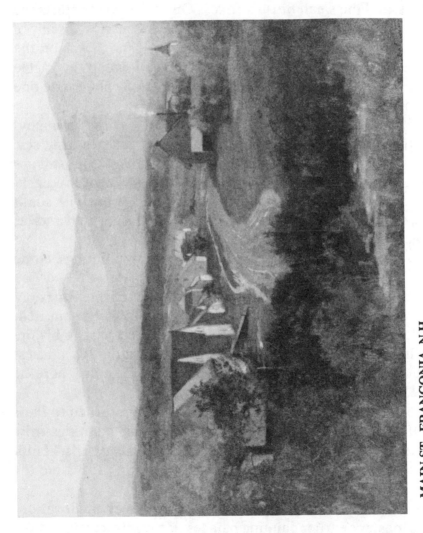

MAIN ST., FRANCONIA, N.H.
*By DANIEL P. SANTRY - (1906) Oil on Canvas, 16"x20"*
(Courtesy of Robert W. Skinner, Inc., Bolton, Ma.)

Studying a number of Santry's landscapes from those early days in France, he certainly followed this advice. Some of his early paintings are inscribed "Road and Fields of Pontoise, 1882." Other scenes, of farms and village houses, clearly show Pissarro's influence and tutoring with low key greens and browns, and the small brush strokes. One such work depicts the rear garden wall of the Master's home. This is as close as any of the followers dared to approach. Madame Pissarro was on the lookout for them and had a handy broom to sweep the raggle taggle students away. The food was for her family and for no one else, however talented.

Santry's paintings of village houses show chimneys thrusting up into a sometimes blue and sometimes gray sky. Some of the works have a lack of obvious brilliance but still are an evocation of light and weather. His garden walls, have back-lighted silhouetted trees that are in deep shadow but with sunlit skies, deep blue in the fading twilight. Durand Ruel held a series of one man shows in 1883.

The Pissarro exhibit consisted of seventy paintings. None sold.

The 1885 cholera epidemic drove most of the artists out of Paris and into the countryside. Santry went to St. Servan, near St. Malo. Here he painted along the channel coast, notably figures in fields of flowers looking toward the water. His address in St. Servan at that time was 10 Rue de la Cote and here he settled down for a time.

When the wave of sickness subsided he returned to Paris and this time found better lodgings. One of his paintings from this period was entitled "A Boy in the Fields, Near Paris." Later on he was able to view the last group exhibition. This time the impressionist paintings sold well.

When in the country he had visited villages and locations of the master's earlier painting palaces. He was fascinated by the small bridge at Pontoise and painted it several times. He also began to bolster his fast fading funds by selling or bartering for food or lodging whatever the village inn patrons desired him to put on canvas.

1886 was his banner year in Paris. He entered the Salon conmpetition with some of his country pictures. After varnishing day he sought to hide himself by working as usual away from all the anxiety and travail. But all he could do was to pace the floor. There his companions found him and placed the newly printed catalog before his unbelieving eyes. It read; "Salon Catalog, 1886 No. 2126, Chez le Charron - etude, Santry, Daniel Francois, ne Boston, eleve de Boulanger et Lcfcbvre, Rue Jacob, 15" The picture was his "Interior of a Wheelrights Shop" and he was rightfully ecstatic. Now he belonged to a select group. Not too many Americans were able to be selected to exhibit in that austere chamber. It was a national honor for Frenchmen and an intcrnational honor for foreigners. Now he could write to his Boston relatives who may have had doubts about his desire to become an artist. The following year his name and address was included in a small book entitled, "The Americans in Paris." He was still living at 15 rue Jacob. It was to be his last Paris address.

He made one more grand tour of the French countryside and his many paintings were being carefully saved for a future studio in his home city. He envisioned being able to sell his low keyed impressionistic canvases to an enlightened American public. He painted again in the places that Pissarro had portrayed, along the Marne River, the Oise, Voisine, and even the hillside near the religious community in Pontoise. Pissarro had made that hill immortal. Another wall painting, this time in Arolles demonstrated that he had learned exactly how to paint light airy, and atmospheric tones. During the next year he conserved and optimistically planned a career as an artist in Boston. The bohemian life in France was exciting and pleasant. The artistic atmosphere was genial if not too lucrative. America should be an improvement.

Daniel, (now without the middle name of "Francois") Santry sailed for Boston with a good stock of his paintings. It was said by many during the rest of his life that he had the appearance of a Frenchman and exuded a humorous and sly bo-

hemian manner. He opened his studio at 12 West St.,Boston, early in 1889. The first order of business was to join the prestigious Boston Art Club. He was accepted on the strength of his French paintings.

Santry exhibited only one picture in the fall exhibition. It was listed as No. 45 in the catalog and entitled, "The Fagot Gatherer." In that canvas a French peasant woman with an armful of sticks seems to be right out of a Pissarro landscape. By now it was probably second nature to him to be painting the same people of rural France that his Master had. The picture however, did not sell at that time.

Several other well known Boston artists had their studios at 12 West Street during that period. There was Charles H. Turner, Charles F. Pierce, and J. Harvey Young. They were well established but very few of them had the advantage of European training. All the men were landscape and genre painters. J. Harvey Young was also noted for his portraits and many prominent Bostonians climbed those narrow stairs, past the Santry studio, to sit for him.

Santry's French paintings were not attracting customers so Santry exhibited three more in the art club's 41st show in 1890. They were listed as; No.20 "A Morning in Winter", No.9 "Evening in February", and No.123 "Interior of a Wheelright's Shop" which was hung between J.J. Enneking's, "Cloudy Day," and a F.H. Tompkins figure painting. The Enneking sold but the Santrys did not. 1891 saw him exhibiting only two canvases; No.13 "A Morning in June," and No.23 "An October Day in Duxbury." This 18 x 24 oil is hardly a scene of Duxbury, Massachusetts. The painting is almost the identical scene as Pissarro's "Along the Marne." The only deviation is that Santry has turned a horse and cart around heading in the opposite direction. However the picture was sold at auction sometime later on and is now illustrated and inventoried in the index of the National Collection of Fine Arts, Smithsonian Institution, card No. 71770301.

The art competition in Boston was fierce; too many

artists in a small area. During this period there was a rapid movement of artists to New York City. The atmosphere of Boston was brahmin not bohemian and this translated into very few sales for all but the most favored of the dowagers of Beacon Hill. Santry had been pondering over some small discreet newspaper advertisements that appeared each winter. One read, "Opportunity for established artist for summer months to exhibit and meet prospective clients from all the eastern states. Apply to Messrs. Bowles and Hoskins, Sunset Hill House, Sugar Hill, Franconia, New Hampshire."

Santry, under pressure of mounting debts, journeyed to Franconia and spent the summer of 1892 as a boarder at the Brooks Farm. The cost was five dollars per week with full meals. The mountainous country brought him memories of the French countryside where he had been content to roam and paint. He soon learned that summer tourists would purchase his paintings of the regional scenes almost before the paint was dry. Some merely wanted a memento of their summer sojourn, others could appreciate a work of art for its own sake. The village people were friendly and he could roam about unhindered with his easel, canvases, and paints. The slight figure of a French looking artist in a velvet beret with a gallic sense of humor caused more than one native to say or attempt to say "Bon Jour M'sieur," with a broad New Hampshire twang.

Franconia is one of the most scenic and picturesque villages of the White Mountains. It lies in a broad meadow at the foot of the high Franconia range through which the Gale River winds its curvacious way. This stream rises on the northern slopes of Mount Lafayette and flows through the vilage. Several narrow roads leave the village. One leads to the hill towns of Bethlehem and Littleton. Another goes sharply up Sugar Hill, which perhaps has the most magnificent views of the Franconia and Presidential ranges in all the mountains. The altitude of Sugar Hill, over 1600 feet, makes the view of Mounts Lafayette, Cannon, and Kinsman, looking easterly, particularly impressive. Twenty-five miles to the northeast is the blue sweep of the Presi-

dential Range with Mount Washington in sharp outline. Santry must have felt that this wide sweeping panorama and its view of the entire Ammonoosuc Valley contained enough beautiful landscapes to satisfy him for a lifetime. The large hotel sitting on top of it all and aptly named, "The Sunset Hill House," provided a large veranda to contemplate this bounty of nature and its geology. Perhaps the capacity of three hundred affluent guests to buy his paintings had something to do with his decision to become an "Artist in Residence."

Franconia alone had fifteen mountain houses and all welcomed artists. Each year over 2000 guests came to these hotels from all over the eastern states and beyond. During the summer and fall foliage seasons they browsed about an artist's stock in the lobby or watched him painting the local landscape, sometimes with critical observations which were blithely ignored by the man in command, wielding the brush and palette. If the buying was slow, raffle tickets were sold and the prize, naturally, was one of the artist's unframed works. The frame could be had for a price. It was good business and an attraction for the hotel.

Santry returned to Boston that fall with renewed enthusiasm and to finish his White Mountain sketches. He had made arrangements for next season at the Sunset Hill House. The artistic climate had not changed in Boston. His brother had become a master plumber with a shop in the South End of Boston at 69 Dover Street. Daniel's fortunes were at such a low ebb that he had to close the West Street studio and move all his paintings and equipment to the rear of the plumbing shop. He occupied a room above the shop until it was time to go to Franconia.

That summer he sold his paintings at what seemed to him a fantastically high rate. The guests bought them and even demanded the frames that he had made up during the winter at the Foster Frame Shop in Park Square in Boston. He was so content that he stayed both at the hotel and the farmhouse for two continuous years. The winters were severe but he painted out of doors as much as possible. He painted in Franconia with its

many farmhouses and red barns all through the valley. Santry also painted scenes of Mount Lafayette in all its seasons and moods. The deep woods, the rushing brooks, the Gale River, the spring blossoms lining the high banks of the river, and the myriads of apple trees, the lush hillsides, and even the maple syrup trying kettles caught his brush. There was much to portray in that high country without wandering too far afield.

Unfortunately, in April 1893, his brother, 40 years old, died of influenza and later that same year, in September, his niece Marie also died. Santry had to return to Boston. He now made his home at 97 Dale St., Roxbury and helped his brother's widow maintain that house. He tried once more to keep a studio and struggled for two years at 27 School St., adjacent to the Boston City Hall. He featured his Franconia landscapes but it was a losing battle and he gave up, never to have another studio or a formal exhibition of his works in a large city.

There was one man that sought to persuade Santry to remain in Boston convinced that the city's art resources would radically improve. That man was Anthony John Philpott. They were both Roxbury boys and at one time attended the same school. However Philpott chose the old Brimmer School as his middle school and graduated in 1877. Santry and Philpott both studied art in the evening. Santry with a landscapist and Philpott with F.P. Vinton, J.R. DeCamp, and W.L. Taylor. Santry went to France to further his studies and Philpott worked in a printing company. He came to a decision that the art avenue for him was as an art critic.

When Santry opened his first studio, Philpott was a critic for a Cambridge paper. When Santry's last studio was opened Philpott helped his friend in every way he could. The good newspaper notices did not bring sales and before leaving for Franconia Santry presented his friend with one of his small French impressionistic paintings simply inscribed, "a mon ami Philpott" and signed Dan Santry. A painting by Philpott himself with a similar inscription dedicated to Santry recently surfaced at an auction in western Massachusetts. Philpott went on to become

Boston's most distinguished art critic working for the Boston Globe from 1893 to 1940 and Santry went to Franconia determined to make the village his home.

After a while he managed to acquire a log cabin far up in the highlands of Lafayette Road. This crude road had great views of Mount Lafayette and Cannon Mountain. It was some distance from the town center but he did have some neighbors, a Mr. and Mrs. Parker. Their grandaughter now recalls them saying that they shared many meals with the artist and that he was very bohemian and good genial company. He gave them three of his paintings in appreciation.

Santry became the first "Artist in Residence" at the new sumptuous Mount Washington Hotel when that hostelry opened shortly after the turn of the century. He worked in the many nearby hotels for years while maintaining his Franconia home. These places were well patronized and for that reason his paintings are in the hands of collectors far and wide. He made many artistic friends, one of whom was Edgar Soames, the noted designer of Grand Rapids Furniture . Soames was a long time summer resident and he appreciated Santry's paintings to the point of purchasing a large number of them. When Soames founded his Museum, The School of Design in Grand Rapids, the collection was presented to them.

Many famous artists painted in the Franconia region but usually down in the Notch where the grand "Old Man of the Mountain," kept his eternal vigil. These painters were but brief visitors and a few even worked the Notch hotels for a season or two. Franconia Village knew but one steady resident artist and he was a refugee from brahmin Boston and still painting in a light French impressionistic manner.

One elderly lady historian and life time resident recently remarked that "Daniel Santry was to Franconia what Benjamin Champney was to the Conway region of the White Mountains. He was the pioneer portrayer of Franconia." It could well be, for Santry worked there for over twenty years and no predecessor artist has emerged who concentrated on Franconia and its lovely scenery.

**SPRING, MT. LAFAYETTE, N.H.**
*By DANIEL P. SANTRY - Oil on Canvas, 18"X14"*
(Private collector)

Ella Bowles, the author of *So This is New Hampshire*, was also an admirer of his work. She refers to him in rather glowing terms as "An outstanding artist of the White Mountains." During the Franconia Bicentennial two notable paintings were exhibited. They were a large "Mount Lafayette in the Spring," and "A View of Lafayette and Franconia Village." There is also on permanent view "A Franconia Sawmill" in the Town Hall. The site of the sawmill is now an unromantic gas station. Most owners of Santry paintings agree with the curator of a large city museum that Santry's Franconia scenes suggest the tranquility of Pissarro, entailing most of the master artist's brushwork and coloring, but on his own terms. It is interesting to compare his 1907 "Old Farmhouse, Franconia" with Pissarro's "Potage et arbres en fleurs" (The kitchen garden and trees in bloom). Viewers of the large travelling Pissarro show have remarked on the similarity of Santry's works. This is understandable given Santry's eight years following and emulating that master painter.

Heavy smoking and alcohol abuse finally wreaked its toll and the artist of Lafayette fell ill and had to return to his brother's house in Boston. He sought a cure in the Washingtonian House on Waltham Street in Boston, hoping to go back to the mountains in the spring. He died unexpectedly on May 20, 1915. The official records state that his age was 55 years, 8 months, and nineteen days,[by actual count he was 56 years, eight months and twenty days old] a single white male, occupation: Artist. The burial place was in the family plot at Mount Calvary Cemetery, Mattapan, Massachusetts. When the late spring returned to Franconia Valley, the *Littleton Courier* had an obituary dated June 3, 1915:

> This community was saddened by the news of the sudden death of Daniel Santry at a hospital in Boston on May 20th. The cause of his death was heart failure. Mr. Santry was an artist of renown. He came to Franconia first over twenty years ago and has lived here for the greater part of that

time.He was kind hearted and generous, genial, and pleasant, and will be missed by a large circle of friends.

Daniel Santry's memorials are his paintings. They are appreciated not only in Franconia but wherever their owners have moved. The octogenarian town historian of Franconia recently wrote, "We cherish all the Santry paintings that are in the town and hope to obtain more works for the new Franconia Museum that will someday shortly be open to the public. He also painted a picture of [my] grandfather's corn field with pumpkins in it. The picture has been handed down in our family." This was the same Brook's Farm corn field where Santry first boarded in 1893 and 1894.

(Note: Much of this material on Daniel Santry was originally published in the *Littleton Courier* of New Hampshire by coauthor, Rolf H. Kristiansen, in two parts on August 19th and 26th, 1981.)

# Chapter Five

## WILLIAM H. TITCOMBE

Poetry and beauty in art, considered by some vices, describe this gentle artist. One does not expect a visionary to be successful, yet he was. One does not expect a country boy to become a fine artist and teacher in a large city, but he did. He had very little formal art training but he painted oils and watercolors admirably. While he lived he had an excellent reputation and was respected by the public, his pupils, and critics alike. He had a profound reverence for his craft, a characteristic of every faithful follower of the muses, whether that craft utlizes the pen or the brush. His paintings today are still admired but hard to identify because very few of them were ever signed.

William H. Titcombe was born in Raymond, New Hampshire on September 24, 1824. Very little of his early life is known. It has been noted that he lived on a small farm and some of his early paintings portray pretty rolling country, scattered apple trees, airy and graceful elms, and in the distance, many miles away, a great bluish hill. There are also pictures of corn fields and broad fields of grass over which the breeze is moving in waves. One picture shows a white house, with green blinds, a piazza in front, and each column hidden with a trellis bearing

roses and honeysuckle. There is also a barn on the right of the picture seen against the dark green of a large orchard. This could very well have been the boyhood home of the artist.

Nothing seems to be known of his schooling but for some reason he left the farm and sought a living in Boston. It has been recorded that he arrived in Boston sometime during 1848 and had a room on Beacon Hill, near the statehouse. He secured a position as a salesman in a drygoods store on Dock Square. He was able to study painting at odd times and the mention in one of his notes of a Ben Stone leads one to believe that he was in the art classes of Benjamin Champney in 1851. What is certain is that he took up painting full time, with a studio in the Mather Building on Tremont Street. Within a year he was exhibiting at the Boston Athenaeum which had been newly moved to Beacon Hill.

Titcombe advertised for pupils regularly in The Boston Transcript starting in 1853. The usual fee was fifty cents for an hour in the art of oil painting. Pupils came at once, nearly all ladies. The young artist could teach well and every pupil that came was encouraged to work their best and try to improve. Some took one lesson a week, some two or three. It was not long before he had twenty pupils. Pupils came forenoons. The afternoons were reserved for work or browsing about art stores, book stores, and even seeking out the publishing houses and offering his services as a book illustrator. All in all, the country boy was doing fine.

There was a need in Boston at that time for some cooperation between artists. The social clubs were few for artistic minded persons and a real art society had not yet begun. Titcombe had the germ of an idea. For some time he had been inviting his pupils on alternative Thursdays for a social gathering to discuss art and poetry. Now he would extend those invitations to include the various artists that he met about town. The landlady where he roomed had kindly let his gathering use her large double parlors and a fine piano. The little club was a success and grew rapidly. Soon the artists began to bring some of their works

and the discussions were lively. We are indebted to J.B. Wiggin for keeping some records of these gatherings. In one such typical meeting a young lady began the festivities with a song entitled, "The Birds Love Song," followed by an anecdote by the artist Cobb who told of being visited, while at work by two ladies. One of the women looked critically at an old engraving of the leaning tower of Pisa; hanging on his wall. "Ah," she said, "Minot's Light." Then they looked at a colored chromo of the State Street Massacre, with Crispus Attucks, just falling, shot, in the foreground. That, they stated is the real thing. Real history; "Corpus Christi was killed on State Street!"

Another artist, a lady, brought down the house with her little story of a Beacon Hill dowager who had died. Her husband sought a medium and asked his wife if she were in heaven and happy. The wife replied, "Oh yes I am in heaven." "Well are you perfectly happy?" The answer came, "Oh, I get along very well, but it is not Boston."

The evening would include much entertainment, more poetry, piano playing, and traditionally ended with a song that everybody joined in; "The Boston Song." This little nameless art society was also charitable in helping their fellow artists, less fortunate than themselves, out of a financial problem now and then. During the years to come some well known painters attended these meetings and J.B. Wiggins recorded their names. Among them were other artists who gave lessons in oil painting, such men as, A.T. Bricher, G.W. Seavey, E.T. Billings, J.M. Stone, C.F. Pierce, S. Gerry, E.L. Custer, G.L. Brown, J.J. Enneking, and S. Griggs. There were also the journeymen painters, Henry Day, Sarah White, E.W. Parkhurst, the art restorer, Harold Fletcher, and artists, Ottilie Borris, J. Harvey Young, J.W.A. Scott, H.R. Burdick, Mrs. J.A. Wiggin, Jacob Wagner, J.F. Cole, and Titcombe's own pupil Miss. A.M. Gregory who became his valued assistant.

Titcombe was an avid book and art collector. His studio was filled with many thousands of dollars worth of books, engravings, and illustrations of Turner, Stanfield, Pyne, Calame,

Harding, Bartlett, and many portfolios of prints. The European influence crept into many of his New Hampshire landscapes. One such landscape has some cattle gazing at the distant line of the White Mountains with an English style manor house in the middle ground.

The artist returned home to Raymond each summer and from there he went on sketching tours through most of the mountain towns. Frederick Vinton, who was mainly a portraitist, accompanied Titcombe on several of these summer tours. He wrote that they were very enjoyable and his companion "knew more of art in all its branches, than any man I ever knew." The brooks, the intervales the peaks, the rivers, like many other artists before them, were duly sketched and color swatches made. The paintings were made in the studio and placed for sale at B.S. Moulton's on Hanover Street and at the gallery of J. Eastman Chases' on Bromfield Street.

Every White Mountain artist has painted many views of Mount Chocorua. Titcombe exhibited one of his at a meeting of the social art club and was moved to poetry which he said was his inspiration to paint the picture:

> With mossy trees and pinnacles of Flint,
> shaggy and wild and many a hanging crag. Sheer
> to the vale go down the bare old cliffs. Huge pil-
> lars, that in middle heaven upbear Their weather
> beaten capitals; here dark with the thick moss of
> centuries, and there of chalky whiteness where the
> thunderbolt has splintered them.

And of the lovely Lake Chocorua, nestling at the foot of the conical peak,, "The solemn pines along its shore, The firs which hang its gray rocks o'er, are painted on its glassy floor."

It is very difficult to trace any artist's early output but there are some records of Titcombe's oils that he considered worthy of exhibiting and placing for sale. In 1857 he had an 18 x 26 canvas "Winter Scene at Lee, N.H." for sale at William's Art

Store. He did this scene several times in varying sizes. His 20 x 30 version is now in the Addison Gallery of American Art, Andover, Mass. Another favorite painting spot was at the head of Lake Winnepesaukee in the small village of Center Harbor. There he sketched some genre type farm scenes with the lake in the background. He finished a large canvas, 27 x 36 in his studio and sold it to a Mr. J.P. Putnam. That gentleman loaned it to the Boston Athenaeum for their 1863 Art Exhibition. This is probably the first major show that any of Titcombe's works were hung.

The next June he exchanged residence in Boston for a season at the family farm. He sketched in Strafford County and then made excursions to Portsmouth, the Isles of Shoals, York Beach, Mount Agamenticus, Garrison Hill, Grand Monadnock, and in the fall visited with Benjamin Champney at North Conway. Some of his canvases from that period have been entitled as follows: "Conway Valley in Autumn, a 14 x 20 size, then a larger one of almost the same subject , an 18 x 24, "Echo Lake," at the foot of "The Flying Horse Ledge," and one of his many Mount Washington Valleys, a 12 x 18, which he used as a model for many larger studio pictures. Champney's studio had wonderful views of the distant mountains and his garden gave him the opportunity to paint the roses, lilies, kalmias, apple blossoms, corn and "Pumpkins." There was one Boston artist who considered himself something of a critic and on one occasion he visited Champney's studio and saw quite a harem of women all painting in oil. The Boston artist laughed sardonically and remarked that there was one woman who must be 65 years old. The truth was that the lady in question was over seventy and could paint a much better picture than the critical city artist.

Titcombe was not strictly a New Hampshire painter. He spent some time in Maine and painted scenes of Casco Bay with its islands, lighthouses, and many ships. One wonders sometimes how an artist chooses the sizes of his canvases. He chose several 18 x 26 canvases to express his impressions of his marine views. Most of Titcombe's recorded works seem to be about this size perhaps varying an inch or two. He made a trip to upper

New York and painted a picinic scene which he simply titled, "Hudson Valley" and it was a 22 x 30 canvas this time.

The once rather green country boy had by now not only become a fine artist but a good art teacher with so many pupils that he decided to expand and founded an Academy of Art, with various courses of instruction. He needed a good deal of financial assistance for this project and he found a friend and backer in the person of a wealthy art collector, Gardner Brewer who lived on Beacon Street almost opposite the Athenaeum. He was always bemused when looking at Brewer's collection of three splendid Fra Angelicos, Verboeckhovens, and many other master pieces, to see down the line several of his own New Hampshire landscapes. So it was with the aid of Brewer and his friends that he opened his Academy of Art in the Liberty Tree Building at 460 Washington Street, Boston. He wrote;

> This institution is designed to be a conservatory of art where a complete art education can be acquired under the direction of competent teachers. The course of study will be progressive, that those who wish, may advance from the elementary forms to the finished work of art, thus acquiring not a superficial knowledge of the science, but a thorough acquaintance with its principles and practice.

The course of instruction included elementary drawing, principles of light and shade, theoretical and practical perspective, design, composition and pictorial effect, painting in oil and water colors, etc., in short all of the elements, in minute detail, necessary to fully equip an aspiring artist with the technical knowledge he requires.

The instructors, all capable and talented artists in their own right, included:

- William E. Norton for Marine Painting, Figure Subjects,

etc. Norton was a pupil of the Lowell Institute and George Inness, and of Jacquesson, de la Chevreuse, and a. Vollon of Paris.
- A.R. Sawyer, Crayon Drawing.
- S.D. White, Elementary and Pencil Drawing.
- W.H. Titcombe, Landscape in Oil and Watercolor, Perspective, etc.
- A.M. Gregory, Assistant in Painting Department [This was Miss Alicia Gregory, one of Titcombes' pupils and his valued assistant.]
- H.R. Burdick, Photograph Finishing and Still Life. [This was Horace R. Burdick who was a fine portrait painter in his own right. He could also teach, when necessary, crayon portraiture.]

There was a great interest in the Academy for many years. Many competent artists were once students at the Academy and a number of them became teachers themselves.

Titcombe attended services each Sunday at The Park Street Congregational Church, where the Reverend Dr. Bartol was the minister. Miss Gregory often as not came with him. On one occasion she persuaded him to address the Church's Womens Temperance Society. Titcombe was a bit reluctant but to the women's surprise he launched into a long and fervent plea that they should not be too harsh on tippling artists. He cited the fact that many Boston socialites who were planning to have their portraits done because of this practice. Many were good men who only lacked the saving grace of self control and the social gatherings could well be held to bear the full blame for their downfall. The applause was barely polite.

The summer of 1875 was enjoyed by several of the Academy faculty traipsing about the White Mountains with their headquarters at J.M. Shackford's farm on Bear Mountain Road. Miss Gregory painted a number of views of the nearby Conway Valley. These pictures were later shown at the Boston Art Club. Titcombe did another 18 x 26, "Summer in New Hampshire"

which was later reproduced in chromo. That summer he also produced his "Quiet Summer Day," with browsing cattle in a mountainous setting, "New Hampshire Summer Evening," with the moon rising in a dark and misty sky, and a "White Mountains," condensed on a small bristol board. The artists struggled up Chocorua Mountainm from the west and spent some time sketching the Champney Falls with its dank, moss covered ravine. One wonders how many times that mountain peak has been painted and how many more times will it be pictured by a discerning artistic eye? There are also contrasting oval shaped scenes of summer and winter scenes attributed to Titcombe of this area.

The Academy of Art prospered for many years but a sad day came when more financial aid was needed to survive. The wealthy patrons had many excuses for withdrawing their aid but Gardner Brewer had a unique reason. He had put some of his resources into erecting a large fountain on the Boston Common some ten years before. Now he wanted to erect another "Brewer Fountain" in the Boston Public Gardens.

Titcombe did not hesitate. He auctioned off most of his extensive art library and it brought four thousand dollars. Shortly after this setback his health began to fail and teaching 50 pupils a week began to take its toll. Some of the faculty had moved on and Miss Gregory substituted for the missing faculty. She was now quite successful specializing in crayon portraits. The newspaper critics spoke well of them. Her loyalty never wavered but her teacher was very ill.

Titcombe was only 63 when he died and only a brief obituary appeared in the Boston Transcript on February 11, 1888. It said,

> Mr.William H. Titcombe, well known as an artist and teacher, died at his studio on Washington Street this morning. During the past twenty five or thirty years some of the most prominent painters of New York and Boston have been his

pupils and derived from him the inspiration which has led to their success. Mr. Titcombe possessed probably the best art library of any artist in New England. For the last quarter of a century he has had a class of twenty to fifty pupils. He was of generous, kindly nature, and his loss will be sincerely mourned by a large circle of friends and pupils. There will be a short service in the Liberty Tree Building, Washington and Essex Streets, Monday afternoon at two o'clock and the remains will be taken to Raymond,N.H. for burial.

A few pupils and friends did gather on that snowy day and listened to the Reverend Dr. Bartol eulogize his parishioner and friend. He said in part,

[Mr. Titcombe] had no vices. He loved poetry, beauty, and art without limit. He was [always] ready to impart what he knew. He never turned away a pupil or a customer. He painted many, many fine pictures and sold them for moderate prices. He had pleasant ways and was full of fun, and the best of company. He was bohemian enough to make the best of life.

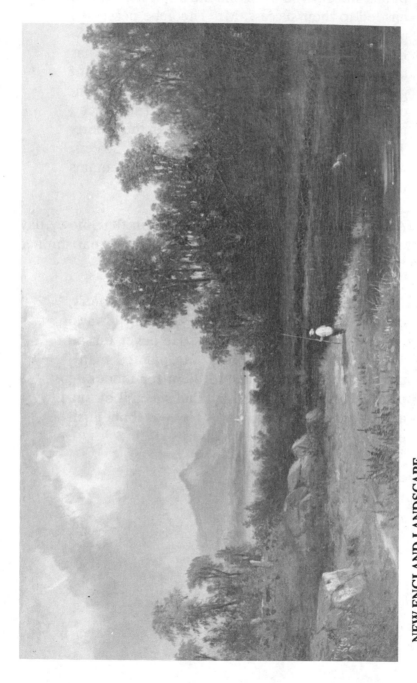

**NEW ENGLAND LANDSCAPE**
*By SAMUEL W. GRIGGS - (1869) Oil on Canvas, 9"x14¾"*
(Courtesy of Richard A. Bourne Co. Inc., Hyannisport, Ma.)

# Chapter Six

## SAMUEL W. GRIGGS

If you were to leaf through the many exhibit catalogs and auction flyers, searching for just a little biographical information on this still prominent artist, you would conclude that almost nothing is presently known about Griggs, his birth date or other significant information. It is unfortunate that records of artists of that era were not better kept. Digging into the past is difficult today, but it can be done, thanks to old books that crop up in remote and unimportant book sales. Thanks also to people like J. B. Wiggin who was sort of a recording secretary in the little social art club that artist William Titcombe started. He wrote down all sorts of information and anecdotes of the various member artists who were either being praised or pleasantly excoriated. Samuel W. Griggs was one of those recorded by Wiggin in his participation in this group.

Samuel W. Griggs was born in the Roxbury section of Boston during the year of 1827. Although nothing is known about his schooling it is known that he was trained to be an architect. He is listed in the Boston Street records of 1848-49, and 1850 as an architect boarding at 5 Lenox Street. He also studied art at this time and in 1854 opened a studio on Tremont

Row listing himself as an artist. He continued as a boarder on Lenox Street for several years but for some reason moved to 4 Lenox Street and then to 6 Lenox Street.

Wiggin records that one of the club members spoke of Griggs as "a Boston boy ...[who has had]... a splendid beginning. He has been long and well known here. He paints landscape, marine, game, and fish ... Every summer he goes sketching far and wide. Now in Maine, then in New Hampshire, and again in Vermont, or in New York, among the Adirondacks."

The small village of West Campton, N.H. was one of the favorite haunts for artists. Each summer in the 1850s and 1860s they came from New York, New Jersey, Philadelphia, and Boston. They painted and sketched together and spent some of their leisure time together in the two village inns. The Stag and Hounds was a small inn, catering to 20 guests, with a bountiful table. The other was more of a hotel, run by the Sanborn family, and could accommodate 75 persons. The small inn charged $7. a week, for room and board, and the larger hostelry $10., a fact that fit the limited resources of most artists. The entire Franconia Mountain range and notch were not far distant and the various painters would chip in and hire a wagon for their sketching jaunts. They made merry parties indeed and in 1858 the Stag and Hounds wagon consisted of A. Durand and his nephew, William Durand; W. Richards, and the two Boston Samuels, Gerry and Griggs. Despite the fact that the elder Durand was quite distinguished, and Samuel Gerry at that time was president of the Boston Art Club, the mountain air and scenery infused a sense of comradery among them, one and all. The Philadelphia Richards (W.T.) was the youngest being only 25 and Griggs at 31, had their talents accepted by the older painters without question. They painted together for many years on these summery jaunts and were joined from time to time by A. Bierstadt and G.L. Brown. Many of the summering North Conway and Saco Valley artists moved to the Franconia hotels and inns as the season progressed. So it came to be that many a fine White Mountain painting came into existence amidst heated discus-

sions by these artists far into the night, mostly about the ill fated Art Union and their own future in both society and the art world, such as it was in America.

Wiggin jotted down a typical anecdote about Griggs at this time. He was out, near Campton, sketching in a book, when he was confronted by a curious farmer with, "Hullo there! Practicing singing?" "No," replied Griggs, "I am sketching." "Well," said the farmer, "I thought it looked like a singing book." And later as he was sketching under the shade of his sun umbrella; "Are you shading a sick critter?" "Not much," said Griggs. "Well, I see you had an umbrella and I didn't know but what you were shading a sick critter; so what are you doin'" Griggs reply was,"I am painting a picture." The now incredulous farmer queried, "Sell 'em? Git yer living out of 'em?" To which the artist replied in the affirmative prompting this further comment, "Well now, I wouldn't give ten cents for a barn full of 'em." Then there was the time, according to Wiggin, when Griggs was sketching a small 9 x 14 oil "New England Landscape." The place was Harrison, Maine and he was staying for a time at the Idelwild cottage owned by Mrs. Fogg, when a farmer watching work suddenly burst out laughing, exclaiming "My wife thought you was a tramp, that had been stealin' our apples, but come to find out, you're the painter feller that boards down to Fogg's" Artists were not universally respected - even in those days.

An Art Club member once said in connection with Griggs that;

> An artist sketching is a great wonder to an enquiring mind. It is a good thing to find a large, handsome pickerel, then take him to your studio, paint his picture, and then eat him for dinner. I should like to see all the pictures that this industrious prolific painter has painted. Now it is a derby hat with a rat-terrier in it. Then it is a straw hat with a Malta kitten in it. Now a fish, a Florida red snapper, in the gayest of color. Now shad or

salmon, perch or smelts. Landscapes in color, or black and white, like a steel engraving. Then mountain, woodland, lake, and river in color. If any shall succeed in being a better artist, they will find it hard to be a kinder, better fellow than Mr. Samuel W. Griggs.

It may have been because of his architectural connections or more probably because of his Boston Athenaeum exhibits that he was quite successful in selling his paintings. He exhibited yearly at all the Boston exhibitions and was a member of all the proper art clubs. He was at all times quite respected and in the summer roamed all over New England and New York varying his subjects to include all aspects of this terrain, hallowed by artists.

Some of his paintings that were exhibited in various years included in 1860, "Near Swallow's Cave, Nahant," an oil 14 x 27. Nahant was at that time an island reached by a small steamer from Boston. Many of the Beacon Hill brahmin types summered there. One critic said of Griggs' marine pictures, "He gets as much of the spirit of the sea in his pictures, as anyone I can name."

In 1861 Griggs was in North Conway, N.H. where he painted among others, "Willey Brook," a 14 x 20 oil. At the time a critic speaking about the joint exhibit of Griggs and his colleagues, said: "Their sylvan magic is constantly felt. The broad impression they convey is more interesting, and good composition is at the bottom of all the pictures. In their polished serenity their discreet lighting, their neat disposal of details, these pictures have a certain museum like charm."

The 1858 sojourn in Campton produced three paintings that Griggs and his companions exhibited later that same year in an exhibition gathered together by Bierstadt and held at New Bedford, Massachusetts.

A good year was 1864 when among some of his exhibition pictures was a 17 x 25 oil simply called, "Landscape." Another,

the same size, a "View on the Hudson," and "Woodpecker on Birch Tree Trunk," 20 x 12, a very colorful work were also included.

By 1865 he was back on the seacoast with a 12 x 19, "View on the North Shore, Massachusetts," and "Manchester by the Sea," a small 10 x 14 oil. Two years later he was again in New Hampshire with a 12 x 16 oil, "A Farm in New Hampshire," complete with cattle, figures, and distant mountains.

The year 1868 he produced Adirondack works such as; "On the Schroon River," a 5 x 8 oil, the first of many Schroon Lake scenes (or as he marked it "Scroon" Lake). There is one New Jersey picture named "Stevens House, Castle point, Weehawken, New Jersey,: an oil 17 x 25, and is a river landscape.

In 1870 he began to do sets such as "The Four Seasons," a set of four, all small 6 x 8 oils, a very saleable subject and size. Then came animal pictures, "Squirrel with Autumn Leaves," a 20 x 12 oil, and "Still Life with a Robin," 18 x 24. And the fish pictures, the subjects you can be sure were all subsequently eaten; "Still Life with Game Fish," 24 x 20, "Pickerel," 20 x 10, "Speckled Trout, Caught," 18 x 27, another "Trout," 20 x 10, and to vary the diet, "Still Life with Fruit," a large oil, 21 x 26.

A sampling of his miscellaneous exhibit pictures included; "Autumn Landscape," his largest recorded oil, 30 x 55, "Falls at Downer Glen, N.H." 18 x 14, "Adirondack Landscape," 21 x 26, "Meadows and Mountains at Bethel," 12 x 16 "Lock Anna from Newport Mountain," 9 x 20, and "Mount Desert, Maine," a 10 x 20.

The Studio Building on Tremont Street, Boston was created with the needs of artists in mind. Practically every artist of note in the city, at one time or another located their studios there. Griggs was no exception. He moved into the first Studio Building in 1867. He occupied several studios there for over 30 years. His home addresses were frequently changed. For some years he had a house in Roxbury on Ball Street. He moved nearby to 26 Woodbine Street in 1874 and the house was listed in his name. It was the custom for the artists of the Studio Build-

ing to hold yearly exhibitions in the building and even charge for admission. The charge was usually only ten cents but it kept out the browsers.

Another good year for Griggs was 1884. He exhibited and sold his large canvas at the Boston Art Club. The picture was No.161 and hung on the line between works by W.P. Phelps of Lowell, and Miss Adelaide Palmer then of Tremont Street. The Griggs picture received a very favorable notice from the Boston Transcript.

The following years were spent in much the same manner, exhibiting in Boston and sketching in the summer wherever his fancy took him. He was an individualist and a very modest and unassuming man. He was of a rather reserved disposition and inclined not to speak unless he had something of real value to say. But he could laugh both at himself and the country sights that amused him. It was by merit alone that he attained his eminence as a painter.

At his death which was publicly noted by the various art clubs. He had on hand, in his studio, several hundred paintings and studies, many incomplete. They were all sold off in several days, but no catalog was kept. Several of his paintings today are in New England museums. However, interest in The White Mountain School faded for a time. Now, happily, the demand for true nature landscapes of that era is rising. Griggs and the other early mountain painters believed in presenting nature as they found or saw it,with the wonder of the changing trees, the solemnity of the forest, the sparkle of a gurgling brook, the serenity of a quiet glade, the grandeur of the valley surrounded by majestic mountains, and the brooding flow of a quiet river. Today only parts of those scenes are painted, if painted at all.

# Chapter Seven

## SAMUEL LANCASTER GERRY

Here is a different sort of Boston painter. He painted much the same New England subjects as other artists but in a vastly different manner. Some artists take a subject in nature, portraying it as starkly realistic, albeit grimly true. Samuel Gerry would take the same subject, and while being faithful to the scene, idealized it, make it so mysterious and attractive as to make one wonder at the secret of his art.

He was born on Atkinson Street, Boston (now called Congress Street), May 10, 1813. The Gerry family and its numerous branches was quite prominent in Boston. A Boston Gerry was Vice President of the United States when Samuel was born. It is thought that young Gerry's early talent for drawing was due to the tutoring of various itinerant portrait painters. At any rate, portraiture was his first venture and then came the painting of miniatures that were so popular with those who could afford them. Even though he had very little formal training in art he was able to travel extensively throughout Europe studying the works of the masters in the museums and palaces. He had no need to hurry his travels and visited and painted in England, rural scenes in France, Roman landscapes, and in the mountains

of Switzerland. He did a large Rhine Falls painting in Germany that attracted a lot of attention when he returned to Boston.

He maintained a studio on Tremont Row for many years and became one of Boston's earliest artists that accepted pupils. He was a fine portrait painter and much in demand by the Beacon Hill and Back Bay families. Their daughters became his pupils. To quote our friend J.B. Wiggin again, "His work is in the best houses, and wherever it is, there is a subtle something about it that is the quality, ... they are that is vastly superior to many of the French pictures that sell for so large a price."

Gerry was a member of the Boston Art Association which preceded the Boston Art Club. One day in 1854 (Benjamin Champney remembered it as 1855), the new Boston Art Club was formed. Champney and Edward Cabot, an architect painter, were the prime movers and Gerry was one of the party of architects, artists, and sculptors, that met in the rooms of F.D. Williams, on Tremont Row, to formulate an organization plan. They evolved a constitution and a set of by-laws that were to last for many years. Joseph Ames was elected President. The next year Champney was elected President followed by Samuel Gerry's election in 1858.

Gerry was a religious man and the mysterious element in his painting of nature reflected his firm beliefs. While on his European travels he heard that George L. Brown was in Albano, Italy. The two artists were born in the same year and had struck up an acquaintance in Boston that was to last many years. Gerry made his way to Albano and went sketching with Brown. With a hope of doing some good he said one day, "George, why do you not give some thought of the life to come, and look forward and upward sometimes? It will make a better and happier man of you." Brown was looking upward at the breathtaking scenery and answered, "I do not trouble myself about the future, for the present is all I can attend to." Nevertheless, he remembered Samuel's kind words. A little while before, a friend had given Gerry a small bible as a keepsake and he had lost it. He thought the custom house officials somewhere in his travels had

confiscated it for their own use. However, he had left it behind at Albano with Brown who thought it was left for him to read as a bit of missionary good work from his friend. Sometime later he fell sick with a virulent brain fever. While slowly recovering he began to read the small bible and as he tells it, Gerry's bible helped him to recover and it truly did make him feel much better as a man and brightened his life so that he was once again able to paint magnificent landscapes such as "A View at Amalfi," now in the Metropolitan Art Museum. The little bible led him to Rome, where he lived many years.

The artists that came to Franconia Notch each summer stayed for a while in Compton Village. The late 1850s saw A.W. Gay, Asher Durand, Samuel Griggs, G.L. Brown, and Gerry gather at The Stag and Hounds to paint the White Mountains in their individual styles. Many of those paintings found their way to the yearly exhibitions of the Boston Athenaeum, New York City, and Philadelphia. The New England landscapes were popular wherever shown and many were sold. While enroute to the Notch in a bone jolting wagon, Brown told Gerry what had happened to his small bible and asked if he might keep it. The answer was a strong affirmative. Tuckerman wrote that the expressions of truth, beauty, and grandeur, in the White Mountain works of these particular artists, were comparable to the writings of Hawthorne, Thoreau, Emerson, and Dana.

Gerry painted portraits, genre, animals, and landscapes; exhibiting them each year in Boston, the Pennsylvania Academy of Fine Arts, and the American Art Union in New York. Some of his most popular paintings were "The Old Man of the Mountain," in many sizes, "The Artist's Dream," and the "Bridal Tour of Priscilla and John Alden." He moved around the White Mountains as the summer waned and in the fall, like many others he painted harvest scenes in the Conway Valley. We like his Crawford Notch paintings and have looked for his painting spots in that area. However, even that terrain seems to have changed since his day.

The Boston art scenes of the 1870s and 1880s were made

up mainly of the two yearly shows of the Boston Art Club, the Athenaeum show, and the Charitable Mechanics Fair in the Mechanics Building. Gerry, now quite elderly and a very respected master artist, exhibited two landscapes in the Boston Art Club oil painting exhibition of 1884. There were some lively discussions among the artists whose pictures were side by side with his. E.W. Longfellow, J.J. Enneking, and T. Wendel, were upholding the impressionists view of the mountains while Juengling, Binden, and Gerry were decrying the demise of the traditional. Young Paskell, listening to the debate noted it all down in his journal. The verdict as vociferously noted by several was, "indistinct, chaotic, blurred, and just a plain botching of colors."

Gerry died in Roxbury at the age of 78, in April of 1891. The services were held from his studio on 65 Munroe Street. Champney and many others lamented his passing. Champney observed that he was now one of the last links between the elder generation of White Mountain artists and the school of the present. He admitted that the impressionistic school has been productive of great good. It had taught the younger artists to look for simplicity and breadth, and attempt the luminous qualities in outdoor studies, but why all the high keys? Gerry and his contemporaries produced charming and healthy qualities and Champney concluded by hoping that the "extreme fad of impressionism has gone by, not to be resuscitated."

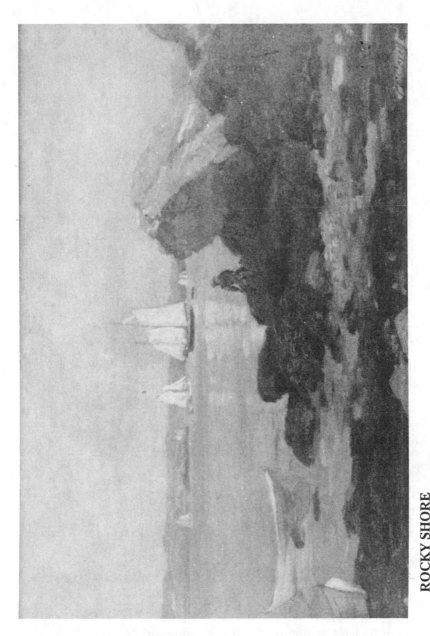

**ROCKY SHORE**
*By SAMUEL L. GERRY - Oil on Canvas board, 9½"x14"*
(Courtesy of Robert W. Skinner, Inc., Bolton, Ma.)

**BERRY GATHERING IN BARBIZON, FRANCE**
*By FREDERICK P.VINTON - (1877), Oil on Canvas, 29¾"x22"*
(Courtesy of Richard A. Bourne Co. Inc., Hyannisport, Ma.)

# Chapter Eight

## FREDERICK PORTER VINTON

The portraitist did not maintain a downtown studio for very long. He acquired a brownstone house at 247 Newbury Street, Boston, and opened a large sitting room as a studio. The clients were shown in by a maid and Vinton soon put them at ease with genial hospitality. It was a curious custom of the day that recent widows would commission him to paint their late spouses from photos and their fond descriptions. Some obituaries even ended with the comment that "Mr. Vinton will paint the memorial portrait which will be respectfully on display at Chase's gallery in due course."

Vinton and many other Boston artists sent pictures to the various Paris Salons. Many were rejected and some never found their way back to America, but Vinton received an honorable mention in 1890. He was also honored in his own country by being elected to the National Academy in 1891. He addressed the small social club of W.H. Titcombe's in 1888 and J.B. Wiggin took it all down. Some of it appeared in The Boston Advertiser of that year included in an article by the critic J.B. Millet:

Ladies and Gentlemen; Art is long. Its ways

are various, and the many ways that artists have of holding the mirror up to Nature give us infinite varieties of interpretation. There need be no antagonism, because we have not the same likes, or because we have not the same facility of expression. ... I have my likes and dislikes as much as any, but I do not undervalue an artist that paints a cheap picture. The ancient statement, that all men are created free and equal, is to be taken with great allowance. All men are indeed created free, within certain very narrow limits, but they get into trouble if they exceed them. In a few rights they may be equal; but for the most part they are utterly and eternally unequal, and I think they are more so in their perceptions of art than in anything else.

In some it is utterly wanting, a minus quantity forever; while others are pilgrims of beautyand children of light until they are translated. ... Boston art is steadily advancing. Many of us are men who in a gust of exultation raise the materials of his craft to the highest power and invests both pigment and technique with an incomparable beauty. There are also thousands of artists that spend their lives squeezing colors out of tubes, or even grinding them, and placing them upon the palette without the faintest suspicion of the fact that they have the ingredients of a big magic. No city in all the world has so many advantages by nature, as Boston has for her children. Its rivers are permanent, and do not change their banks. The islands in the harbor are rocky and immovable. ... Boston is situated in the toe calk of a mighty horseshoe, for eternal luck. It is about a hundred miles around on the South Shore to Cape Cod. It is a hundred miles around on the North Shore, and more if you count it.

Oh, the handsomest rocky islands, green fields, pretty bays, sandy beaches, lighthouses, cities, towns, villages, hotels, summer houses, sparkling waters, ... vessels of all kinds, and people of all kinds, on more beauty than any other city can show this side of the New Jerusalem. ... Her beautiful West bay is a water park fairer than Venice ever knew. ... What drives in summer. What sleighing in Winter. ... No stagnant waters like Marseilles and Mediterranean ports. ... No dykes like Holland. No little sewer of a river like the Thames or Seine. ... No winter like St. Petersburg. No heats like India. ... No white ants to eat your house down.No volcanoes to shake it down or burn it. ... The sails, the rides, the drives around Boston, are a continual surprise, ... This is the city that we love, with the sunlight reflected from her golden crown. With all these grand advantages Boston and its art will forever continue to advance until the Angel shall stand with one foot on the sea and the other upon the land, and [time] shall be no more.

It was the critic, Millet, who launched Vinton's career in 1878 with his article extolling the painting he brought back from Europe, "The Little Gypsy Girl." The paper again was The Boston Advertiser and it also told of Vinton's 1878 Salon picture of a "Neopolitan Head," that was sold at the Salon for 1200 francs. That same year he had another picture painted in Europe on exhibition at the Boston Art Club. It was purchased off the wall of the Art Club by Mrs. Dix. The painting sales picked up remarkably in the eighties and as one Art Club member remarked, some pictures were being sold before the paint was entirely dry. Some of the well known Boston names that patronized the Art Club and the yearly Mechanic's Fair were the Ames, the Ullmans, the Nortons, the Wigglesworths, the Ditsons, the

Warrens, and even C. Vanderbilt purchased one of Julius Stewart's works entitled, "Honey Moon." The Boston Symphony conductor, George Henschel began his collecting at these exhibits.

Frederick Porter Vinton died on May 19, 1911 at his Newbury Street home. Over one hundred Bostonians loaned their portraits to the Museum for a great memorial exhibition. A few of his silvery landscapes were also shown. His biographer wrote, "He was a strong, incisive and thorough draftsman, a serious and studious observer, with a deep respect for his art and for himself as an artist."

# Chapter Nine

## JOHN ROSS KEY

Family tradition shapes the destiny of many men. John Ross Key was one man who rebelled at tradition at a time when it was not proper nor fashionable to do so in a distinguished family. Great, great grandfather Phillip Key had emigrated from England in 1720 and founded the family estate he named "Terra Rubra", in Frederick, Maryland. Before long he was the magistrate for Carroll County. Grandfather Francis Scott Key studied law at St. John's College and married into a family with a long tradition in the law, the Charltons. Their six sons followed suit and some of them entered into the law firm that had been founded by an uncle, Phillip Barton Key. Francis Scott Key had seriously considered entering into the clergy of the Episcopal Church but the family tradition prevailed. He did however become a reader of St. John's Church in Georgetown and a delegate to the general church conventions. He also wrote poetry, mostly doggerel verse, but in one great flash of inspiration wrote down the words of the future National Anthem and achieved immortality. He later said, "If it had been a hanging matter to make a poem I must have made it."

That, poem, made on the historic night of September 13,

1814 was dashed off on the back of an old envelope. Shortly afterwards he transcribed it on a piece of paper. (Now a collector's item, last selling price, $24,000.) He called it, "The Defense of Fort McHenry," and to be sung to the tune of "Anacreon in Heaven." It was not the first time that he had used the music of the old English anacreonic Society. The song was printed and reprinted in magazines and after a few years began to be called "The Star Spangled Banner." It did not cause any wave of patriotic fervor but was played by army and navy bands.

One of Key's six sons was Edward Taylor Key, another lawyer, who had married Virginia Ringold, from yet another rather prominent Washington family. Edward did not live to see his son. He was murdered on a Washington street by an irate senator in broad daylight and before the eyes of many passerbys. The scandal that followed was increased when Congress exonerated the murderer with a verdict of justifiable homicide.

John Ross Key was born on July 16, 1832, just two months after the murder. Virginia christened her son after his great grandfather, who had recruited, equipped and drilled a company of troops for the revolutionary war. The murder affected the early life of John. He lived with his widowed mother and grandfather Francis Scott Key in the old Key mansion on the banks of the Potomac. His artistic tendencies were noticeable at an early age and a very sympathetic mother encouraged his charcoal drawing. The grandfather regaled him with patriotic tales and took him fishing. The family fortunes changed abruptly when Francis Scott Key died in 1843.

He had hardly become a teenager before circumstances forced him to help in support of his mother. Logically his drawing talent and an assist from an uncle, Cadawalader Ringold, a naval department cartographer, led to a job as draftsman in the Coast and Geodetic Survey. One of his coworkers and one whom he became very friendly with, was a young man, also with artistic aspirations, one J. M. Whistler.

Being tied down to a desk did not sit well with young Key, especially when exciting reports and tall tales of the far western

expeditions passed through his office. He did some illustrations for the reports of the J. C. Fremont survey of 1853. Finally, after many applications he was jubilant at this appointment as map-maker in the advance party of the "Lander" expeditions. Their mission was to chart the best overland trail for the large wagon trains to the west. The trail led through the hostile Indian terri-tories of Utah and Nevada. Now he could sketch the landscapes as well as the routine mapmaking. The journey slowly brought him from St. Joseph, Missouri to Oroville, California. That was the beginning of a life long quest for strange new places and the urge to portray them.

The rumblings of the war followed him. Shortly after his return to Washington, the holocaust began. Early in 1861 along with ten other grandsons of Francis Scott Key, he joined the Confederate Army in Richmond. It was an agonizing decision especially since his mother and her family, the Ringolds, were for the Union. Key served as a mapmaker and official painter, and was commissioned a lieutenant with the Corps of Engineers. Several of his paintings from that period still exist and were enti-tled, "The Federal Siege at Charleston, South Carolina," and "The Attack of the Yankee Ironclads on Fort Sumpter, April 7, 1863."

The war eventually ended and people attempted to pick up the threads of their lives. Art was forgotten for a time while the nation sought to stabilize itself. John Ross Key however, simply continued his painting and perfecting his art. He was fortunate to be able to work at his trade of mapmaking and to paint while travelling. He painted in Maryland, Washington, Pennsylvania, and the Cumberland Mountains. The sizes of his canvases and subjects are interesting. Some of them were: "A View Near Oakland, Maryland," a 15 X 30 canvas. Oakland was the home of his brother and is close to the border of what is now West Virginia. "Trees, Chain Bridge Road," near Washington, 17 X 23, "Frewry's Bluff, James River," a river scene with ships, a large canvas 22 X 48 and a scene he was to duplicate many times. Many Potomac River scenes, all with ships, were also

painted, including some sunsets, and all varying from large to miniature sketches. They were to be exhibited later on and eventually most of them are now preserved in museums. These 1865 pictures included one very fine work that has been admired and is now in the Maryland Historical Society's headquarters at Baltimore and is entitled, "A View of Pennsylvania."

The "Frewry's Bluff" painting began his career as a full time artist. The following year began with the exhibiting of two works at the National Academy of Design in New York City. They were listed in the catalog as No. 55, "Sunset Cheat River," (For Sale) and No. 302, "Wilds of the Alleghenies" (For Sale). They did not sell. Undaunted he exhibited the same pair at the same place in 1867. One sold. Later that same year he exhibited several other pictorial landscapes and received a mention by Tuckerman in his *Book of the Artists*. That critic wrote "Key of Baltimore has shown much talent in his picture of 'Fort Sumpter." He was living at that time with his mother at 32 Franklin Street in Baltimore. Key's mother, Virginia Ringold Key wrote frequently about her wandering son to relatives. Wherever the young artist stayed for a time he would send for his mother and set up a temporary domicile. She had a relative in San Jose, California, General Henry Morris Naglee and he preserved her correspondence. Her letter of December 15, 1867 states that J.R.K. had spent the summer in Oakland and in Cincinnati, and will spend Christmas in Baltimore with her and thence to New York. She ends the letter by saying, "John is indefatigably industrious and really a hard student in his profession. Everyone agrees he will make a name for himself and perhaps his having to work so hard just now to make his bread will be in the end all the better for him."

Her letters to Naglee are now preserved with his papers in the Bancroft Library, University of California at Berkeley. They show that Key in 1868 spent some time in New York hotels, then returned to Baltimore and took his mother to Oakland. The summer and fall were spent in Cincinatti and Pennsylvania. Key exhibited at the National Academy that year and

noted that one picture, item No.182, "The Glade, Allegheny Mountains," was sold to a Mr. William G. Brown. Two notable pictures from that year were a 32 x 16 canvas "A Landscape of the Cumberland Mountains," (now at the Washington County Museum of Fine Arts, Hagerstown, Maryland) and a 22 x 18 architecturally fine oil of "The Temporary White House, Rock Creek Park."

Key long had a yearning to see more of the wonders of California. Now he resolved to do just that and made preparations for the long journey. Mrs. Key wrote to Naglee, "We sent John your letter in which you described the earthquakes and he said he was delighted to hear that your place had not suffered from the effects of it and he hoped there would be no more, for he should be sorry if the mountains were upset before he had a chance at them."

The relative, General Henry M. Naglee, had fought with distinction on the Union side and was the widower of Key's first cousin, Marie Antoinette Ringold Naglee. She died tragically at the age of 22 earlier that year. The General extended an invitation and a helping hand to the artist rebel who had ignored the family tradition of law and only wanted to paint the mountains and seashores.

Journeying by train and stage coach Key arrived in California during the summer of 1869. Whether by design or chance he traveled with a fellow artist, Gilbert Munger. The two young men stayed together and sketched at Lake Tahoe and at Big Trees. Remembering the tall tales of Major Savage and the reports of Fremont, they set out for the valley of Yosemite. Efforts were being made, even at that time, to name the area a national resource. The paintings of Bierstadt and the photographs of Watkins were the only evidence that had given the people on the Atlantic some idea of the sublimity of that incredulous valley.

The two artists found the traveling very difficult. The roads were narrow and rough and every sort of conveyance had to be resorted to. They knew that they had to get into the valley and out before the first snows choked the passes. The high Sier-

ras rewarded them with breathtaking views which they carefully sketched. When they finally achieved the awesome entrance to the valley it was sketched with notes of the evershifting colors and cloud formations. They were able to recognize such names as Tioga Pass, Sentinel Rock, and Halfdome. Many of the now well known points had not even been named at that time, so they invented some of their own. The lake where they had spent considerable time was then called, "Lake Bigler." Key, however, preferred the Indian names. All the reports of the gigantic beauty of the place were true. They found that the meadows and the banks of the Merced River were being grazed by thousands of sheep. One herder was a young man named John Muir, at that time, just another herder, but one who had dreams and a deep appreciation of the old valley of the Ahwahnee Indians. They had long been driven from Yosemite by homesteaders and miners. Somewhere still in that valley lies the "Mother Lode," the site of a legendary huge gold find, sought by thousands to no avail.

When October dropped the first snows, the artists reluctantly left the valley, That one trip had provided enough sketches for many years of studio work. Munger headed for San Francisco and Key was pointed towards San Jose and his relative and sponsor, General Naglee.

The traveling southward to the coast was easy. Some of the fine ocean views were caught in Monterey pictures. One such canvas, a 10 x 21, "Monterey Bay," has been exhibited recently at the Santa Cruz City Museum and is owned by a college professor.

Monterey was named after the third largest city in Mexico and when Key arrived there, it was still a small Spanish type town populated with old California hidalgos and Mexicans. The state constitutional convention had met there only 20 years prior. Once again he was one of the first American artists in that region of Alta California. He earnestly set about attempting to portray all the charm and its rich historic tradition. Ever a student of American history he was impressed with the stories of

Father Junipero Serra and the chain of missions that he had created. Serra had landed in Monterey just one hundred years before the artist's arrival. The first mission was too close to the military and Serra moved it to neighboring Carmel.

When Key sought out the mission of San Carlos Borrodeo, he found it in ruins. It had been abandoned and neglected for thirty years. The roof had fallen in and it presented a doleful sight. The mission indians had fled to the hills and the present Padre's home was in Monterey where he had taken the church's sacred objects for safe keeping. The artist found the grave of Serra and it was surrounded by the final resting places of hundreds of Indians and a few Spaniards. The mission had flourished for 64 years and several thousand Indians had been confirmed as Christians. The crops had been good and the Indians willingly built the mission walls with a lime plaster made from burnt sea shells. Key painted some scenes of the Mission garden with its many large blooming flowers, growing wild and the rotting arbors. He did not have the heart to portray the old Mission in its state of decay.

He tarried at Santa Cruz before crossing the mountains to the valley city of San Jose. Several pictures were the result of his visit to the curving coastline. There were entitled, "Sailboats on the San Joaquin River" and "The Carmel River." Both are large canvases and they have found a permanent home in the University of California, one in Santa Cruz and the other at Berkeley. Some critics have called them "artistic pictorials."

The winter was spent on the Naglee estate in San Jose. The General had retired there and had become extremely wealthy manufacturing brandy. Between the torrential winter rains the artist found time to paint views from the estate and the rolling hills of the Santa Clara Valley. Naglee urged him to exhibit in San Francisco. He wrote to his Mother about his intentions and she in turn reported to Naglee in a letter dated January 21, 1870, "John's bright, hopeful spirit is a great blessing to him. He always works as if he knew he was going to make a fortune...I feel he was quite right to prolong his stay."

**LAKE TAHOE**
*By JOHN R. KEY - (1871) Oil on Canvas, 20"x40"*
(Private Collector)

The fortune however was not to be made. San Francisco, in spite of being a rapidly growing American city was in a business depression. Key exhibited in the Mercantile Library building and the "Alta California," the city's leading newspaper had this to say:

"Of a dozen of John Ross Key's pictures, there are three lovely views of Lake Tahoe...an evening effect, giving a still tranquil scene, bathed in the mellow light of a late sunset, is the finest of these. Like all Mr. Key's pictures this shows a conscientious study of local peculiarities, the foliage and tree shapes being faithfully reproduced." High praise and low prices, always the bane of an artist's efforts. The prices ranged from $10 to $30. Friend Munger joined him in a two man exhibit but with the same result.

Key travelled southwards on the old El Camino Road back to the Naglee estate where he spent the summer with painting excursions to the Santa Cruz Mountains. There in the Big Basin country he attempted to portray the huge Sequoias but no canvas could ever complement those ancient monarchs which were almost full grown long before recorded history.

There exists in the Naglee papers a promissory note which promises to pay back $1950 in gold coin and $400 in currency, "the whole being advanced to me, December 4, 1870" signed J.R. Key. So with a borrowed fortune he returned to Baltimore in easy stages, sketching frequently. He wrote to his benefactor on April 23, 1871 from yet another temporary address, 113 North Charles Street, Baltimore, "I shall go to Newport this summer and have taken a little cottage. I have made this move in hope—and have fine prospects of selling my pictures and making acquaintances that will be of service this fall in New York. What do you think of the plan? You know people there have much leisure and plenty of money".

In Scribner's Monthly reports on September 1871, an article entitled "Sojourners at Newport,"it was reported that "Key, who has brought hither from California a series of carefully studied views of the most remarkable scenery of that region, which he is now busy in elaborating into landscapes, interesting from their authenticity, effectiveness and associations. Mr. Key has many orders"

However he did not go to New York but opened a studio on Tremont Row, Boston. This enabled him to venture from that studio to the great many painting places of New England. The summer of 1872 was spent entirely in the White Mountains of New Hampshire. Here the mountains were mere hills compared to the western peaks. Each hill however had more character and history along with Indian legends. Whatever future exhibitions he was to essay, the white mountain pictures were to prove the most popular. A 12 x 36 canvas of Mount Washington was his first New England work.

He joined the Boston Art Club with is commodious apartments, galleries, and Library on Boylston Street. He found himself in the company of almost 500 member artists, none of whom had ever been west. Most western pictures were thought to be exaggerations and dubious perspectives.

Key portrayed such subjects as fishing in the mountains, views of the various glens, waterfalls, climbing the mountains, mountain sunsets, sunrises over the peaks, and rivers. A favorite was a 7 x 9 exquisite miniature showing two boys tending sheep on the hilly North Conway slope of Mount Surprise and gazing at the bulky mass of Mount Washington, a scant 30 miles away. Just to give a small idea of the dimensions of the miniature; the trees, complete in every detail measure a bare two inches; the two boys with their straw hats measure a half inch. The eight sheep scattered about the hillside, are only a quarter inch long and again every detail is visible. Mountains and clouds complete the picture. The effect is airy and the colors are high keyed for that era. The John R. Key signature is printed in letters of less than one sixteenth of an inch high. What good eyesight he must

have had! This painting on board must have passed through many owners before it finally was found and recognized as a New England masterpiece, and in a dust bin in a Goodwill store.

Key liked Boston and especially the praise bestowed on him by the newspaper critics. The critics of those days, unlike those of the present, were lavish in their commendations of the artists and their works. They were eager to give an assist upwards not a slap down.

Virginia Key joined her son at his Beacon Hill lodgings and it proved to be a semi-permanent address. It was a time of contentment and prosperity. She enjoyed the social activities and the Key name opened doors both for her and the artist. The newspapers reported from time to time as on October 18, 1871, The Boston Evening Transcript wrote,

> We have had the pleasure of a viewing of six pictures from the easel of this artist now on exhibition at the gallery of Williams and Everett; Mount Diablo, Almaden Mountains, Point Lobos (near Carmel) Emerald Bay, Lake Tahoe, and a view of our own coast at Newport, Rhode Island. They are all treated with that refinement of feeling which indicates a true lover of nature...He has well selected his views of pastoral scenery - the real golden fields of California...and made us acquainted with something more than the perpendicular aspect of that country.

Again in January 30, 1872, the Boston Evening Transcript's critic Earl Marble writes of a Lake Tahoe scene on display at the gallery of Elliot, Blakeslee and Noyes, "If it is called dry, we must remember how dry the California climate is in summer and recognize its faithfulness to nature. Its solitude is heightened by the deer upon the stretch of land jutting into the lake, and the greenish blue of the sky and reflection in the water are peculiarly Californian."

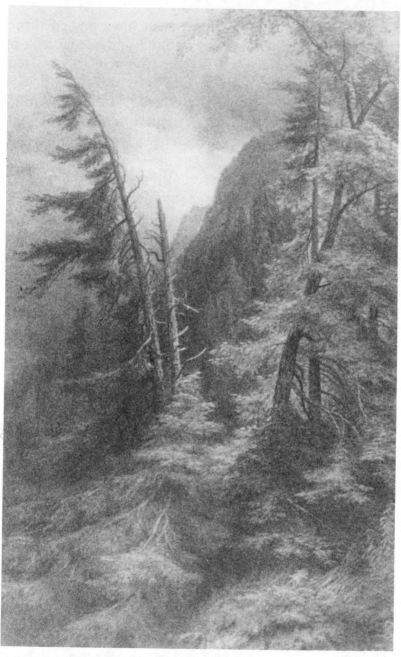

**MOUNTAINSIDE, YOSEMITE VALLEY**
*By JOHN R. KEY - Charcoal/Paper (Beige), 34¼"x21"*
(Courtesy of Robert W. Skinner, Inc., Bolton, Ma.)

Critic Marble's review in February 24, 1872, of a reception in the Lawrence Building where Key had his studio along with the future Californian painters, William Keith and William Hahn, he wrote, "Key's 'Lake Tahoe,' which was shown recently has been much improved, gaining in strength and losing nothing in poetic sentiment, which latter feeling predominates in all Mr. Key's works. He also renders the California atmosphere finely giving us the placidity of the lowlands, while others have represented the rugged mountainous regions..."

March 23, 1872, Mrs. Key in a letter from 34 Mount Vernon Street, Boston to H.M. Naglee, "John is working hard...He has made many friends here and has been received most kindly and hospitably by all the clubs and society generally. Boston is a city of clubs; the ladies have a club and there are literary musical, art and of course clubs for gentlemen such as they have everywhere..."

May 19, 1872 recorded a letter from John Ross Key to H.M. Naglee. He wrote: "I have been very busy this winter and spring, and have just placed my winter's work on exhibition. Enclosed you will find a catalogue. I have good prospects of which I will drop you a line soon - just at present cannot tell how the pictures will go..."

May 25, 1872 brought an extended review by the Boston Evening Transcript critic, Earl Marble. The Williams and Everett gallery show,

> One peculiarity of Mr. Key's touch must not be overlooked, which a contrasting reference to "Lake Tahoe" and the Oakland scene in the Alleghenies hanging over it, will illustrate. His style of painting is by no trick or manner learned from some tutor, but is original with himself. Note the contrast presented between these two scenes. If

the touch were a trick there would be points of resemblance. But there are none. Each bears its own weight of evidence as to truthfulness and fidelity, and anyone with a critical eye can see is not small. Mr. Key paints nature, and it is pleasant to reflect that he sees it with such a kindly poetic eye...Classified with Mr. Key's pictures is a very fine view of the Pacific Ocean by Gilbert Munger, the New York artist, who usually is Mr. Key's boon companion in his sketching tours...

1872, July 13 Boston Transcript; "J.R. Key has gone to the White Mountain region to pursue his summer sketching..."

November 23, 1872, a letter to H.M. Naglee; datemarked The Boston Art Club, Boston, Mass. from Key read:

> This last summer was spent in the White Mountains most pleasantly in many respects. On October 23rd I pulled my stakes and pitched my tent on this campground, just in time to witness the great fire that has caused so much sorrow. (The Great Fire in Boston of November 9.) Last season I suffered a great draw back in my business from the Chicago conflagration, and now comes another one even worse. I did not lose any pictures in either fire, but business has been so prostrated I fear little will be doing this winter but I cannot complain as the season opened most favorably for me and I have ample work for the present. Indeed I was never in such grand luck until this fire came and upset me. My profession is a slow one...and I beg that you will have patience with me in regard to my indebtedness to you...and I shall succeed in repaying the amount, but not so easily the deep debt of gratitude. On my return

from California I thought I could do something in
Baltimore but found it impossible.

He goes on to say at long length that his work sells for
little profit but is finding encouragement in Boston and is doing
quite well.

Selections from the art news of the media tell the artistic
climate of the 1870s. The following are brief quotes mostly from
the Boston Evening Transcript (hereafter cited as BET);

| | |
|---|---|
| December 13, 1872 | BET; "The studios above the club rooms [of the Boston Art Club] are nearly all taken...Mr. Rowse will occupy a suite of rooms there with Messrs. Bellows, Key, Barry and others." |
| May 5, 1873 | BET; "John R. Key exhibits an ardent love for White Mountain scenery in the large pictures lately finished of the Conway Meadows and other portions of Northern New Hampshire." |
| June 2, 1873 | BET; "Key [and others] will spend the summer abroad." |
| September 23, 1873 | BET; "Among Mr. Prangs' recent chromos is a set of four, after paintings by John R. Key, which reproduces that artist's style in a marked degree. The two of "Lake Tahoe" and "The Sacramento Valley" are especially notable." |
| April 8, 1874 | BET..."and John R. Key has several views painted since he has been abroad." |
| April 11, 1874 | BET; Report of an art sale, "'A View of Bercktesgaden (sic) Tyrol,' by John R. Key sold to Mr. Reed for $65.50... 'In the Forest, California' [sold] to Mr. Thayer for $110." |

October 13, 1874    BET; "Key has been in Paris this summer."

March 2, 1875    BET; "Of the Boston artists in Paris, the studio of John Jr. Key, 9 Rue Chaptal...Key is honored by having a picture in Goupil's window near the opera house. It is in good company and looks well.

Then there is a revealing letter from Virginia Key to H.M. Naglee, dated August 10 (no year) and from an address c/o a Mrs. Nichols, 20 Tudor Street, Lynn, Mass.

There have been a great many changes in my circle of friends since I last wrote to you. The most interesting to me was John's marriage. He has a nice little wife and a dear little girl. They are living very nicely and quietly in Boston after two years abroad where John had to work as well as study very hard. His trip was a benefit to him, and I think he improved very much though of course I am a very parcial (sic) judge but I feel sure that he is fulfilling the promises that he gave of being a fine artist and standing high some of these days.

On October 19, 1875, Boston Evening Transcript had this item;

Since his return from Europe in the spring, has been sketching among the mountains of New Hampshire, and has now taken the small gallery in the art club building for the exhibition of his works. His style is now more picturesque and his subjects more interesting. His method is more broader, his color more true and delicate and his handling more free and natural...Several views of

the Seine are picturesque, in one especially of a story half revealed in melancholy suggestion and sombre effect...gray and sombre tones...

October 30, 1875  BET read; "The paintings by John R. Key, which have been on exhibition at the Art Club...were sold yesterday afternoon. There were thirty pictures included and the prices ranged from $60 to $280."

October 3, 1876,  BET; The opening today of Mr. John R. Key's studio for the reception of pupils at 1761 Washington Street...[far down into the South End of the city in a low rent district] marks a new departure in the line of art study in this city. In stead of the ordinary two hours occupation of the studio allowed by artists to their pupils who pay by the lesson, Mr. Key's rooms are open for the free use of students throughout the day so that after receiving the usual attendance in the way of teaching, an opportunity is enjoyed for utilizing the instruction received while it is still fresh in the mind.

November 3, 1876  BET; an article about the Philadelphia Centennial Exhibition; "There seems to be a good deal of misapprehension and vagueness of understanding as to the awards made by the judges in the art department. The only two medals given to Massachusetts artists by the original committee were granted respectively to William M. Hunt and John R. Key." Then there follows a long dissertation on the subsequent illegal committee whose awards upset a great many artists in the country. The upshot of the matter was that the medal was withdrawn after a later purchase of the work by the Corcoran Gallery of Art in Washington. The

picture was the well known large, 38 x 73 canvas "The Golden Gate" which was No. 82 in the Centennial catalog (The Handbook of the American Paintings in the Collection of the Gallery of American Art.) The picture sold for $500 to the Corcoran Gallery.

November 27, 1876

BET; "John R. Key has several charming charcoal drawings on exhibition at the gallery of Doll and Richards. Mr. Key is peculiarly felicitous in this branch of art...his pictures having all the lightness and effect of atmosphere that can generally be obtained only through the medium of color."

November 29, 1876

BET; a review of the works of various artists at Williams & Everett. Mr. Marble states,

Mr. Key is to vary his oil paintings with charcoal drawings, many of them large size, and embracing every variety of foreign and American landscape, including views of the Thames, the Seine, the Swiss Lakes, the White Mountains, the Alleghenies etc. These pictures institute a new feature in art sales. The rage for crayon and charcoal pictures has increased during the past year, but there are few artists who can boast special excellence in either, so far as landscape goes. Mr. Key is an exception, his long and careful practice having made him adept in that art so magnificently represented in France by Allonge'."

January 15, 1877

BET; "John R. Key has sent three charcoal subjects to the water color exhibition in New York that are very strong and decided in touch and graceful in composition. Two are American...one of "Cherry Mountain" and the other of "Lake Winnipiseogee (sic)."

March 24, 1877

The Boston Evening Transcripts had this to say about the Art climate in Boston; "Where are you going next season?, is beginning to be the question among the artists."

April 4, 1877

BET;The Boston artist is neglected very seldom selling a picture in his studio or at the gallery until deciding to leave in disgust, he puts his pictures, into auction room, where the patrons of art crowd the place of sale and bid for his works. Why not buy the pictures of the artist and keep him here, instead of driving him away by withholding timely patronage.

The exodus of some well known painters to New York had begun and would continue for a decade. Too many artists were concentrated in a small area and in a city that would not support a bohemian climate. This was brahmin Boston not Paris.

April 16, 1877

BET; One of the most important art sales of the season will be that of John R. Key, which is announced to take place at the gallery of Williams and Everett the latter part of the month...In the coming exhibition he will have ninety five pictures - oil paintings and charcoal drawings - comprising a large variety of subjects and including unquestionably his best works. Prominent among them are a number of White Mountain views, some of them taken from views hitherto neglected by artists and presenting new aspects of Mount Washington and the lesser peaks. There are delicious bits of New England scenery, old orchards, hayfields streams and hillsides, painted with loving care, and full of sunshiny out door feeling that so many artists fail to get. Then there are scenes

from the Pacific Coast, views along the Thames and Seine, and in the romantic Bavarian region, all painted from original sketches. Some of the more important pictures of the collection were painted out of doors and are thorough transcripts of nature.

May 1 & BET; contained articles boosting the Williams
May 8, 1877 and Everett sale in glowing terms. Then a week later the critic reported, "The sale of the Key collection was largely well attended and although the pictures brought fair prices, there were by no means what they were worth."

Key continued his efforts in Boston for another year sending one picture to the National academy of Design: No. 667 "Cloudy Morning, Mount Lafayette" and in 1879, one last picture; No. 438 "Summer Afternoon, Lake Tahoe".

It was with mixed feelings that he closed his Boston Studio and took his growing family to Stockbridge in the Massachusetts Berkshire mountains. The summer was spent pleasantly while he pondered his next move. Boston had treated him royally with many memorable personal triumphs but could not support a career and family as well. He decided to try a new career and a new city.

During the next decade very little of John Ross Key's activities were recorded. He opened an interior designing business with his wife as assistant. He very seldom painted but he did send one work to the "Fourth Annual Black and White Exhibition," Chicago, 1882 (U.S. Art Directory and Year Book). He is not listed after that until 1893 when a watercolor was sent to the "World's Columbian Exposition".

Now towards his sixtieth year he inadvertently began yet another career. It began with the Werner Company of Akron, Ohio, lithographing many of his old World Fair architectural pictures. Key attended the Columbian Exposition and the build-

ings fascinated him. He painted "The Peristyle" the mining and electrical buildings, the Court of Honor, the golden entrance to the transportation building, scenes from wooded island and general views from the colonnade. The Werner Company proudly advertising "their fine color printing," made them into chromos. Key's style of painting, though different from that of the seventies, is certainly not in the vanguard of the nineties. The carefully outlined leaves are gone; now dashes of color represent leaves. People are represented by plops of paint, and the sky is suggested by loose brush strokes.

It is safe to say that he did not miss a subsequent fair and was listed as an exposition artist. He had not long to wait between fairs. The Trans Mississippi Exposition came along in 1898. Then the Pan American Exposition in Buffalo, New York in 1901. He painted everything that intrigued him. Between fairs he painted patriotic monuments and found a ready market for them.

The main feature of the Pan American Fair was an awesome electric tower of light. It is interesting to note that an offshoot of this tower was sold to cities designed to illuminate the downtown sections. He heard about the one sent to San Jose, California. The tower consisted of a tall girder ringed triangle with wide rings of light bulbs narrowing to the pinnacle; a dazzling arc lamp at the top. It did indeed light up some of the downtown areas but on Saturday nights inebriated citizens would attempt to scale the structure, dropping off at various heights. The town boys had almost two hundred targets, smashing the bulbs with well thrown rocks. However the tower is now preserved in the town's historical park courtesy of the Naglee estate which also help provide funds for the upkeep of San Jose's many parks.

The next American extravaganza in 1904 brought the Louisiana Purchase Exposition to St. Louis. Key was there painting many of the fair buildings which in reality was a World's Fair in the grand tradition. The paintings never left Missouri. They are now owned by the Missouri Historical Society and their building is still in the original fairgrounds.

Key remained in Chicago in virtual obscurity until early in 1918 he returned to the scene of his most notable works and opened a studio at 372 Boylston Street in Boston. The BET critic, W. H. Downes welcomed him with:

> Those who are able to spare an hour in J.R.Key's studio, will find that it is worthwhile. Mr. Key is holding a studio exhibition from February 26 to March 16th. He came to Boston intending to hold an exhibition of his work, but was unable to get frames shipped to him in time, owing to the freight congestion, so he decided, as he puts it to hold a "frameless exhibition" in his studio. It is over forty years since his last exhibition in Boston.. He is an interesting man and has had many experiences, including a journey to the Pacific coast in 1859 by mule team from St. Joseph, Missouri, to Oroville, California.

Frames or no frames he sold practically all of his pictures. He also found himself in demand as a speaker at the cultural clubs where he once had been a member. He spoke at the Art Club and said he was a member of the original White Mountain School and not the Hudson River School as some art books proclaimed him. He told of his experiences with Kensett and McEntee and said he also was a friend of George Inness, Wyant, and Homer. Once upon a time he said he worked with Whistler and Munger: "alas, all gone now."

The evening transcript had one more item on March 2, 1918,

> Mr. Key has made a number of studies of the rose garden at Mount Vernon, Virginia; a charming old place in the English taste, where Washington took a great deal of pleasure; it lies back of the house and is enclosed by a closely trimmed

box hedge. Several other historic mansions of Virginia and Maryland recall colonial days, including the genial old balconied house of the artist's ancestors, [now torn down to make room for the "Francis Scott Key Memorial Bridge"], not far from Annapolis. It will be remembered that Mr. Key is a descendent of the man who wrote "The Star Spangled Banner.

Key closed the Boylston Street studio and returned to Baltimore where his family had finally taken root. He had been an artist for sixty years even as Benjamin Champney was. He had not settled in any one place for long and because memories are short he did not have the admirers and followers of a Champney.

John R. Key died in Baltimore, March 24, 1920. The present status of his pictures vary. They crop up at auctions and the prices are nominal. The West Coast Art Museum curators greatly value his paintings and class him with the early California artists of the first class. The East Coast curators exhibit him with the Hudson River shows, hardly knowing his dates or any other pertinent information. Certain Boston Galleries, historically well established, sell his large important works for the middle five figure range. Even now several one man shows are in the stages of planning out on the West Coast not far from the old Presidio where Key stood gazing in rapture out over the Golden gate. The sun was slowly setting and the stirring notes of.the old Anacreonic anthem was being played by the army band. As the last notes were wafted about by a stiff breeze, the flag came down, the sun disappeared quickly, and a masterpiece in paint had been born in the mind of a young artist.

**A Listing of World Fair Pictures**
**by**
*John Ross Key*

(including their present locations)

| | |
|---|---|
| 1898 Trans Mississippi Exhibition | "A Camel Parade" 20 X 30 |
| | "A Daylight view of the Fair" 20 X 29 |
| | (All on display at The Josyln Art Museum, Omaha, Nebraska) |
| 1901 Pan American Exposition,Buffalo, New York | "Electric Tower" 45 X 44 |
| | "Pan American Building, Park Lake and Boat House" 22 X 17 |
| | "Electric Tower" 22 X 17 |
| | "Midway Scene" 6 1/2 X 23 |
| | (All owned by Buffalo County Historical Museum) |
| | "Trans Mississippi Scene" Daylight" 20 X 30 |
| | (Owned by Joslyn Art Museum, Omaha, Nebraska) |
| 1904 The Louisiana Purchase Exposition, St. Louis, MO. | "The Grand Basin and Palace of Electricity" |
| | "The Palace of Machinery" |
| | (On display at the Missouri Historical Society) |

A note about the "Golden Gate" in the Centennial Exhibition, Philadelphia. The actual title was Entrance to the Golden

Gate", measuring 38 X 73 and was on display at the Corcoran Gallery for seventy years. Unfortunately and for some reason to which we are not privy, this painting was de-accessioned in 1951 and sold through a New York dealer. The present whereabouts of this American masterpiece is unknown.

**A BELGIAN DAIRY MAID**
*By WILLIAM A. J. CLAUS - (1877) Oil on Canvas, 24"x36"*
(Private collector)

# Chapter Ten

## Other Neglected or Forgotten Artists

A few Boston artists that are just now beginning to come into their own. Some museum directors and art dealers looking for "rediscovered artists" are mentioning these men as new names. Their works have lain dormant but now there is new interest and auctioneers are quick to push for higher bids. The truth is, that they have been merely neglected and forgotten; and for no apparently good reason.

## William A.J. Claus

William Claus, no one seems to know his middle two names, was born in Germany sometime during 1862. He is listed

as a portrait painter but we have seen interiors and several island shoreline paintings, all in oil. Also listed is the brief comment that he studied at the Julien Academy in Paris. Judging by his paintings he certainly was influenced by the Dutch Masters. Following his art studies he was somehow able to go to India where he set up a small studio and painted the portraits of influential Indians. This was a novel and profitable venture and he repeated it when his fortunes were at a lower ebb some years later. He emigrated to the United States and arrived in Boston. His birthdate seems to be in some doubt but he is listed in Boston as an assistant art teacher in the newly opened Boston Museum School during 1877. It is also known that he took lessons from the respected Otto Grundmann, who came from Europe to teach at the new School. Grundmann was well schooled in the Antwerp and Dutch schools of art. Among Claus's pupils were Jacob Wagner, Edmund Tarbell, and Frank Benson. The low salary, the too many indifferent pupils, plus the steady bickering among the school's faculty caused him to resign and early in 1884 sailed once again for India. This time he stayed for almost four years and amassed enough money for a studio of his own.

Misinformation runs rife in many art dictionaries. For instance there is listed a Mrs. May A. Claus, a painter born in Berlin, N.Y. in 1882. It further states that she studied with W.A.J. Claus at the Museum School. Her studio address is the same as Claus's, 410 Boylston Street,Boston. It is possible of course, ignoring the dates, that she studied with the artist and waited for his return to Boston, and then married him, also sharing the same studio. She was a miniature painter exhibiting at the Pennsylvania Academy of Fine Arts in 1922. W.A.J. Claus exhibited at the Boston Art Club several times. A retired lady told us that her husband took an interest in Claus and promoted him among his friends. Their walls were covered with Claus paintings and were much admired. She never mentioned a Mrs. Claus. She further said that he had a summer studio in Attleboro and had a number of students.

The known paintings of Claus are few but they are now beginning to crop up in auctions and art galleries. His best known work is entitled "The Old Pioneer," and was purchased by the Boston Art Club, present location unknown. He was selected to paint the portrait of Massachusetts Governor Greenhalge, which is hanging in the Boston State House. The portraits that he did of the Bostonians, Carl Faelten, Dr. Eben Tourjee, and Dr. Stowell are in private homes. His interiors were done in the Boston Museum of Fine Arts during its early days on Huntington Avenue. One depicted the grand staircase and the others were of the English rooms that were later broken up and changed. He also spent some time on Nantucket Island painting beach scenes, wharves, and warehouses. These oils were mostly 7 x 9s on board.

A particular favorite is entitled "A Belgian Milkmaid," 36 x 24, very much in the Vermeer influence. The milkmaid's costume is complete with wooden clogs and the expression on her face is seriously pensive. She is just coming off a wooden bridge and the backgrounds are darkly subdued leaving the figure predominant. A very pleasing picture and indicative of much talent. Many other fine Boston artists have had temporary wealthy patrons yet have wound up in poor circumstances and forced to desert the city. It was the same with Claus. He faded from the Boston scene in the 1920s and local records do not indicate any further aspects of his career. He certainly was a capable and talented artist and the end result was satisfying and artistic works.

Most of the following are not mentioned in any art research libraries or standard art books. However, they were all working artists maintaining studios in Boston around 1884. They must have prospered for a time and are mentioned favorably in art periodicals and the news art media. Their pictures would be an interesting find if for no other reason that they were professional artists with high hopes in the frigid brahmin atmosphere of the time.

# Sarah D. White

A critic spoke of her in this fashion, "[Miss Sarah White] is a lady artist of some distinction. She has a home in Middleboro and Boston. She just believes in Boston, which is assurance of the highest taste. She paints in oil, and has many orders for crayon work. She does fine crayon work. Not long since, she paid a visit to Southern California. That was a good thing, but it was a better thing to come back to Boston, where she is known and appreciated." Between 1887 and 1891, Sara White's studio, in Boston, was located at 12 West Street.

# E.W. Parkhurst

We have seen mention of Parkhurst in Boston Exhibitions. The only reference found beyond this was a laudatory mention in an oration at the art coterie founded by Titcombe. "He is a man who paints many pictures at moderate prices and gives as much art for the money, as any man I know. He has been in Europe, and travelled much in America. He is honest and true, easy and kind. He is so good that he will not chide me, even for this self portrait. He is a Second Advent Christian, and

doesn't care who knows it. He is teetotal and anti-tobacco. He is smart and industrious. It is pleasant to meet him here, and it would add largely to the promise of the sweet by and by, to know that I should have for a near neighbor Mr. E.W. Parkhurst. Perhaps we might go sketching together."

# Edwin T. Billings

There is some notice at least of this artist and his works may be seen in some public buildings. He was a portrait painter and his subjects were the most prominent men of his day. Most are forgotten but the pictures remain and the artist's signature is recognized and remembered. Billings was born in Greater Boston, studied in Boston, exhibited there but later on, moved to Worcester. He was born in 1824 and died during 1893. One of his subjects was Governor Andrew, the Massachusetts Civil War Governor. When he enquired if the picture was satisfactory, the governor replied, "Too confoundedly like me." He also painted Abraham Lincoln, Garrison, Senator Sumner, Webster, Col. Ward, the orator Phillips, and many other prominent men of the day such as John B. Moor, M.P. Wilder, Gough, Parker, Pillsbury, and S. G. Poster. When George Fuller died unexpectedly late in 1884 many of his fellow artists paid their respects and genuine admiration for him by painting his portrait. Both Billings and Ennekings's works were draped in black and exhibited in the Art Club and public buildings. Today they may be found in the Museum of Fine Arts (by request only).

Painting squirming boys brought in by adoring parents

have always been a problem. Billings squelched the moving model by occasionally and firmly sitting on him.

Many of his paintings are also owned by the Worcester Art Museum and a few are on permanent display at that city's Mechanic's Hall.

# Albert Borris

This artist is very much unknown today. He has entries in several art club exhibits and that is about all. Viewing several of his pictures gives one the impression that he was some European artist painting with the black shadows of the Munich School. However, he had an uncommon ability too manipulate paint with a sort of dash of occasional brilliance. Albert and Ottilie Borris came from East Prussia and settled for a while in Washington, D.C.. Eventually they opened a studio and picture gallery in the South End of Boston. Albert's entry in the Charitable Mechanic's Association Fair exhibition of 1884 was entitled "Polish Grain Boat," and the price asked was $200. A critic of the day was impressed with the Borris's picture gallery with its scenes of Washington, Boston, and of Germany. However, he was also impressed with their menagerie of canaries, rabbits, doves, cats, and several monkeys. "Dandie," the black monkey with the white face drew the admiration of all the neighborhood children. Around 1891 the Borris's listed their address in that part of Boston, now known as West Roxbury, as Wren Street near Oriole Street.

# Cyrus and Darius Cobb

These artists were twin brothers and probably the most successful brother team in all art history. They studied together and worked together for over 20 years until Cyrus devoted himself to his chief profession as a lawyer. Practically every Bostonian has knowingly or probably unknowingly viewed some of their combined works in sculpture as well as painting. The large Soldiers' Memorial Monument on the Cambridge Common was designed and executed by them. It was unveiled in 1869 and the city paid them the then handsome sum of $25,000. A few of their portraits are in the Boston Custom House and many other public places.

Cyrus and Darius were born in Malden, Massachusetts during 1834 in the same room that saw the birth of another prominent Malden citizen, Adoniram Judson. (What names to conjure with.) After they had determined on an artistic career they refused all opportunities offered them to go to Europe for instruction in art. Nature was their main master but for a time they studied together in several Boston art schools. They had the same studio in the Tremont Street Studio Building and painted many pictures from the rooftop. Once again portraiture became an artist's means of livelihood. While studying law, Cyrus painted the very prominent Bostonians, the Reverend A.P. Peabody and Dr. J. Appleton. Darius busied himself by painting the port of Boston, custom collector Simmons now in the Custom House. His portrait of Rufus Choate was purchased by the Suffolk Bar in 1877. Showing his adaptability to many arts he carved a bust of B. P. Shillaber from a solid block of Marble which has been standing for many years in the Chelsea High

School. The portraits of Governor Andrew and Professor Agassiz are both owned by Harvard College. There is quite a charming picture of four children of George Walker who built the Walker building on Boylston Street. The brothers were not only artistic but musical, literary, and witty. You could consult them on any subject and it seems they could throw daylight on anything that might be nebulous to you. Darius wanted to send to an austere Boston Exhibit a picture of some Boston Women's Rescue league members stopping lady bicycle riders because it was considered immoral for women to ride bicycles!

Artists were again represented when the brothers sang in the great chorus at the Boston Peace Jubilee. The great coliseum built for that purpose swayed to the "Blue Danube Waltz" led by the composer. The chorus sang "Danube so Blue," and sent many Bostonians in search of that river whose waters were always practically black. The Boston ladies begged for a lock of Herr Strauss' hair which he graciously handed out. That magnificent head of flowing black hair never diminished but his sheep dog was almost denuded.

Darius sent portraits of Cyrus and Sylvanus Cobb, Jr. to the Centennial Exhibition at Philadelphia in 1876. A jury judge met them after inspecting the paintings and came away a bit bewildered. He remarked, "They are very talented men. I do not know them apart and cannot consider them apart."

Darius was more prolific but then Cyrus was applying himself to his law practice and he naturally made quite a reputable lawyer. He could defend you and then calmly paint your portrait.

Among the most important figure pieces that have the signature of Darius, (or at least they were so considered in his day,) were his "King Lear," and "Judas in the Potter's Field." In 1878 he added a "Christ Before Pilate," and the three pictures were exhibited widely in and about Boston. His interest in landscapes never waned and all of Boston were his subjects. He found beauty in "The Back Bay Lands," an oil done long before the Back Bay ceased to be a swamp. Then he found time to

lecture on art and many times before young people's groups as well as the ivy covered halls of Harvard. Even those austere walls lost some of their dignity when he refused to allow the windows to be closed to shut out the din of the chattering birds in the ivy. The students could see his mouth move and his arms wave but never heard a word.

He freely gave advice to prospective artists along these lines. "You can never succeed in an attempt to uplift or educate the public to a standard above them by offering them that for which they have not asked. It is not the details that make a picture great but unity is there when given a few simple truths."

The critic Aldine wrote after a visit to his studio:

> Darius Cobb has lately finished a view across the common from the roof of his Studio Building, that is so much a novelty in the way of treatment, as well as subject suggested, that it deserves longer mention than is at present possible. The strength of the picture is the sky; a mass of clouds reaching across the canopy, white with noonday light massed upon it throwing much of the middle distance, such as the tops of the trees, into comparative shadow, and lending to several church spires and prominent buildings something of its own clearness and vigor.

Those words were written in 1876. Do we look at paintings in that manner nowadays?

The Boston Transcript reported on June 24, 1876, after an Athenaeum exhibit, "Darius Cobb has given us a picture that will go down as the standard one of Choate... a picture which is not only an outward semblance of the man, but one which seems permeated with his very spirit. It is full of that shaggy strength which impressed itself on every beholder, and which those who remember his forensic eloquence will appreciate and acknowledge."

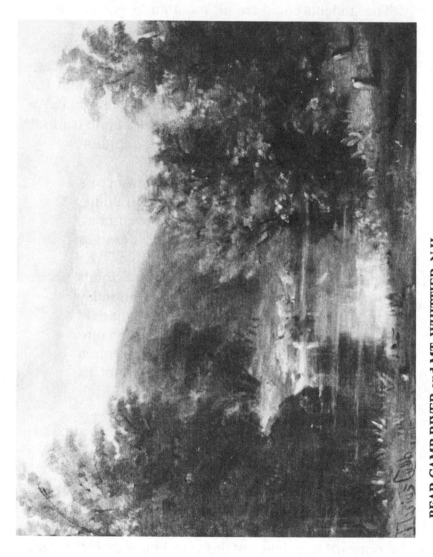

**BEAR CAMP RIVER and MT. WHITTIER, N.H.**
*By DARIUS COBB - Oil on Canvas, 14"x18"*
(Private collector)

The attorney Cyrus died in 1903, respected in both legal and art circles. Darius worked for another 14 years and after a long and distinguished career died in 1919 at the very end of the world war. A few strong personalities that were so well thought of in their own years. Surely the Cobb Brothers were representative. Today they are forgotten and neglected by the perpetual critical sophomores of art.

# John White Allen Scott

Here is a landscapist who brings high prices today. The gallery people seek to keep it that way and not too many of his fine White Mountain scenes are easily sold. It was not always that way and in his time he struggled with but one purpose in his mind, he was anxious to leave behind him works true to nature.

1815 was the birthdate of John Scott and the place was Roxbury, Mass. The early date is the reasons for the present day high prices. He was mostly self taught and he had a great love for mountains scenery. He painted in all the White Mountains and the Catskills. Beyond that he was a pioneer in climbing up those peaks long before trails existed.

When Benjamin Champney was 17 he was admitted as an apprentice to the Pendelton Lithographic Company. There he was in the company of Nathaniel Currier, Fitz Hugh Lane, William Rimmer, and John Scott. A Mr. Moore had succeeded Pendelton in the business and had he known what fine artists those young men would turn out to be, it might have lessened his contempt for the new generation. Champney and Scott's paths

were to cross many times and it is curious that their love for the White Mountains began at the same time.

Champney departed for Europe to study and soon Scott and Lane went out on their own to publish lithographs. The artist Samuel Gerry in partnership with Mr. Burt had a place where they painted signs on Cornhill at the foot of Washington Street. Some of the young artists began practicing painting there. Scott experimented in his leisure moments with oil colors, grinding the pigments and doing little landscapes and also drawing from casts. Several of the young men had a hand in painting the sign for the Cornhill shop. It showed a bold Scotch Highlander with a slain deer in front. At that time there were few artists in Boston; Fisher and Doughty were doing landscapes; Salmon, marines; (his many views of fleets of ships in Boston Harbor all seemed to be the same ship from different sides;) Harding was the principal portrait painter; Willard and Ames were just beginning and George Fuller came a little later. Scott ventured to exhibit at the Boston Athenaeum in 1842 and continued to exhibit his works until 1905. By that time he too had practically outlived all his fellow Boston Art Club members. He painted the usual New England Marines, flowers, shore lines, and still lifes. He married and had one son, Charles, and was now firmly ensconced as a professional artist with a studio in the old Tremont Temple building along with Pope, Hanley, F. H. Lane, Ames and the portrait painter Mason.

Shortly after 1851 he took his family to North Conway for a painting vacation. Scott as a young man had climbed many of the New Hampshire and New York mountains but knew the artists had discovered the region and came in small contingents from Boston, New York, and Connecticut. Ordinarily there was hardly a guest in town during August but now the American Barbizon began to be covered with umbrellas with an easel underneath and an artist busily sketching or painting the wider stretches of the intervales and the solid forms of the ledges rising up beyond. Behind it all was a line of granite peaks all forming a scene of surpassing beauty. The White Mountain School had

been created and would leave a continuing mark on American art history.

The images that the artists painted were in subdued tones, quite dark in spots and at first emphasized the rugged terrain. Gradually they sought out the peaceful and pastoral landscapes. Scott was no different. It is difficult to separate his works from the others but they all had their individual characteristics. His outstanding feature were the trees. The critics of the time found his trees, country roads, and waterfalls, "very pleasing work from an honest artists."

The danger and adventure of the jagged peaks and deep valleys were marred one summer when his son, Charlie, died suddenly in North Conway. The saddened Scott however never lost his love for the picturesque aspects and wild beauty of the White Hills. He painted gentlemen and ladies going up the mountains on sleek horses surrounded by clouds and a vast wilderness.

The Scott home was in Cambridgeport, Mass. He retired from a studio in Boston to a vine covered small studio in his home. That room saw much work and many visitors. The house was on a corner and behind a high hedge where he raised flowers, painted them, raised fruit, painted them, then ate them. He died there in 1907.

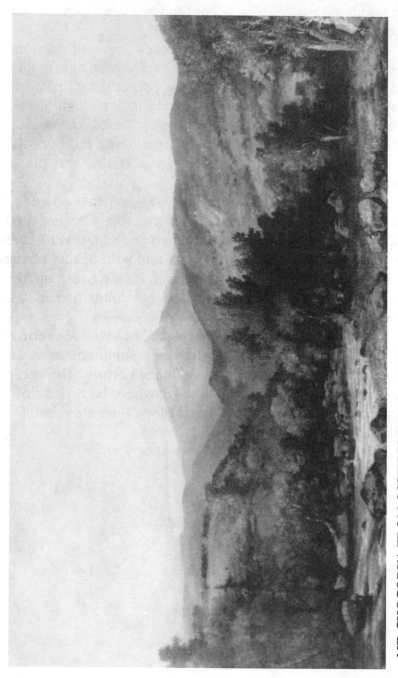

MT. CHOCORUA FROM OSSIPPEE RIVER, N.H.
*By JOHN W. A. SCOTT - Oil on Canvas, 22"X36"*
(Courtesy of Robert W. Skinner, Inc., Bolton, Ma.)

# Chapter Eleven

## WILLIAM PRESTON PHELPS

The traveler of not too long ago, bound for Keene, N.H., would head out of Peterborough on the Dublin Road. After passing through that hill town and around Dublin Lake he might notice an inviting side road that promised a view of old farmlands and typical New England landscapes. Before long he would come to a strange looking structure and pause to wonder about it. Near a small gray farmhouse was a large building with a high enormous window divided into ten equal panes. The window faced directly north. Later the traveler would find out that the curious chapel like edifice had been the art studio of William Preston Phelps. Looking southward he could see that gray summit of granite known as Mount Monadnock and all the rocky pastures and hills leading to it. It would be all too natural, with that splendid view, for any artist to fall in love with such a massive mountain.

The artist was born in that part of Dublin, New Hampshire, later known as Chesham, on March 6, 1848. He was the eldest son of Jason and Mary Webster Knowlton Phelps. The Phelps farm and homestead was established in the year 1756, and had been continuously worked by the same family. The

small gray house that sheltered him was home to his father, and his father's father, and a long line of hard working farmer ancestors. Like all country boys, he was brought up with a thorough knowledge of farm work and an early love of domestic animals. He exhibited a decided talent for drawing and filled the blank pages of his school books with views of the homestead, the pastures, and the broad sweep of the hills, always showing Monadnock dominating the distant horizon.

When William was fourteen years old, the elder Phelps, after watching his son's artistic efforts and listening to his aspirations, considerately sent him to Lowell, Massachusetts, to work for a well known sign painter. After all, that large city was only fifty miles away and the boy could come home when he had his fill of the city's stuffy atmosphere and noisy crowds. However young Phelps quickly learned not only sign painting but decorative striping and scrolling as well. By the time he was twenty-one he was carrying on a successful business by himself. He took the train to Boston several times a week to attend the free, evening drawing classes of the Lowell Institute. Soon he began to dabble in landscapes giving more and more time to it as his technical knowledge increased. The paintings were placed in the sign shop and before long they were being sold. One Lowell business man was so impressed by the young artist's efforts, he invited him to supper along with some of his work. The supper turned out to be a gathering of prominent persons interested in Lowell's civic and artistic climate. They saw in Phelps'work great promise for the future, Cautious deliberations followed and in a few weeks they urged him to drop his commercial business and enter the field of legitimate art. They offered to back him financially and one of the backers, a German, with an artistic heritage, suggested the Royal Academy in Munich, where other Americans had attended that famous Bavarian art school. Phelps had been married for only a short time and was loathe to leave America, but his wife and friends urged him to pursue his studies under such auspicious surroundings abroad. His bride was one of the daughters of a prominent Lowell family, Anna

Maria Kittredge. In 1875 he settled his affairs and journeyed to Germany.

The academy was a strict school and the drawing course encompassed every thing from blocks to the figure. Technique was stressed as foremost in the painting classes under Velten. The results were lacking in color harmonies but he learned the importance of detail and slow controlled finishes. There were a number of other American students some of whom were new-comers like himself. One became a life long friend. He was of Scotch ancestry by the name of Walter Shirlaw.

The foreign art students could not help being affected by the war of 1870 between the Germanic states and France. Munich was fiercely Prussian and still celebrating their spectacular victory over the French. The kingdom of Prussia had become the dominating state in a powerful empire and the American students were constantly caught up in this patriotic flurry. It was difficult to concentrate and put in the necessary hours of tedious practice. The art masters, Velten, Meisner, and Barth, would not tolerate any laxness. However Velten loved to paint hunting scenes in the Royal Forest and generally brought his students along on those painting excursions. Those painting excursions were very congenial and merry.

Munich, at that time, was an important art center and a great cultural city. Its art loving kings had built it up as a modern Athens. The number of art students in the 1870's was larger, in proportion to the whole population, than in any other art center in Europe. Phelps studied the works of the many Munich masters and sought out Carl Piloty for some lessons in the figure. However, at the end of his first year he became unbearably lonely and returned to Lowell much to the surprise and dismay of his backers. He assured them of his progress and had only come back for his wife. This time she returned with him and made a home for him in Munich. She accompanied him on painting trips along the Rhine and Dussel rivers where he painted many scenes of the hills and farmlands. The surrounding countryside was of great beauty and many of these paintings

were subsequently brought back and exhibited in Boston and Lowell.

Soon Phelps felt that he was ready to sell some paintings in order to return some money to his backers. He found an outlet in the Kunstverin, an association of Munich artists. They had a gallery and weekly sales for their members. A system of circulating the paintings around neighboring cities had been instituted and whatever works had not been sold were raffled off at years end. This income enabled Phelps to open a small studio and some of his pictures were accepted for viewing at the international exhibition in the Glass Palace. During the following summers, the couple traveled throughout Europe sometimes in the company of his friend Shirlaw. They visited France, Belgium, Italy, and of course, Venice, the Mecca to all artists.

When the courses at Munich were finished Phelps and his wife went to Paris. They maintained their Munich address and returned there, after a few months studying landscapes with Pelouse and Antoine Guillemette. Phelps sent several works to the New York National Academy of Design for their 1878 Exhibition. Four were accepted and sold not only to their delight but to that of their backers in Lowell. For the first time Lowell had a European trained artist who would live in Lowell, or so they hoped. Lowell's other artist, James Whistler, had deserted the city to become one of England's greatest. However, civic pride always claimed him as a Lowell man who now belonged to the world.

Before returning home the Phelps spent some time in Scotland. The artist painted in the highlands and many cattle pictures resulted. There is a painting of a large and wild looking bull hanging in the best room of a Peterborough, N.H. farmer that we have seen which the owner firmly stated will hang there forever.

The National Academy entries consisted of two still lifes and two landscapes. One was entitled "A Valley View." The other was of a good size, a predominantly brownish fall scene, with forest and mountains, entitled "Mountain in Germany." It

was sold for five hundred dollars, an excellent price and very encouraging for the artist. It enabled him to travel and paint for most of 1879.

He was preparing to return home early in 1880 and submitted paintings to the National Academy once again. Two pictures were accepted, another mountainside which the academy titled,"Autumn," sold for $125., but it was the large, popular subject of the day, "The Soil Tillers," that brought the almost unheard of price of $1000. The elated Phelps returned to Lowell to find that the Lowell Art Association with a sense of pride, had also purchased two of his National Academy pictures, "Evening," and "Morning." He opened a studio in the Post Office Building in Lowell and kept it for many years. The only journeys he made now were to Boston for exhibition purposes and to attend some of the Boston Art Club meetings.

Phelps had brought back a large number of German and European works that had taken him years to execute. He also had exchanged some of his pictures with his fellow artists and now put them up for sale, along with his own, in Lowell. Some were sold but art is always controlled by the ever present state of the economy. The mills of Lowell were in constant trouble with unhappy workers ever striving for better conditions and a decent wage for their long hours of toil, and toil it was. Phelps had to supplement his portrait and landscape painting income with his old trade of sign painting. Early in the 1880s he attempted a large exhibition in Boston. The Williams and Everett Art Store with its nine gallery rooms were always on the alert for new and capable artists. They accepted Phelps' entire collection from Munich, supplemented by his fellow artists' traded works, and set up a large two day auction. The pictures were to be sold without frames. The art store, of course, was to get the framing jobs. Interestingly the artists turned down some low bids and retained their pictures for another day. Phelps considered the sale moderately successful.

A glance at the catalogue listings may suggest that Phelps painted some of his New Hampshire scenes while in Europe,

perhaps from some indelible memory. The records do show that many of the European scenes by various artists were purchased by The Parker House Hotel where they are still hanging, and the old Boston Theatre, some hanging in the foyer and rooms of that old elaborate showplace. Looking through the Charitable Mechanics Association catalogue, one will notice the brahmin Bostonians' fondness for European works, however murky.

The Phelps family now lived in the Centralville section of Lowell and the artist walked each morning to his painting studio near Merrimack Square. Many farmers came to sit for portraits and family groups. They returned home with cattle pictures that Phelps carefully placed all around his studio. He was well acquainted with and shared their pride in farm animals. He visited the old farm during week ends and painted many cattle scenes, goats and sheep in pastures, and animal heads of all sorts. That branch of the business was very successful.

One of his large and important European paintings was entitled "The Tillers of the Soil." This work hung for a long time in the main gallery of the Museum of Fine Arts in Boston. After a year on loan, the picture was returned and placed in his studio. Several summers were devoted to the painting of shore views along the New England coast from Pigeon Cove, Rockport, to York, Maine, and the island of Grand Manan, New Brunswick, Canada. Another season was pleasantly occupied painting in Arizona, New Mexico, and California. His large painting, "The Grand Canyon of Colorado," was extensively exhibited.

Teaching was another lucrative facet of the business. Of all the many Phelps' pupils the young John J. Coggeshall equalled his mentor in enthusiasm and artistic zeal. He became a lifelong friend and companion on all sorts of painting forays out of the city of spindles - as Lowell was then known. He later wrote, in essays published by the Lowell Sun:

> Mr. Phelps had a splendid education and the friendship of men already famous. His social qualities had made him a multitude of acquain-

tances and the studio soon became a favorite meeting place for men of artistic and literary proclivities who not only found their host a good listener but a fine narrator as well. His anecdotes of famous artists whom he met abroad,his descriptions of life among the art students of Munich and Paris, and the stories of his tramps through various portions of Europe were intensely entertaining and always found eager listeners. That social trait never interfered with what he was doing. He was a tireless worker, and could talk and paint at the same time. These congenial souls would discuss not only the local art scene but would bring up all the bickerings of Boston and New York. David Neal, an established Lowell artist, the newspaper art critic Phil Marden, and occasionally [his old friend] Walter Shirlaw, the able illustrator and portrait painter from New York were among the participants. There are those that considered the eighties as the golden age of Lowell Art and I was proud to be the pupil of such a man. Mr. Phelps was tall, of commanding, well nigh imperious presence, and always a conspicuous figure in the community. He was ever free from the bitter criticism of the works of others and always ready with honest advice and patient help. To his own work he gave the sincerity and perception of a wide cosmopolitan experience. He spoke many times of the value of learning from others and cited as an example, learning many things from his fellow students, William Chase and Frank Duveneck, while in Europe.

Phelps' parents died within a short time of each other and the artist inherited the family farm at Chesham. He determined that the farm work should go on even if he could only

supervise it during short visits. "Up to that time," to quote from an 1897 essay in the New England Magazine, by Charles E. Hurd, "Phelps had painted steadily and with artistic zeal, but he had not found that for which he had been searching from the beginning." and further quoting:

> He had gone on painting all sorts of subjects, German, French, Venetian, and American skillfully enough, to be sure, and winning commendation from the critics. But the one thing into which he could put his whole soul had not yet revealed itself. Nor could he tell what it should be. It came at last like a revelation. He was standing one afternoon on the little porch of the Chesham home and looking southward. He saw what he had seen with his outer eyes a thousand times before, but he had never seen it as now. Mount Monadnock hovered over the wooded ridge and across the valley and long green slope. The great mountain with its grey summit of granite shouldered against the sky. The sunlight lay warm upon its side and cloud shadows floated lazily by. The lower slope was beginning to be touched by the frosts of early autumn and was a mass of variegated color. This was it at last. It had come. the commonest things now took on new meanings. The artist had now found and recognized his life work. Then began his real success. Here were the things he had known from boyhood which had grown in his soul and had lain dormant for years. From that moment he worked under the influence of a new inspiration. He studied the mountain with the eye of a lover. In sunshine and shadow, in storm and calm, in all seasons, and under all conditions, he watched, noted, and painted. It was not the mountain alone by which

he was inspired but the forests, the great mountain with its grey summit of granite shouldered against the sky. The sunlight lay warm upon its side and cloud shadows floated lazily by. The lower slope was beginning to be touched by the forests of early autumn and was a mass of variegated color. This was it at last. It had come. The commonest things now took on new meanings. The artist had now found and recognized his life work. Then began his real success. Here were the things he had known from boyhood which had grown in his soul and had lain dormant for years. From that moment he worked under the influence of a new inspiration. He studied the mountain with the eye of a lover. In sunshine and shadow, in storm and calm, in all seasons, and under all conditions, he watched, noted, and painted. It was not the mountain alone by which he was inspired but the forests,fields, the brooks, taking equal delight in all of them.

The Phelps' homestead occupies a pleasant position on a hill on the main road to Dublin. It overlooks the valley in which lies the little village of Chesham. It is more than a century old typical farmhouse, built for all time, and for the comfort of its occupants. Nearby, the artist built a large studio with a huge window to admit the northern light. The immense chimney built of stones quarried and gathered from the fields gives the building a peculiarly picturesque appearance and strangers driving past have, as we noted before, often mistaken it for a chapel.

The large fireplace inside takes up a good part of the room. Beside it is a great wooden settee with its seat and high back only too reminiscent of the comfortable furniture of the artist's forefathers. The long bookcases contained a vast amount of german literature and the artist's violin still hangs on a peg. Two studies for his, "Grand Canyon," and the "Tillers of the Soil," hung on either side of the stone fireplace.

147

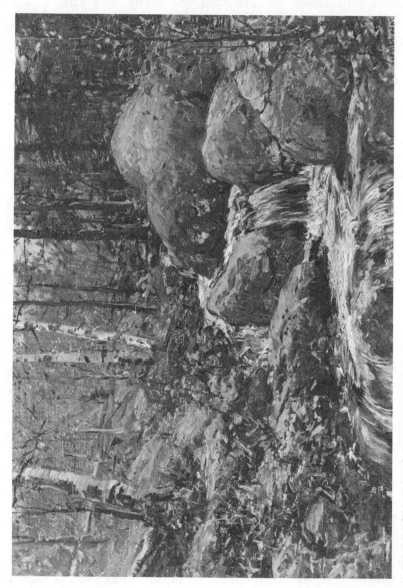

**HURRICANE BROOK, DUBLIN, N.H.**
*By WILLIAM P. PHELPS - Oil on Canvas, 14"x20"*
(Courtesy of Richard A. Bourne Co. Inc., Hyannisport, Ma.)

Phelps visited every point from which the mountain was visible. He studied all the characteristics. There is a particularly fine view from Nelson which he had put on canvas several times. He portrayed views from the villages of Troy, Jaffery, and Fitzwilliam. The views from Dublin are impressive and it is this side of the mountain that he was most delighted to paint. From here one gets the whole magnificent sweep of the mighty ridge from the ground to the summit. The lake at its foot, its borders studded with spruces, and silver birches, forms an interesting and contrasting foreground which renders the distance doubly effective. Phelps climbed daily upon the slopes many times to the little hotel that was then precariously anchored to the summit. That rounded peak rises 3500 feet above the sea. The word monadnock is a geologic term meaning a hill standing alone in a flat place. The extensive view embraces many larger and famous mountains to the north and west. No less than 30 lakes are visible with untold numbers of villages stretching toward Massachusetts and Maine.

One of the artist's favorite subjects was Monadnock Brook, a beautiful, winding forest stream with many quiet pools in the summer. When swollen by the autumn rains it becomes a turbulent and rushing torrent. The falls and miniature rapids furnished material for many a charming picture. The artist's pupil, Coggeshall, recalls that on one occasion they were painting beside the brook high up on the mountain, when a sudden downpour drove them to seek shelter in an old cellar hole. When the tempest finally subsided they returned to the brook. The easels, canvases, and other paraphernalia had been carried away by the quickly engorged torrent and no amount of searching ever turned up any part of their equipment.

It seemed natural in such an environment that an acute interest in winter scenery should manifest itself. It is a phase of nature that did not attract too many artists of that period. Phelps soon discovered what many artists considered as merely black and white work, required even a keener eye for color that spring of summer landscapes. He found the gradations and tints of

white, brown and blue to be infinite. Phelps was so fascinated with winter landscapes that he built a little portable hut which could be carried on a sled and be put together anywhere at a likely site for painting. It was warmed by a small oil stove and there were windows in the front and sides. It was said that he could sit and paint in the bitterest cold days of winter and be quite comfortable. The Lowell critic, Marden, said, "It is doubtful whether any other American artist had succeeded in rendering more perfectly the spirit of a winter landscape. " One of his genre snow pictures is called "Breaking Out the Road." It typifies the efforts of snowshovelers and oxen working together after a huge snowfall to keep the New Hampshire country roads open in spite of bitter odds. The many winter Monadnock views are considered among his best works.

Phelps reluctantly closed his Lowell studio. He could not maintain both studios although he attempted to do so for a while. He kept his Lowell ties and friends intact until his death. The family lived on Sixth Street until 1890 and in that year settled in Chesham. There were two daughters who rejoiced in the country along with their parents. We have seen a small charming portrait entitled, "Little Indian Princess." The model was probably his daughter, Ina. It is a delightful work of a winsome child looking very much as an Indian Princess should.

The Monadnock country was now beginning to attract summer artists. Pupils came to the Phelps farm and also to another artist whose studio was down the road some distance. This was the summer studio of Abbott Thayer, an artist of immense importance. He was assisted by his long time pupil, Richard Meryman and soon the shores of Dublin Lake were dotted with artists' umbrellas. Phelps, Thayer, and Meryman are sometimes referred to as "The Dublin School of Art." Thayers' "Winter Dawn on Mount Mount Monadnock," is considered to be one of the finest examples of American landscapes now hanging in the Freer Gallery of the Smithsonian Institution in Washington, D.C. However, it is William Preston Phelps that is still called "The Painter of Monadnock."

MONADNOCK TRAIL
*By WILLIAM P. PHELPS - Oil on Canvas, 14"x22"*
(Private collector)

Coggeshall describes his work with Phelps as a great privilege. They spent days on the mountain, tramped through ever rising pastures and observed the browsing cattle. They were out in winter dawns and Coggeshall has memories of trailing after slow moving oxen clearing a path through deep snow, and in the spring, the thin smoke of a sugar camp rising in the forest silence. Phelps was scornful of the indolent methods of the indoor painter. He would take his larger canvases to the open, build shelters above them and work for days without removing them, rain or shine. He worked unremittingly until they fairly breathed of the wild scenes about them. The pupil felt that the trees were made to exist individually and nowhere else in the world is there a tree just like the one growing there. The autumn sunlight or the spring blossoms merely enhance them but their unique character is evident even in the rugged winter. This then was the Phelps method of creating art for 27 crowded years.

The 1897 New England Magazine article previously cited comments that; "Mr. Phelps has decided ideas about art, and it may be said that they agree with those of the best painters. He has little patience with fads which now and then seem to run like an epidemic through the ranks of the profession. Art with him is a serious thing and any attempt to debase it is like laying hands on the Ark.", and as further noted by Mr. Hurd in this article, Phelps emphatically stated:

> There is a deal of humbug in much of the talk about art which you hear in the studios and galleries. You are forever hearing about handling and technique... And then you hear people insist that a picture must be an exact reproduction of nature a sort of colored photograph. That may be one kind of art, but it isn't the kind the honest and earnest painter believes in and strives to master. ... Besides the mere detail ... there is a sentiment, a feeling which pervades the whole - you may call it the poetry of nature if you like - something

which you cannot see, which is not material and yet is as much a part of the landscape as the trees and grass themselves. If you don't get that, your picture is nothing but a colored map. But the man who can reproduce that feeling canvas, who can make the one who sees the picture feel as he felt, that man is an artist, and his work is a work of art.

And Hurd continued; "He could not have put more tersely and accurately the one great article of faith to which all genuine workers in the field of art must subscribe. It is the lamp by which his hand has been guided in the past, whose light, steadily followed, has given him a sure place among American artists."

Early in 1917, shortly before his seventieth birthdate, the artist still at his easel, suffered a stroke. He was physically broken and unable to paint. The Phelps homestead continuously occupied since before the revolution had to be closed. He was taken to a hospital in Concord, N.H. and eventually was able to live with his sister, Sarah, in that city.

There was a sad sale of his paintings in August of 1917 at the studio. The collection was scattered among a hundred or more homes. Even the furniture and personal effects were sold by order of the Probate Court of New Hampshire. A lifetime of work was suddenly gone even as the strong winds sweeping down from Monadnock's heights mercilessly strip the leaves from the trees.

Phelps died in Concord on January 6, 1923, aged 74 years and 10 months. The funeral was held in Lowell, as he had wished and during the season's heaviest snowstorm, as he probably would have wished. It was attended only by family and a few friends who struggled through deep drifts to pay their last respects. He was buried beside his wife in the Edson Cemetery.

Coggeshall, who was a pallbearer, wrote in his essay, *The Painter of Monadnock*,

Yonder basks Monadnock, violet hued against a cobalt blue sky, today, tomorrow, and forever, serene, remote, and unchanging; like some proud mistress who waits a new Lover. But the boy who dreamed, the man who loved and wrought so well has passed the cloud wrapt height into a cheerless valley. His brush will no more give us his vision of the Hills. Other men will paint the mountains but the privilege of possessing a work from the hand of William Preston Phelps becomes trebly precious as Finis is written across the career of the Great Lover of Monadnock.

# Chapter Twelve

## LOUIS K. HARLOW

Louis Kinney Harlow was born in Wareham, Massachusetts on March 28, 1850. He studied, at the age of 12, with an old English artist. A deer's head drawn by the youthful artist on the blackboard received many compliments from his school mates and teachers. He went to Phillips Academy but soon found himself more suited for pencil drawing than the pursuit of his studies at the Academy. In 1880 he opened an art studio in the old Studio Building in Boston. He experienced the hard times common to all struggling young artists.

During 1882 he received an invitation from a group of 30 or more student artists, from Detroit, asking him to teach them. This group was later responsible for the development of a museum of fine arts. Harlow turned out to be a capable teacher and his ability to instruct pupils in the rudimentary principals of art gave him employment in many western cities.

He returned to Boston after some years of teaching and an exhibition of his collected works was held at the galleries of Walter Kimball. The show was so successful that he was able to go to Europe. Travel, hard work, and intelligent observation in England, Holland, France, and Italy, broadened and deepened his talent. The critic, Frank Robinson said later of his works:

The Dutch pictures, especially the watercolors, were studied and influenced his manner and style, which in turn gave him the ideas he has eminently improved upon. Few indeed are the artists who can as readily transcribe a thought or scene on the paper as Harlow and rapidity of manipulation of color in the wash is interesting to watch. This born grace of his, the handling of color, is of special advantage in the use of watercolors, enabling him to fix an effect from nature which the more solid pigments are almost incapable of being made to do.

Harlow, before settling into his life work, married a school sweetheart who had been patiently waiting while he sought to rid himself of a certain wanderlust. Her name was Julia Coombs and their first child was born in 1877. He found lucrative employment illustrating books published by the C. Klackner Company and the old Boston firm of Samuel E. Cassino.

The numerous books illustrated were to be found in most New England homes and were made especially for the holiday trade. Books have always been popular gift items at Christmas time and other special occasions and it was no different in the 180s. Harlow's pictures were to be found in Longfellow's works, New England Travel Books, the popular poet's series, many Shakespearean editions, and his "Floral Tributes," in many bibles.

Messrs. Prang and Company, whose colorful art reproductions graced many a home throughout the nation, employed a staff of artists and here Harlow worked for many years. He painted a special services of watercolors. Among them, now collectors' items, were the famous Evangeline Series, scenes of Shakespeare country, a California Mission Series, and naturally a New England Series depicting all its beauty in all seasons. Some of the titles are self explanatory; "Sketches in Dutchland,"

"Echoes in Aguarelle," "American Poet's Homes," "Snow Bound," "Green Pastures," and an etching of note, "Daybreak."

The Harlow studio at 6 Beacon Street became a resort for Artists, critics, amateurs, and connoisseurs. Many an aspiring artist climbed those crooked stairs to his studio and he always patiently assisted the beginners and illustrated his points with a deft pencil. He enjoyed working in front of such a mixed company, keeping up an animated conversation on almost any theme, and at the same time handling a large etching plate, designing and painting it in color.

The opportunities to exhibit were frequent and one of his favorite annual shows was the Jordan Art Gallery located in the Jordan Marsh Company dry goods store that began in 1893. His seascapes sold particularly well and the reason may have been the Cape Cod scenes which were, after all, his native turf and could never be mistaken for anything but the genuine article.

There was no end to the variety of subjects. The artist in Harlow brought forth flowers, figures, landscapes, architectural works, wood interiors, themes from the poets, and whatever he saw on his daily walks in Boston.

The artist died in Waban, Massachusetts, on April 30, 1913 leaving behind a wealth of art, many friends, and three children all of whom lived to a ripe old age and had inherited a talent for art.

Most present day dictionaries of American artists have little to say about this fine artist. They simply say "Watercolor artist and etcher. Active in Boston in the 1880s. No birth or death dates."

# Chapter Thirteen

## JAMES HARVEY YOUNG

The future portraitist was born in Salem, Massachusetts on June 14, 1830. When he was 12 years old the family moved to Boston and at the early age of 14 he began working as an assistant to John Pope in his studio in the old Tremont Temple. He had the temerity of youth to put out his own shingle as an artist four years later in 1848. Commissions being very scarce he traveled about painting portraits in a very primitive manner. Realizing his shortcomings he entered the office of some well known architects and acquired a considerable and useful knowledge in the use of the pencil. The only time he was away from pursuing a career in art was when his father needed him to help in the management of a resort hotel in New Hampshire. This was a short period however, and upon his return from the country he established himself in a studio over Leonard's Auction Rooms on Tremont Street, Boston.

Young began by executing portraits in oil for five dollars each. The price was low enough but the patronage was too small for him to make even a meager living. Unwittingly he had joined the majority of artists who were in the grip of similar circumstances. He resolved to give up art but John Pope talked him

into taking over his studio. He too had enough of Boston and its penny pinching brahmins and was going to New York City to try his luck. Young's first commission amounted to eighty dollars and he was on his way. His reputation was made when he painted a fine portrait of Major Foster of the Salem Cadets. The picture was on display in Child's picture frame store and it attracted the attention of Mr. John Duff who commissioned the artist to execute his son's portrait. Mr. Duff became an earnest advocate for Young and from that time forward he never wanted for employment in his art.

The studio at that time was in the Mercantile Library Building and there he became friendly with a neighboring studio artist, William Morris Hunt. Needless to say he learned much from that eminent man. He painted the portrait of the well known actor of the day, William Warren. That was in 1867 and even today it retains a full rich tone, and shows the geniality and true characteristics of the man in every respect. Young's principles in art have ever been the poetry of subject and color. He also felt a sympathy for his subject when he painted the portrait of that lovable old gentleman, Dr. Peabody, which now hangs in the Exeter Academy. Among his many other portraits that drew much praise were those of Horace Mann, Edward Everett, William H. Prescott, Erastus Hopkins, and Massachusetts Governor Claflin's father. One can readily see the artist's force and power of portrayal in all these pictures. These are works of art that will stand among the best ever painted in Boston.

By the time the 1880s rolled around Young had painted for forty four years and his works were numbered by the hundreds. For relaxation he liked to paint interiors, dwelling upon the artistic arrangement of draperies. It is impossible to say much about his landscapes. They are so few and far between, but he did remark, according to J.B. Wiggin, "that landscape was just about the highest form of art."

He was well known and respected in his lifetime. Today he is a rarity but his life story may well be considered as a prime example of what talent, much application, and a minimum of teaching can accomplish.

As an older artist, Young was always kindly disposed to help beginning artists, always remembering his own privations. He had suffered much, losing all his works in the Great Boston Fire of 1872. Hunt's works had suffered the same fate and it affected his health. Young, however, did not mourn though he sincerely regretted the catastrophe. Soon after this he set up his easel at 12 West Street where the younger artists found him amiable and helpful.

Daniel Santry, Jacob Wagner, and William Paskell were among his informal pupils. Young had watched Paskell sketching in between his chores at the shop where Paskell's father gilded and framed. Young taught the boy his way of drawing which he had in turn learned while working in the architectural office many years before. Paskell was very grateful and in his day to day journal entries often refers to "Mr." Young. This was a mark of esteem. He called most of the other artists by their surnames in his journal entries, having been so familiar with them from the age of eight.

He did not exhibit frequently, studiously avoiding publicity. He did exhibit one picture at the Mechanic's Association show in 1884 at the urging of the subject and owner of the portrait, Mrs. Oliver Ditson, and on occasion, at the Paint and Clay Club. He was also a vice president of the Boston Art Club where he was not only an esteemed member but one of the founders.

James Harvey Young died in 1918 and his obituaries were prominent in the papers despite all the war news headlines. He was a great artist but mostly forgotten today. His portraits, wherever they hang today, are the sole remnants of, and testimonial to, his art.

In the book, *Some American Primitives*, by Clara Endicott Sears, the author tells how J. Harvey Young at the age of 18 was a New England itinerant portrait painter traveling about and painting in a very primitive manner. One of these primitives is in the collection of the Fruitlands Museum, Harvard, Mass. It is the picture of Charles L. Eaton and his sister. These were Boston children, the boy then about four and the sister six years

of age. The picture is large and shows quite a few of the furnishings of a typical drawing room of that period. The two children stand in the center of the picture holding hands. Both have light hair, blue eyes and fair skin. The girl wears a delicate pink dress with trimmings of white lace and white pantalettes. Around the neck and along the edge of the sleeves is fine embroidered muslin. She wears black shoes, laced, and white stockings. A pink frill falls over the shoulders edged with pink fringe. She holds a bright red book in one hand and the other clasps her brother's . There are three rows of puffings on her sleeves. The boy has a dark blue dress on, black shoes, and white stockings; the same style of frill of white muslin edges the neck and sleeves. With his free hand he holds the reins of a toy horse, which is yellowish in color on a wooden base. The carpet is an old fashioned Brussell variety with symmetrical designs and flowers scattered over it. It is warm in coloring and reddish brown. Behind the children is a grey marble table; or rather, it is a painted wooden table made to look like marble. The toy horse has a dark mane and dark hoofs.

Anyone who could paint all those details correctly in a primitive would resolve to study art seriously and Young did that. Soon all suggestion of primitiveness left his work. He became a portrait painter along well established lines.

Many primitives show signs of real artistic ability. They show a talent that is capable of growing and developing into something that is beautiful. You need not be a specialized collector of what is called the folk art of America to appreciate them. Most of them are unsigned. They may be the early work of artists who later became well known but would rather forget that period of their lives.

# Chapter Fourteen

## HORACE ROBBINS BURDICK

When one considers the longevity and prolific output of all the New England artists few can even approach the lengthy career of Horace Burdick. He was a professional artist, a photographer , a photo colorist, an art conservator and restorer, a teacher of art and photography in several art academies, a picture framer, an etcher, and a great walker for over eighty years. He had taken quite a hike a little more than two weeks before his 98th birthday but, it was said, this did not contribute to his death a few days later on September 18, 1942. He is best known as a landscapist and we first became acquainted with his work when a 16 x 20 White Mountain painting came into a local art gallery (Clorans) to be sold. The painting was dated 1888 and was one of the finest Mount Washington scenes we have ever seen. It was obviously a view of the mountain from the old Glen House Hotel grounds in the Peabody Valley of New Hampshire. Three great hotels had been erected on that same site and each had burnt down within a short time of each other. They had housed over 500 guests at one time and were lavish in comfort and design, wide verandas with tall towers on both sides to view the primitive solitude depicted in this painting by Burdick, done

with his touch for soft impressionism. The picture showed the great mountain rising abruptly from the fields with the ever present white clouds casting shadows over the summit. If the rest of his works were equal to this picture, he must have been quite an artist; they were, and he was.

Horace Robbins Burdick was born in East Killingly, Connecticut on October 7, 1844. He attended the Union Hall School in Providence, R.I. He came to Boston to continue his work and studies at the Lowell Institute. He had been painting still lifes and crayon portraits with some success. This income enabled him to enroll in the Boston Museum School where he studied under G. Hollingsworth, E.O. Grundmann and Dr. William H. Rimmer, matriculating as a full fledged portrait painter in oils. His reputation rests mainly on the noted Boston portraits now hanging in the Old State House, Faneuil Hall in Boston, and in many banking houses. He also has portraits in Harvard University's Memorial Hall, several New Bedford banks, Berkshire Court House, other banks in Berkshire County, six portraits in Massachusetts Institute of Technology, in the State Supreme Court and in the New London City Hall in Connecticut. However, his earliest exhibitions starting in 1875 were in various art galleries including Williams and Everett, Noyes and Blakeslee, Sullivan Brothers and Libbie, as well as the Boston Art Club, The Pennsylvania Academy of Fine Arts, and the Art Gallery at The Jordan Marsh Company consisting of pictures of fruit, hillsides, trout fishing, coastal scenes, many varieties of flowers, and. some sunsets. He also exhibited paintings from time to time of Greater Boston's North and South Shore coastal scenes, Vermont and White Mountain landscapes. He found time to pursue all his other professional enterprises and continued to restore paintings for over fifty years. His teachings even included courses in coloring and photo finishing at William Titcombe's Academy of Art and when one of the other art teachers fell ill, Burdick easily substituted for them.

The exhibits brought him many awards, but the medal awarded him at the Boston Mechanic Charitable Association's

Fine Arts Exhibition, according to his daughter's records, pleased him most. He was in competition at that show with many famous American artists. J.B. Wiggin wrote, after attending one of the Boston Artists Exhibitions, an annual affair in the Williams and Everett Galleries in a salute to Horace Burdick, he said "What fine portraits, pleasant landscapes, and Oh such grapes, peaches, cherries, and other fruit."

Burdick had studios at 616 Washington Street, Boston, 2 Cheshire Street in the Jamaica Plain section of Boston and many Malden addresses always in the vicinity of Malden Center, before purchasing his home at 16 Park Avenue in Malden. He had studios in Malden for forty years and in 1923 became the oldest living member of the Boston Art Club. That year saw him completing a portrait of President Calvin Coolidge which went on exhibit at the Malden Public Gallery in the Library, a gallery still noted for its large "Lincoln and Cabinet" canvas . The library is right around the corner from Park Street and now houses substantially all of the Burdick sketches and memorabilia.

The Alexander Hamilton portrait by Burdick is in the Berkshire County Savings Bank and a good deal of his other works are located in western Massachusetts. The artist lived for a while in New York City and reprinted herein are records of his two exhibits at the National Academy of Design.

Those who knew him recalled the artist as a man walking energetically all over the city of Boston visiting galleries, always genial, and asking if any of his old works ever turn up. He was intensely involved in religious study groups and was a member of the Boston branch of The Home of Truth.

When Horace Burdick died in his 98th year there were very laudatory obituaries in all the Boston papers, his home town paper, and the New York Times. He had outlived all his contemporaries of the 1880 Boston art scene. His daughter, an artist in her own right was besieged for years by collectors trying to buy his works. She told them in no uncertain terms that all his works had been sold and would not admit anyone in the house.

However, when she died there was a large auction of over 700 works found on the premises. The lamentable outcome was that the Commonwealth of Massachusetts garnered the proceeds as their were no heirs-at-law.

During the latter part of the nineteenth century Horace Burdick was much in demand as a lecturer. He succeeded so well that he wrote a book on *The Ideals of Art*. Although the book is hard to find we have parts of his handwritten manuscript available. The preface is a whimsical, tongue in cheek, look at his early career wherein he stated:

> Allow me dear reader to introduce myself. I am one hardup; age somewhat over thirty but less than forty; five feet five inches tall; inclined to corpulence; open countenance; a brow, (that unless the preparation I am now using works all the wonders it is advertised to) will soon reach to my heels.
>
> My general appearance is decidedly commonplace. In a thousand I am perhaps the last person you would notice. It may have been this fact that awoke in me an ambition to do something that might rescue my name from oblivion. So far all my efforts have resulted in failure. I have peddled newspapers, swept out a tailor shop, been cash boy in a dry goods store, errand boy in a book store, copying clerk in a lawyers office, printer in a photographic gallery, until I developed enough of the artistic talent to be employed in coloring photographs and finishing them in India ink. Next I painted still lifes, landscapes, and finally portraits for sitters that paid low prices which led me to the conclusion that I have not yet hit upon my proper vocation.
>
> My friends have always been generous toward me in the way of advice. Strange to say not one of

them agrees excepting that I am a failure and the only way to success lies through the path they advise. One says, "You ought to devote your whole time to painting fruits and flowers." Another, "You ought to fill your studio with a variety of small and pretty sketches from Nature and advertise for pupils." Still another wants to know why I don't stick to portraits in which direction he thinks my talents will most likely make an impression on the public mind.

Meanwhile genre painting seems to present the greatest attraction to me. But the expensive models necessary compels me, in order to keep the wolf from the door, to design cuspidors, paint altar pieces, or make drop cushions. So they call me fickle minded and perhaps I am. At all events when a lady friend suggested that I should write a book, I jumped at the idea. I have many ideas on art topics which many times I had longed to give expression to.

The very things I had before attempted in color might now be accomplished in black and white. Now readers, you know me, good natured, impecunious with only so much education as could be picked up by desultory reading of a habit of observation. I am driven by the desire to earn an honest dollar to the desperate expedient of writing a book. The deed is accomplished. The results are before you. If on the following pages you can find anything to commend it, don't fail to make it known to others of your acquaintance with a gentle suggestion that they should buy a copy and read for themselves. If, in a critical mood, don't fail to make as much noise about it as possible, for by so doing you will advertise the book and increase its sale and add to the profits of your much obliged and very grateful friend.

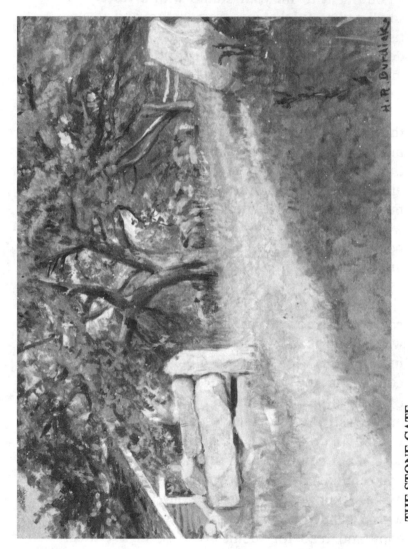

**THE STONE GATE**
*By HORACE R. BURDICK - Oil on /Artists panel,9"x12"*
(Courtesy of Richard A. Bourne Co. Inc., Hyannisport, Ma.)

Burdick's book contained lengthy dissertations on the art of China, Japan, Egypt, Greece, Rome, Romanish Church art, Germany, Holland, France, England, and finally America. He quotes Emerson who said "That in America, if anywhere the highest ideal of the artist is to realized. Thus in our fine arts not imitation, but creation is the aim. In landscapes the painter should give the suggestion of a fairer creation that we know. The details, the prose of Nature he will omit and give us only the spirit and splendor. He should know that the landscape has beauty for his eye, because it expresses to him a thought, which is to him good; and he will come to value the expression of nature and not nature itself. He will give the gloom of gloom and the sunshine of sunshine."

Some other quotes from the manuscript that are just as pertinent today as they were a hundred years ago;

> Beware of the danger of losing your enjoyment of art through an abuse of the critical faculty. Art students are the severest critics. Remember that there does not exist such a thing as a faultless work of art. As things go it would be a monstrosity, a thing out of harmony with its environment. Remember too that a picture should never be judged by what it fails to be, but what it is. There is no life of growth in negation. Pictures are not made to be criticized, but to be enjoyed. Your art instruction will be of no avail, if instead of developing a capacity to appreciate the best, it only leads you to detect the worst.
>
> This leads one to say that another danger facing the artist is in the temptation to imitate the manner of the master whose works are most admired. The presence at the art museum of a collection of paintings by that astonishing young genius, Anders Zorn, will present to many of his admirers a forcible example of this subtle tempta-

tion. But bear in mind the precept of Emerson that imitation is suicide, that no success can come to you except through the cultivation of your own individuality. You must take yourself for better or for worse and develop that within you, you were made to express if you ever hope to be worthy to compete with this fascinating master. ... Compete, did I say, let me hasten to take that back. There should be no competition in art. Every work of genius is unique. There can be no just comparison between masters. They all had a vision of beauty which they revealed to the world, each in their several ways, and all are admirable because each is true to his own ideal. You should learn to look for and guard that gleam of light from within, which leads you to feel in the presence of even the greatest works of art, that the best is yet to come. It is in your own individual ideal that catches the revelation. Instead of finding fault with others for not having realized it, you should bend every energy towards its realization in your own work and thus become in your turn a revealer of that phase of truth and beauty which appeals with such force to your nature.

Now I must say a word about the relation of art to nature, or if you please, Truth in Art. An artist soon discovers that Nature is infinite in its variety. Also that ones ability of observation and execution never so remarkable, still, a perfect representation of even the simplest is absolutely impossible. It is not only impossible but for artistic purposes, undesirable. The axiom must always remain that Nature is one thing and art quite another. It is the artists province to make an abridgement of the complexity of Nature to select such facts as will serve the purpose he has in mind

and put all his emphasis upon them so that the spectator may be made to feel the same sentiments that aroused his enthusiasm. ...

Be true to the best that is in you; look only at the best; aim at the highest; and in time you may realize the goal of your ambition and become a true artist.

Burdick was well liked and admired by many of his contemporaries. His private papers include friendly references to William Titcombe, John Ross Key, John J. Enneking, Alfred Ordway, Frank H. Shapleigh, William E. Norton, Scott Leighton, James Wells Champney, R. Swain Gifford, Jean Paul Selinger, and William F. Halsall.

His articles on art have been printed in various art journals of the day and in 1927, as the oldest living member of the Boston Art Club he was honored by the group when his portrait of President Calvin Coolidge was placed on exhibition. Burdick was also regarded as an authority and the leader in his day of painting restoration and conservation. Both American and foreign museums consulted him.

## Exhibits of Horace R. Burdick Paintings

*Annual Exhibition of Original Paintings by Boston Artists:*

Williams and Everett Gallery

| March 23 & 24, 1875 | No.46 | *Cling Stones and Sweet-Waters* |
|---|---|---|
| | No.61 | *A Hillside Ramble* |
| | No.81 | *Strawberries* |
| June 8 & 9, 1876 | No.30 | *Trout Fishing* |
| December 8 & 9, 1876 | No.17 | *Little Nahant Coast* |
| | No.21 | *Twilight, Roslindale* |
| | No.81 | *Bear Mountain from Derby Line, Vt.* |
| | No.102 | *The Valley, Clarendon Hills* |
| | No.109 | *A Relic of the Empire* |

## Museum of Fine Arts, Boston.

| April-May 1879 | | *The Latest News.* |
|---|---|---|

## Noyes and Blakeslee.

| May 1880 | No.2 | *Strawberries, Jonquils, and Oranges* |
|---|---|---|
| | No.9 | *Oak at Clarendon Hills* |
| | No.19 | *Peaches* |
| | No.29 | *Forcing the Season* |
| | No.38 | *Fruit and Flowers* |
| | No.44 | *Peaches* |
| | No.49 | *Autumn Fruits* |
| | No.54 | *Strawberries;* |
| | No.74 | *Plums, Crab-Apples and Cantelope* |

| | |
|---|---|
| No.82 | *Lady Washington Geranium* |
| No.83 | *Jonquil* |
| No.95 | *Marshall Neil Rose* |
| No.100 | *Roses and Pond Lilies* |
| No.121 | *Cherries and Bowl* |
| No.125 | *Buerre Clairgeaux and Bartletts* |
| No.128 | *Strawberries in Gilt Dish* |
| No.131 | *Beurre Clairgeaux* |
| No.134 | *Peaches and California Plums* |
| No.137 | *Sunset* |
| No.140 | *Blackberries and Raspberries* |
| No.144 | *At Clarendon Hills* |
| No.146 | *At Clarendon Hills.* |

## Sullivan Brothers and Libbie.

| | | |
|---|---|---|
| April 26 & 27, 1881 | No.60 | *Fruit* |
| March 15 & 16, 1883 | No.41 | *Seaside Meditation (with frame)* |
| | No.51 | *Strawberries and Oranges* |
| | No.112 | *Fruit* |
| | No.123 | *Autumn Fruits.* |

## Jordan Art Gallery, Jordan Marsh and Co.

**1896**

| | |
|---|---|
| No.119 | *A Brunette* |
| No.120 | *Study Head* |

## Boston Art Club

*- Oils unless noted otherwise -*

| | | |
|---|---|---|
| 1880 | No.76 | *Beurre, Claergeaux, and Bartlett* |
| | No.78 | *Box of Raspberries* |
| | No.124 | *Blackberries and Raspberries* |
| 1881 | No.60 | *Landscape* |
| | No.193 | *Blowing Bubbles* |
| | No.276 | *Head* |
| | No.279 | *Portrait* |
| 1881 | 2nd Exhibit | |
| | No.82 | *Fruit Composition* |
| | No.ll2 | *Native and Foreign* |
| | No.131 | *Sketch at Rifle Range Yonkers, N.Y.* |
| | No.410 | *By the Seaside* |
| | No.423 | *Landscape* |
| 1882 | No.152 | *Grapes, Peach, Apple* |
| | No.181 | *Grapes Peaches, Crabapples* |
| | No.210 | *Pomegranates and Plums* |
| | No.80 | *On Catskill Creek (water-color)* |
| | No.l30 | *Plotting Mischief (watercolor)* |
| 1883 | No.3 | *Portrait* |

|  | No.28 | *Fruit Composition.* |
|---|---|---|
| 1884 | No.82 | *Lena* |
| 1888 | No.71 | *The Letter* |
| 1889 | No.79 | *Home Industry* |
|  | No.150 | *Peaches and Grapes* |
| 1890 | No.118 | *Portrait* |
| 1890 | Drawing Ex-hi-bit |  |
|  | No.87 | *Three Beauties* |
| 1891 | Drawings |  |
|  | No.113 | *Winnie, Ideal Head* |
| 1891 | No.96 | *Portrait* |
|  | No.173 | *Pineapple and Strawberries* |
| 1892 | No.37 | *Grapes and Peaches* |
| 1892 | Drawings |  |
|  | No.158 | *Portrait on Ivory* |
| 1893 | No.52 | *Portrait Study* |
| 1894 | No.37 | *On the Beach at Point Aller-ton* |
|  | No.152 | *First Day of Spring* |
| 1894 | Watercolors |  |
|  | No.132 | *Portrait Study* |
| 1896-1897 | No.12 | *White Grapes, Pear, and Ap-ples* |
| 1897 | No.172 | *A Blonde* |
| 1898 | No.17 | *Fruit* |
| 1898 | Drawings & Watercolors |  |
|  | No.70 | *Saugus Marshes* |
|  | No.177 | *Portrait* |

|        | No.186   | *Pineapple*              |
|--------|----------|--------------------------|
| 1899   | Drawings |                          |
|        | No.8     | *Portrait*               |
| 1900   | No.93    | *Pleasant Outing*        |
|        | No.168   | *Fruit*                  |
| 1900   | Drawings |                          |
|        | No.20    | *Squash Patch in June*   |
|        | No.179   | *Fruit*                  |
| 1901   | No.52    | *Picture Book*           |
| 1901   | Drawings |                          |
|        | No.21    | *Reading Like Papa Does* |
|        | No.79    | *Pears*                  |
| 1902   | No.3     | *Moonrise from the Mount*|
| 1902   | Drawings |                          |
|        | No.229   | *Glory of Autumn*        |

Fifteen Years Later:

| 1927 (Jan.12-21)    | No.66 | *A Modern Girl*      |
|---------------------|-------|----------------------|
| 1931 (March 4-21)   | No.34 | *The Village Bridge* |
|                     | No.67 | *Towards Evening*    |
|                     | No.73 | *The Late Mowing*    |

# Chapter Fifteen

## CHARLES EDWIN LEWIS GREEN

It is not our intention to attempt to write a biography of C.E.L. Green. That has been done in a most satisfactory manner by Frederic Sharf and John Wright in the 1980 catalog of the Essex Institute exhibition, "C.E.L. Green, Shore and Landscape Painter of Lynn and Newlyn." However, as they noted, "It is regrettable that very little or nothing has been found to shed light on Green as a person and as an artist." Perhaps we can add to that paucity of information through comments on Green and his times gleaned from the journal of artist and contemporary, William F. Paskell.

Green was born in Lynn, Massachusetts in 1844 and like many other artistically minded men, had to first establish himself in business before seriously studying art. He was very successful in his business pursuits and soon became well known in Lynn as a business leader and a civic minded official. When he was about 35 he was able to give it all up and devote himself to art. He first met William Paskell in Boston and invited him to his studio with the intention of giving the young artist some lessons. Green was then 40 and Paskell was barely 18. According to the journal they were friends also, each having a mutual

respect for each others paintings. Paskell noted on viewing Green's work at the 1884 Massachusetts Charitable Mechanic Association's Fifteenth Exhibition that; "Green has a nice piece of color in his large picture. [No.138, Jeffries Point, Swampscott, Mass.,an oil listed at $300.] The whole is painted with the knife and is handled in a most masterly manner." A Paskell journal entry in March of 1885 noted a visit to Green's studio and of the younger artist giving Green a sepia drawing of "West Roxbury Pk." [now known as Franklin Park]. Another entry the following April, Paskell "called on Green and had quite a talk with him. Worked on the Chocorua and improved it." (Paskell took his works to several studios and worked under the artist's supervision as a way of getting informal instruction).

Green along with others encouraged the younger man to give a one man show that spring. It proved to be a disaster, in that no paintings were sold, although he did receive favorable newspaper criticism. In any event, several artists bought pictures there and this, at least, encouraged Paskell.

The Boston Evening Transcript of May 15, 1885 wrote of a Boston Museum exhibit with some favorable comment on Green, Monks, Paskell, and Waugh. At that time, Green's criticism of Paskell's work included praise for a palette knife study and a small sunset, but he found fault with several others of his work as being "too yellow." In fact Green liked the small 7 x 10 sunset study of a scene in Brookline, Mass. so well that he offered one of his pictures to Paskell in exchange for it. The picture of his own work which he traded was described by Paskell as a "beautiful thing, full of light and air and poetry." This remark is similar to the present day criticisms of Green's works.

The journal also indicates that the two artists met many times in Green's studio on School Street or at Ida Bothe's studio on Franklin Street, working together and discussing art. Among the topics discussed was probably their mutually shared desire to visit England to work. Before too long they did just that. Paskell went to Kent and Green to Cornwall.

How many other times their paths crossed is not known

yet but their careers contained a love for marine scenes. Paskell's time has not arrived but Green's stature and place in the world of art is well established.

**FISHING BOATS ASHORE**
*By CHARLES E. L. GREEN - Oil on Canvas, 19¾"x27"*
(Courtesy of Robert W. Skinner, Inc., Bolton, Ma.)

# Chapter Sixteen

## LEMUEL D. ELDRED

Eldred was born in the Massachusetts south shore town of Fairhaven. The year was 1848 and his early years were spent on the beaches and later fishing just off the coast with his father. The sea was his mentor in many ways and his sketches were always ocean scenes. He walked often to neighboring New Bedford to observe the comings and goings of the whalers. The sailor's tales have always enthralled the boys who wistfully lounged around and about the docks. Eldred asked to study art and proved so proficient that his parents sent him to Paris and the Julien Academy.

He studied dutifully and persevered for the entire course at the art school and as soon as possible began to travel to find some of the locations and wonders that he had heard so much about from the sailors. The European scenes did not attract him and before long he found himself in Tunis. He portrayed desert and oasis scenes paying a great deal of attention to the "ships of the desert," the camels. After a long sail up the Nile he reluctantly returned home.

Fairhaven marveled for a while at his strange African and Egyptian scenes. The small town was no place, however, for

a working artist. In 1873 he opened a studio at 26 Pemberton Square, just above Scollay Square in Boston. He shared a loft studio with a well established artist, A.H. Binder.

The two artists simply had to paint portraits at low fees to eke out a bare existence. Their hearts were not set on this type of art however. Eldred's foreign scenes began to sell and he joyfully set out on Sundays for the nearby beaches and the familiar sights and smells of the ocean. New Englanders have always had a special penchant for marine paintings. Several artists made fortunes painting the headlands of New England jutting seaward and promptly moved to New York forgetting the rugged coasts that enabled them to do so. Eldred was content to paint in his Boston studio and enlarge upon his small oil sketches. He roamed the coasts painting, on the spot, very small oils that compressed spacious seascapes yet did not lose detail or composition. The usual curiosity of those who enjoy watching an artist at work led to an instant, on the spot, demand for these small paintings. He was sore pressed to bring back to Boston any sketches at all for his studio work. His cure for this was to seek out deserted stretches of coast far up in Maine.

Eldred's long career seems to have been spent on the coast and islands of Maine. The Boston Art Club exhibited for many years these marine scenes. Judging by the titles he painted all over the islands of Casco Bay and spent a good deal of time on Squirrel Island in Boothbay Harbor. The Boston steamers travelled regularly to all the larger Maine Islands and Squirrel Island provided summer homes for over a hundred Boston families. The fishing schooners out of Boothbay provided much of Eldreds ocean details and were depicted against fiery sunsets or fog shrouded waters. His harbor views also contained waterfront mansions, or lobstermen hauling in their catches. He carefully portrayed the rare ospreys nesting on partially submerged and dangerous ledges. He painted the old stone chapel at Ocean Point and even rowed out to sketch on Damariscove Island. The cranberries grow wild there and legend has it that the members of Plymouth Colony once came to fish and trade there.

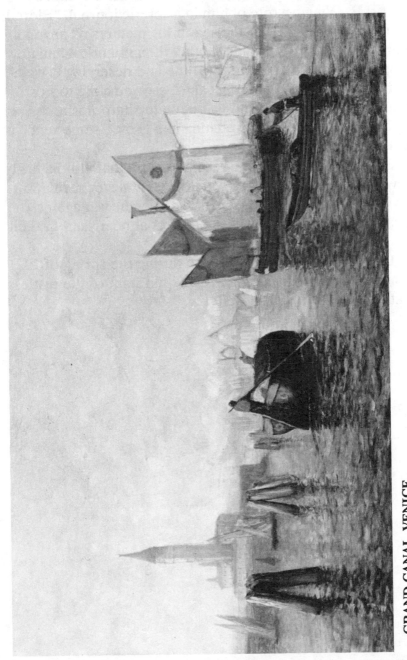

**GRAND CANAL, VENICE**
*By LEMUEL D. ELDRED - (1879) Oil on Canvas, 14"x22"*
(Courtesy of Richard A. Bourne Co. Inc., Hyannisport, Ma.)

During his later years he summered in far off Lubec and Eastport. J.B. Wiggin wrote of him in a coterie journal, "Eldred gets as much of the spirit of the sea in his pictures as anyone I can name. He is a faithful student of all things nautical and now very popular, winning fame and fortune and deserving it well." Age tamed some of his wanderlust and he stayed close to Boston in his later years, but still painting, out on the harbor islands and nearby beaches. He turned to etching and gained some renown in that field.

Someone remarked at a recent auction that although Eldred lived through three major wars they had never seen a warship or fort in his pictures. Most artists depict the war against the ravages of nature and happily are pacifists at heart and in their art.

Lemuel Eldred died in Boston during the spring of 1921 and is buried in his native Fairhaven within sight of the restless sea that he had portrayed so well.

# Chapter Seventeen

## WALTER LOFTHOUSE DEAN

The career of this marine artist reads like fiction. However, it is based on newspaper criticism, magazine articles, old catalogs of auction sales and exhibitions, some recollections by relatives, and a perusal of many of his works. Men like the conservative art critic, W.H. Downes, and A.J. Philpott of the Boston Globe wrote that he was an adventurer, a first class sailor, a wanderer, but all in all a high minded gentleman, soft spoken but forceful, and perhaps one of the greatest American marine painters of his time. For some obscure reason, not much has been written about him. He is hardly mentioned in art books but his pictures show up at auction and even there the interest is low as are the sale prices. Many have been seen in warehouses, the storage being paid by relatives. This will change just as surely as the seas pound the New England coasts and ships sail the oceans.

Walter Dean was born in Lowell, Massachusetts, on June 4, 1854. The family moved to Boston when he was still a small child. The various seasonal holidays and strong family ties brought them back to Lowell frequently. The boy's schooldays were passed in the Boston public schools. The large nearby har-

bor and waterfront fascinated him. He spent every possible hour when his school classes permitted, on the water. On the occasion of his 15th birthday, his parents presented him with a Herreshoff cat boat which he named "Fannie."

Young Dean soon became an expert sailor, and entered the Fannie in all the harbor races and incredibly won every major race. The next summer he raced in the Marblehead, South Boston, Newport and Long Island, New York, regattas. 1875 saw him venturing further along the coasts and when the magazine, "Forest and Stream," published an account of that year's races sailed in American waters the Fannie was declared to be the champion of the season. The young sailor had amazingly taken first prize in each race but more importantly he had begun to observe and sketch all aspects of the sea.

When Walter graduated from middle school he was given the opportunity, by one of his Lowell relatives, to work and study the business of cotton manufacture. He worked at every machine from the opening of the raw cotton bales to weaving and finally the baling of the finished cloth. That sort of occupation would irk any young man especially after experiencing the vigorous challenges of the open sea. He soon gave up the mill work, returned to Boston and entered the free Evening Drawing School.

The following year he was sent to the Massachusetts Institute of Technology and studied architecture for a short time under Professor William R. Ware. This occupation held little attraction for him and he gave it up, much to the chagrin of his parents. Now he entered the Massachusetts Normal Art School to take the elementary course. This time he had found what he always had been seeking and studied there for three years, taking the third and fourth year courses in one year. Upon graduation he was appointed a teacher of drawing in the Boston Free Evening School where he worked for two winters. The summers were again spent on the water. It seemed to his parents that his wanderlust had finally been eased and they were gratified when he was appointed art instructor at Purdue University, Lafayette,

Indiana. Dean actually enjoyed that teaching position for two and a half years. Unfortunately, Indiana had no coastline and the sea once again called. He returned to Boston, an artist in his own right, but resolved to follow his natural calling, marine artistry.

He was advised to go to Paris for further studies and in 1882 did just that. He endeavored to study for a year at the Julian Academy and listed his teachers as M. Lefebvre and M. Boulanger. The progress was slow and painful. Fortunately M. Achile Oudinot, a delightful old French gentleman, who had been an intimate friend of Corot and also a fine landscapist, took the young American under his wing. The year with Oudinot was not only enjoyable but taught Dean the refinements of his art and the beginnings of his understanding of how best to express his own individuality in paint.

It was natural that before returning to Boston he journey along the coasts of Brittany, Belgium, Holland, Italy and England. It was a long leisurely ramble. The sketch books were filled with a mass of drawings and his trunk bulged with oil studies. The breezy North Sea and the Zuider Zee were pictured full of spirit and color. Holland and the Dutch fishing boats held a peculiar attraction and his future painting exhibits always contained such titles as: "A Summer Day on the Dutch Shore," "Stormy Day, North Sea," "Beach at Scheveningen," and, "Dutch Fisherman, Bound Home." The artist in him was too busy absorbing the foreign shores to even conjecture that one day in the future art critics would praise his Dutch paintings. England interested him and he found his family roots in the historic small Lancashire town of Clitheroe. Some day he would paint Clitheroe Castle as it had been in the days of its glory. It may have been a good thing not to know the future but it would not have made any difference to the sailor artist. He came back to Boston without any idea of settling down in a stuffy studio.

Dean acquired the old twenty six ton yacht "Undine" in 1885 and fitted it up for a voyage. He filled the cabin with blank canvases, sturdy easels, paints, brushes, and sketch books. He

lost no time testing the maneuverability of the old craft and sailed it over to the Boston Yacht Club at City Point. There he plotted a four month cruise. The voyage started in a March gale and he sailed alone acting as his own skipper and never taking a pilot. The many islands of the harbor were too well known to him and they were soon left far behind. He cruised northward along the New England coast anchoring the Undine each night in a harbor or quiet bay. Standing on the deck whenever possible he would paint at a securely fastened easel from sunset to dusk and continue again for a while at sunrise. One of his better known pictures came about this way. He watched two boys in a dory running out in the pale greens of early morning, under sail, one steering with an oar, the other at the mainsheet. He titled the picture, "The Open Sea."

Gloucester harbor had always drawn him whenever he was near. He had made a mackerel cruise, during one of his school vacations, on the fishing vessel, "Annie C. Friend." They hauled at their nets off the Grand Banks. At that time he was just one of the crew and had very little artistic aspirations. Now he was his own master cruising at will, carefree and easy going. Before he left Gloucester he had added a dozen titles to his growing list. Among them were: "East Wind," "Home Port, Gloucester," "Conomo Point," "Taking in the Main Staysail," "Summer on the Waterfront," "Wharf Pier," "Bass Rocks," and the "Cape Ann Sand Dunes."

The voyage of the Undine is unique in the history of American art. It lasted an entire sailing season and was a floating artist's studio in every way. The pictures were painted on the site and even informally exhibited at the mooring docks and wharves. Many sketches were made for future use. Future exhibits also contained many of these works and won commendations. Continuing northward he sailed in and out of the hundreds of inlets, bays, and harbors of Maine. The northward journey ended at Eastport, Maine and then it was out to the open sea and beating back to Boston where the voyage ended. He had seen the busy fishing fleets and great flotillas of pleasure boats

everywhere to bear witness that the old maritime spirit was still strong in New Englanders.

The Undine was put up in drydock for the winter. He still resisted the need to settle down in the confines of a city studio. Dean felt the need to become familiar with the square rigged vessels, which as every marine painter will agree, are far more picturesque than the big windjammer schooners that had displaced them in the coasting trade. He shipped before the mast as an able seaman for voyages on the Barkentine Christian Redman, and subsequently on the Bark Woodside. Again his sketch books were filled and future pictures from these voyages held such intriguing titles as: "Off the Carolinas," "A Lively Porpoise," "The Falling Barometer," "The Deep Sea," a large 40 x 40 oil now at the Farnsworth Museum, Rockland, Maine, and a descriptive "Cutting In" in which he shows the immense carcass of a whale suspended alongside a whaleship.

The artist sailor was now 32 years old. He had exhibited only sporadically. His parents had even shown one of his many "Breezy Day" paintings when he was only 17 at the Museum of Fine Arts. The other exhibits were few and far between. He was virtually unknown. Now, if he was to seriously apply himself as a professional artist, it was high time to acquire a studio and show at the art clubs. The lofts on top of the hilly Pemberton Square attracted him and his first studio looked out over the waterfront and far out to sea. With his telescope he could make out the details of Castle Island with its Fort Independence, the buildings on Thompson's Island, Spectacle and Moon Islands, and northward, Lovell, Apple, Point Shirley, and the outlines of Great Head Winthrop. He knew them all, felt home at last, and settled down to work.

The first major exhibit was at the 1887 Boston Art Club show. They had accepted two of his European marines and it was the beginning of a long association with the prestigious organization. The Paint and Clay club accepted him on the recommendation of his long standing membership with the Boston Yacht Club. On the whole Boston was not a bad place to work.

Five short winter months in the studio and then a floating studio on the laps of the waves, journeying where the winds and his whims took him.

The following year the Boston Herald took notice of his Art Club entries; they wrote,

> Walter L. Dean's pictures are always satisfactory and in this exhibition he has three good ones. They are "Smokey Southwester," "Outward Bound," and a most beautiful, "November Evening." Mr. Dean knows boats as well as a surgeon knows anatomy, and consequently his craft would sail in any weather.

The entries of Childe Hassam, Frank Bicknell, C. B. Coman, Mary Trotter, Ross Turner, Charles Woodbury, and W.F. Halsall, all well known and established artists, all were hanging on the line nearby. The Boston Herald critic made no mention of their efforts.

Most of his Art Club exhibit works received good notices but there were exceptions. For instance, the transplanted French critic wrote in his book, *Boston Artists*,

> Walter L. Dean's paintings show honest study or rather good observation of Nature but this public taste! How many more masterpieces would we have if artists did not feel obliged to satisfy the taste of mobs? [Apparently he did not appreciate pictures of fisherfolk earning a living.] The stupid mob of today is like the mob of four thousand years ago. We do not care to enlighten the shoemakers, and servants. It is a task of apostles.

On the other hand the Boston Journal in 1890 wrote in this manner of one of his Dutch paintings, "'Boats in the breakers off Scheveningen,' has the honor of a purchase by the Boston

Art Club. The water which dashes over the boats is brilliantly painted. The breakers seem to sparkle, and the whole scene is one of life and energy."

The occasion of the visit to Boston by a part of the United States Navy's Atlantic Fleet, a crack unit popularly called the "White Squadron," inspired Dean to create a large canvas. He spent many hours sailing around the anchored battle vessels studying and sketching every detail. When the painting was completed it measured nine feet in width and six feet three inches high. He designed it to fit on a roller with a frame that could be easily taken apart and the four sections would also fit into the long box with the canvas. It was a neat arrangement that made it easy to transport. The painting depicts five great white cruisers, lying immobile at anchor. The warships are capable of both steam propulsion and sail; set up as square riggers, with their large sails partly furled. In the foreground the most conspicuous vessel is the flagship, "Chicago," Rear Admiral John J. Walker in command. Farther up the harbor lie the cruisers, "Newark," "Atlanta," "Yorktown," and the "Boston." At the main topsail yardarm of the "Chicago" flies the signal, "Furl Sails." The "Newark" is guard ship of the squadron as is indicated by the white flag showing a red cross, displayed at her masthead. The historic yacht "America" is seen running up the harbor between the "Chicago" and the "Atlanta." In the distant background of the picture the city of Boston with its prominent gilded state house dome, is visible at the left. East Boston is at the right hand and the Charlestown Navy Yard between the two. The old sloop of war "Wabash" can be seen at one of the navy yard docks and the Bunker Hill Monument is in view beyond the state house. Under a clear blue sky the water is rippled slightly by a faint breeze, and is full of dancing reflections showing contorted images of the white cruisers. A soft veil of smoke hangs over the distant city. Dean, at first entitled the picture "The White Squadron" and proceeded to exhibit it. The public and the critics hailed it as a masterpiece.

For some years there had been much discussion in the

press and Congress as to how the four hundredth anniversary of Columbus's discovery of America should be commemorated. A great fair was talked about and many sites suggested. Boston was one of them and if that happened Dean had his masterpiece ready. He showed some smaller pictures at the 1884 and 1887 exhibition at the Massachusetts Charitable Mechanic Association and received a silver medal for his "Low Tide, Scheveningen." Also shown were "Market Boat, Capri," and "At the Fountain, Capri."

The summer of 1887 he sailed to Gloucester bringing a number of works to be exhibited. He considered Gloucester as his home port and a few seasons later opened a small summer studio there. It was sort of a ramshackle place but right on the harbor where the tourists strolled and inspected paintings as though they were experts.

Dean soon had exhibited the length and breadth of New England. New York beckoned and he joined the Salmagundi Club there. The 1891 National Academy was the beginning of his New York Exhibits. There is a comment in their catalog of 1891. It reads, "In the 'Open Sea' of Walter L. Dean, the effect of boat motion and the expansion of ocean distance are cleverly caught."

Chicago was finally chosen for the Columbian World's Fair but time had run out for 1892. The project was moved forward and the opening set for Spring 1893. A few buildings were dedicated late in 1892 to retain at least some of the anniversary significance. The fair site was swampy and insect ridden and the land had to be built up by moving 120,000 cubic yards of earth. A mammoth undertaking. The Neo Classical buildings of a Florentine style were hastily constructed around a long lagoon. It was all very grand and nothing similar had ever been done in America. For the first time in history a moving sidewalk would take people from building to building. All aspects of science and art were to be exhibited.

The magnificent Palace of Art was fortunate to have as its director, the eminent professor of art, Halsy C. Ives. Profes-

sor Ives spent most of 1892 visiting most of the countries of Europe. There he conferred with prominent government officials, leading artists, the heads of the great art museums, academies, and noted art collectors, with the aim of creating such interest that truly representative and excellent art exhibits would head across the Atlantic from all these countries. Even the Japanese would be represented for the first time in an international art exposition.

A special American committee visited the large cities of New York, Philadelphia, Boston, Cincinnatti, and sought out mostly well known artists to contribute so as to obtain a strong American showing. Walter Dean was included in the small Boston contingent. He naturally selected his "White Squadron" to show. He had been considering a change in the title. He felt that the serene aspects of the entire scene did not suggest any thoughts of war. He had always advocated that the most effective way of maintaining peace is to be strongly prepared, therefore he simply named the painting, "Peace." His other pictures selected were the popular "Open Sea" and "The Seiners' Return."

Dean personally preferred to handle the hanging of his large canvas himself. He brought the pictures to Chicago, saw to the preparations, and left instructions that he would retrieve them at the shows end. Then he went sailing on the lake. The Fair was a huge success with crowds from all over the world and every city, town, and hamlet in North America. When Dean and many other artists returned for the closing ceremonies, they witnessed one of the thronged events on October 28, 1893. The large gathering along with all sorts of dignitaries included mayors from almost every city on the continent. The host mayor, Chicago's Carter Henry Harrison closed the speechmaking by declaring that on the following Monday the massed bands of all the nations would play and the great chorus sing as the fair ended.

However, as fate or a criminal mind would have it, the mayor was shot and killed instantly by an assassin's bullet as he

was returning to his Ashland Boulevard home. The shocked city closed the exposition immediately with a brief sombre ceremony, without any of the music, speeches, or the magnificent display of fireworks that had been long planned. Dean packed his pictures and returned to Boston.

The large painting, "Peace" had drawn a great deal of attention at the fair. Professor Ives had selected it as one of the best four paintings in the American Gallery. Several government officials, representing the Navy became very interested. However, it was not until the Boston 1899 South End Free Art Exhibition, where the "Peace" painting was again on display that an official of the House Committee on Naval Affairs approached the artist with an offer to purchase it for the government. Dean happily loaned the picture to Washington and supervised the hanging in the Office of Naval Affairs to await a Congressional appropriation. A report was made on January 19, 1900. No action was taken and the picture remained in limbo but highly visible to the admiring naval officers.

Back in Boston, the sailor artist resumed his mode of living, painting and exhibiting with the summers mostly spent sailing and sketching. Eben Jordan's clothing emporium had been greatly expanded and the Washington Street Department Store now included a sizeable art gallery. A tradition had begun and yearly exhibitions of oil and watercolor works of New England artists were held from 1894 on. Dean's entry in the 1896 Jordan Gallery Exhibition was one of his many "Gloucester Harbor" scenes. This one with very delicate almost pastel hues looking across the harbor towards East Gloucester. The catalog states that he was "an exhibitor at all the principal galleries and had received the highest award in the 1895 Massachusetts Mechanic's Charitable Association show. Works have been purchased by Boston Art Club and Library buildings of Fitchburg, Ayer, and many other public and private collections." The "Gloucester Harbor" was hanging next to another marine scene, "Morning After Storm, (old Minot's Light)" by William F. Halsall. Strangely this Boston Marine artist also had a painting

hanging in the United States Senate, his "First Flight of Iron-clads."

In recognition of Deans' growing reputation the Boston gallery of Doll and Richards gave him a one man show. That prestigious establishment was for a long time the exclusive agent of Winslow Homer. The exhibit was later repeated at the Worcester Gallery and the Poland Springs Art Gallery in Maine. Some of these works were entitled; "Little Niagara", "Anchored off Manchester," "Gull Rock, Eastern Point," "Westward Bound," "Rocky Neck Bar, East Gloucester," and "Schooner Polly 1804."

Many well known Boston artists had served willingly or unwillingly on art juries but it was a willing and eager Walter Dean that sailed for Paris early in 1900. It was an opportunity not only to be part of Europe's greatest exposition but a chance to visit the places were he had learned the true meanings of fine art. The Fair boasted three marvelous attractions; The lofty Eiffel Tower, and an improved moveable, "The Trottoir Roulant," where 50 centimes paid for travel along a circular route connecting the Champ DeMars with the esplanade Des Invalides, and the Olympic Games, held for the first time outside of Greece. Copying somewhat from the Chicago Fair the French incredibly dined 20,777 Mayors from the largest cities to the tiniest, at a dinner served on 606 tables and prepared in 11 kitchens. The fair was a great success but Dean found that the artificiality, dazzle and glitter detracted from his fond memories of Paris and he returned to Boston without a single sketch.

It was not surprising that the sailor in him decided he must have another cruise and this time in strange waters where the dangerous reefs were unknown. He journeyed to Puerto Rico and hired a coastal vessel with a pilot. He was prepared for sketching and painting the water vistas but the Spanish type architecture attracted him and he painted many landscapes as well. The titles of these pictures were unusual for his palette; "Catano, Porto Rico, March 9, 1903," "Gate of San Juan," "La Garita Del Diablo (The Haunted Sentry Box)," "Castillo Com-

ercio, San Juan," "Yglesias, Las Monjas," and "The Carmelite Convent, San Juan, Porto Rico."

These works were on display in his studio later that year. The Boston Globe of November 27, 1902, commented, "The Porto Rican studies of Walter L. Dean" are "faultless" and as "investing the details of the romantic Spanish colonial architecture with all the charm of glorified light."

American artists began planning for yet another great fair. This time it was the 1903 St. Louis Exposition. Art and science once again were to be joined. Professor Ives was also to be the director of the St. Louis Palace of Art and he asked for the large "Peace" canvas. Dean borrowed it from the Naval Office and set it up. He was awarded a medal for his efforts and the picture again caused much admiration. There was much to see at this fair that the other fairs lacked.

Great strides had been made in the automotive, wireless, and aeronautical fields. An automobile actually had been driven from New York to St. Louis. Wireless messages were transmitted to Chicago, a distance of 250 miles. Thousands of people queued up in long lines waiting to participate. The first American dirigible flight was made from the fairgrounds by Captain Baldwin in his airship, "The California Arrow." Music of the non stop variety was provided daily by a special exposition band made up of top musicians from all the states. It was a walk of almost five miles, up and down myriads of aisles, in order to see all the paintings in the Palace of Art. The large "Peace" canvas was highly visible at one end of the center aisle.

Walter Dean was elected Vice President of the Boston Art Club shortly after the turn of the century. He was also honored by being appointed Rear Commodore and life member of the Boston Yacht Club. Suddenly however, he fled the big city and sailed to his home port of Gloucester and purchased an ocean front home. Cape Ann had long been regarded as his natural painting place and he had spent many summers in various seasonal studios with a small boat moored nearby. During the hottest days of the summer, his neighbors would put a plac-

ard on their doors, reading "Gone Fishing." Dean's placard would, naturally, read "Gone Sailing." Now he opened a permanent studio and each morning, rowed across Gloucester Harbor to his place of business. When he had occasion to exhibit in Boston he sailed back and forth carrying his canvases.

One of his Gloucester scenes was exhibited about this time at the Boston Art Club. The title was, "The Rosalia D'Ali" and it drew this comment from the Boston Globe art critic, "One of the marines of interest is a picture of an Italian Salt Bark by Walter Dean. It represents the vessel lying at the wharf in Gloucester Harbor and is discharging her cargo to a little green lighter alongside. The picture is fine in execution and composition."

A salon exhibit was held at The Corcoran Gallery in Washington, D.C. during the month of February, 1907. The Washington Herald, of the same date, had this to say,"The most attractive marine in the nation's First Salon, Corcoran Gallery is Walter L. Dean's 'The Deep Sea.' It shows a misty day on the Newfoundland Banks, two men in a dory are hauling aboard a huge fish, while their boat lists dangerously. ... it is gloriously painted."

It would be difficult to list all of the sailor artist's fine works and a bit tedious reading but a few words about his Naval paintings are important. Some of the titles are self explanatory such as; "U.S.S. Minneapolis," "U.S.S. Columbia," "The Prarie State." all pictured during their visits to Gloucester. "Coaling," "The New York," and "The Indiana" painted while at anchor in the Presidential Roads, Massachusetts Bay. However his large canvas, "U.S.S. Gunboat, Gloucester at Santiago, 1898," recalls one of the most thrilling incidents of the Spanish American War.

A pleasure yacht had been transformed into a small naval gunboat and renamed, "The Gloucester." One of the officers of the ill fated battleship, "Maine," Richard Wainwright had been placed in command, and attached to the fleet off Cuba. That day they were seeking to engage the Spanish fleet and soon a running battle started. The enemy destroyers. "Pluton" and "The

Furor," were protecting the rear when perceiving their fleet veering away toward the open sea, they decided to make for the protection of Morro Castle. Notwithstanding that these were very modern destroyers indeed, Commander Wainwright flung the puny, "Gloucester" directly in their path with all guns firing. The ex yacht "Corsair" maneuvering adroitly riddled the formidable warships mercilessly, sinking them both and then coming about to pick up the survivors.

Curiously Dean was still painting European scenes from his memory and old sketches. One of them must have been very interesting indeed. The Boston Transcript wrote "Mr. Dean shows in his studio some good French scenes. One of them 'The Sardine Fleet, Concarneau, France,' shows a group of boats in the Bay of Biscay where about 700 sardine boats are engaged in fishing. Included also were such local titles as, 'The Road to Joppa, near Rockport,' and 'Gloucester Schooner at Home.'"

There are many references to his exhibiting outside of Massachusetts. They brought favorable comments from the press whose critics said in part, "An admirable class of marines which are held in deserved favor." Dean's paintings were shown almost annually from 1905 on at the New York Academy, Carnegie Institute, Chicago Art Institute, Worcester Art Museum, Corcoran Gallery, and The Poland Springs Gallery.

What happened next is a bit of a mystery. His friends conjectured that he was contemplating a world cruise and needed funds to fit up a suitable vessel. At any rate he decided on a large auction of practically his whole collection. The auction was held lasting the better part of the week of April 5, 1911, at Leonard's Auction Rooms on Bromfield Street, Boston. There were oils, pastels, and watercolors of all sizes. Besides the American marines, there were scenes from France, Holland, England, and the Bay of Naples. There were 148 oils, five watercolors, and six pastels which went under the auctioneer's hammer. A great many were sold for the very good price of $300. each. Whatever plans the sailor artist had in mind were suddenly sidetracked by illness, something he had hardly ever experienced.

Most persons, knowing of his nautical background and reading about his cruises, expected to see a large strong bluff and perhaps red faced seaman. Instead when meeting him at exhibitions they were surprised to find a small, dapper man, with a neat moustache, very polite and soft spoken. His full head of hair was jet black and the brownish eyes were steady yet alert.

Walter Lofthouse Dean died in his East Gloucester home on March 13, 1912. Many news items summed up an active, fruitful, and distinguished career. The Boston Post said in part;

> He was ex Vice President of the Boston Art Club; on the board of government; member of the Copley Society, the Paint and Clay Club, Boston, Salamagundi Club, New York; member of several North Shore, Massachusetts Art Societies; ex Rear Commodore and life member of the Boston Yacht Club. He had also served on the Boston Jury for [the] International Exposition, and the jury of the Chandler, Paris , prize scholarship, Boston. Mr. Dean, of late years, since he has reached the maturity of his genius, has been regarded as the foremost marine painter in America. He was a sailor as well as an artist. He was a lover of the sea in all its moods and not only portrayed its magic but interpreted its mystery. Whether it is a vessel seen far out to sea or the dash of wild surf against half hidden rocks, all is masterly. Whether it is a schooner beating into Boston Harbor, or a Scheneningen boat in a stiff breeze, there is made upon the beholder an impression of the certainty of the artist's knowledge of every rope, every spar, and every sail he paints.

The Boston Advertiser wrote, "Someone has said that Walter Dean was cradled on the lap of the Ocean. ..." and the article goes on to chronicle his 1875 feats with the vessel Fannie.

The Boston Globe recalled, "His Carnegie Institute exhibit of several years ago, 'Off the Whistling Buoy,' is one of the strongest sea pictures ever painted."

The Boston Transcript spoke of another picture, "'Crossing the Shoals,' was a fine painting of a ship feeling her way through a tortuous channel in thick weather. In all Mr. Dean's pictures of the sea, one feels the salty breath of the ocean and the intimate aspect of the craft."

Little mention was made of the masterly large work, "Peace." That painting apparently had been forgotten until a newspaper article in the Washington Post, January 12, 1929 announced,

> In the legislative act approved last May 14th, provision was made for the purchase of a painting entitled, "Peace." This painting for many years [30 to be exact] has been in the possession of the House Committee on Naval Affairs, occupying a prominent place in the office of that committee. A report recommending its purchase was made by the Committee on the Library in January, 1900, and owing to the failure of an appropriation, the painting remained in the Capitol office. Owing to the death of the painter, Walter L. Dean, the purchase was again neglected by the heirs of the painter until recently. Action has now been taken by the Joint Committee on the Library resulting in the appropriation of $5000.00 to provide for its purchase.

The government had finally acquired a national treasure and today the great painting is viewed daily by the thousands that throng the Nation's Capitol Building. The guide refers to it as an "Allegory."

At this writing the once eminent sailor artist is all but forgotten with the exception of occasionally being included in

Cape Ann exhibitions. Some people in Gloucester remember him and strongly feel that his name should be on a par with the more famous painters that have lived and worked on the rugged North Shore and the tempestuous waters off Massachusetts. In our opinion the name of Walter Lofthouse Dean should be mentioned in the same breath as that of Fitz Hugh Lane, Winslow Homer, Kilby Webb Elwell, Helen Emery Knowlton, Augustus Waldeck Buhler, George Wainwright Harvey, William Partridge Burbee, Edward Henry Potthast, Charles H. Woodbury, Maurice Prendergast, and Reynolds and Gifford Beal. They are all gone now but their works still glorify the old sea port's legendary past.

**SCHOONER ENTERING GLOUCESTER HARBOR**
*By EDWARD HARVEY - Watercolor*
(Private collector)

# Chapter Eighteen

## EDWARD HARVEY

Somewhere in Gloucester's oldest and somewhat neglected cemetery rests a man, just as neglected and forgotten. Along with some of the first and most prominent families of Cape Ann; the Babsons, the Somes, the Ellerys, the Rogers, and even the first schoolmaster, Thomas Riggs, all share equally this hallowed ground as their last resting place. Cemetery records reveal that he is there in the vandalized earth amidst broken glass, beer cans, and smashed markers. A tall monument which would be the envy of a minor Pharoh, rises impressively in one part of the graveyard, and that too is overgrown with dense foliage.

The man that lies there, according to present day hearsay, was a ne'er do well, an alcoholic, and the black sheep, of an otherwise respected and cultured family. He died penniless at the local poor farm and the family, with a collective sigh of relief, buried him in one of his brother's suits. Yet this man, will surely, someday, receive his belated recognition as one of New England's finest watercolor artists.

He struggled and suffered during his fifty-five years as much as a Gauguin or a Van Gogh. Even so, he produced pic-

tures as pristine and airy as a Mozart andante. His name was Edward Harvey, the younger brother of the noted Gloucester artist, George Harvey.

Edward was born in Gloucester, Massachusetts, on January 2, 1862 and the name given him was Angus Edward Harvey. He was the son of Thomas Harvey, a well known schooner Captain originally from Cape Breton Island. His mother was Rhoda Wainwright whose family lived in the nearby town of Rockport, George always signed his paintings, George Wainwright Harvey.

The Harvey boys, during their teens, heard a great deal about Gloucester's legendary artist, Fitz-Hugh Lane, born Nathaniel Rogers Lane, who was neglected for some time after his death. A gradual revival of interest in his importance was taking place while George and Edward were in middle school.

Following the town's practice both boys were sent out with the fishing fleets as apprentice seamen but their real talents lay on the landward side. George, who practiced sketching at every opportunity, drilled his brother in all the rudiments he knew. When Edward was twelve years of age, Winslow Homer was living for a season on Ten Pound Island, in Gloucester Harbor, and producing water colors that were on display in the town's store windows. Gloucester had many visiting artists even in those days, and they contributed much toward the popularity of water color art in the Cape Ann area.

The native artists however, such as George and Edward, had one great advantage. The sea was in their veins and the neighboring Atlantic was their year round mentor. The busy port, with its great European salt ships, fishing draggers, and sleek schooners of all sizes, abounded with nautical activity. The wharves and docks were the main attraction and here they did their first sketches.

The two brothers roomed together for some time on Prospect Street and later moved to another boarding house, just around the corner on Marchant Street. Here they could see the entire inner harbor from what was then called Windmill Hill. Then George made a fine marriage, to a distant cousin on his

mothers' side of the family, and later traveled to Europe for several years.

On the other hand, Edward was on his own. The only land based work he could find or seemed suited to was clerking. Like Fitz-Hugh Lane who also started out as a clerk but later turned to shoemaking, Edward Harvey never could rise above the title of clerk and he had all he could do to eke out a simple living.

On Sundays and holidays however, he lived the life he wished to live. He became a Sunday artist and deftly painted all parts of Cape Ann. The scenes he produced portrayed the sea and its landfalls in all its ever changing moods. Anyone who grows up in Gloucester recognizes the sea as something cruel. Ten or more vessels were lost each year. Too many sailors were abruptly gone forever.

But in Edward Harvey's watercolors, serenity and brightness are foremost. His perception of light brings a splendor of revelation. The ocean becomes a giant mirror and casts a unique reflection of light back to the shore. The Cape Ann light differs, or seems to, from all other rocky shorelines. Wet rocks gleam with a light that is ever changing in its many hues. The sands sparkle like a myriad of gems and Edward Harvey, with his light palette and without the benefit of formal training, somehow managed to accurately depict the sea where it meets the land with its myriad of facets.

Some of the places that he painted would have been very difficult to get to, especially for a poor young artist, excepting for one great invention, i.e.,the trolley car. It was during the 1880s that horse drawn cars slowly circled the Cape along a single track which was later electrified in 1887.

On Sundays and holidays Edward would leave his boarding house and walk down to the Waiting Station on Main Street. There he boarded the trolley which ran to Long Beach, then further out to Eastern Avenue and on to Rockport. In summer, the open cars swayed perilously close to the open water but produced breathtaking views of Pigeon Cove, a stop near Halibut

Point, then called Haul About Point, Lanesville, named after an early settler, Bay View, Annisquam, Riverdale and back to the Waiting Station. Another single track went towards Rocky Neck and all of East Gloucester. The cost was a penny per mile and the only delays were the usual cows on the track.

When George Harvey returned from Europe he was a known and recognized artist as well as a respected member of the Royal Dutch Art Society. He and his wife, Martha, set up adjoining studios on the river road leading to Annisquam. Martha was an expert photographer and George produced many fine paintings and etchings using her photographs of Gloucester as studio models.

Unlike his brother George, Edward went to nature for his inspirations and painted delicate water colors on location. On Cape Ann, particularly in and about Annisquam, there is that lure of nature that brings one back, time and again. So it was with Edward Harvey. While his brother exhibited in Boston and New York, Edward resigned himself to selling his pictures locally and usually to passing tourists

Every aspect of the sleepy village of Annisquam is depicted in his pictures. The small village in Edward's day, and even today, consists of an 1830 church, a library with an attached hall, a tiny schoolhouse, a firehouse, and a market. The church now has a hand carved and polished wooden cross attached to the church sign which was made by Elliot Rogers, a cousin of the Harveys. Rogers called it, "His ticket to heaven." A nearby long timbered bridge, crosses the river harbor and there many white sea-captain's houses line the river bank.

Edward was very prolific in his depictions of all these places. His favorite vantage points for painting were along the rocky shore and included the lighthouse on Wigwam point which was accessible only across Squire Norwood's pasture. His watercolors show two different lighthouses there. The first was built in 1801 and had to be rebuilt in 1897. Beyond this picture book lighthouse is Ipswich Bay, sparkling with deep blue water. There are some gray day pictures too, and many "After the

Storm" scenes where huge boulders, rounded by glacial action, are the only inhabitants pictured. Across the bay, one can see the sand dunes on Plum Island twinkle in the distance. Nearby, as in just about every New England town there is a "Sunset Hill," an eminence from which many a scene was painted.

As time went on, George Harvey's fame mounted, He produced many oils, watercolors, copper etchings, wood engravings, and pencil sketches. Although Edward did some oils, his medium, due mainly to his financial situation, was principally watercolor. Frustrated financially and snubbed by his brother's in-laws, he went to the docks and grog shops for companionship and peace of mind. Before him, Fitz-Hugh Lane had dragged himself painfully on his crutches to the same wharves to escape domestic strife. Soon Edward sought solace in alcohol and painted just to obtain a bottle. Then all too quickly, he had to sleep where he could on the docks.

Like the writer, Edgar Allen Poe, the artist Arthur Clifton Goodwin, and so many others of like talent before him, this talented and sensitive artist was beaten down by life's realities and frailties. Strong drink and its ravages on the body and mind had not affected his sure hand. He had painted for over thirty years and his works were carried away by vacationers to all parts of the country, while others of his works were bandied about in grog shops and were hung in the captain's quarters aboard every type of sailing vessel.

Finally, they took him along with his painting materials to the poor house, then politely referred to as "The City Farm." There Edward Harvey died of lumbar pneumonia on December 2, 1917. If you love the many hued vistas' of the North Shore or any of Massachusetts' shores, its sandy beaches, the surf drenched rocks, the white topped breakers, and the never ceasing lapping of the waves, seek out the watercolors of Edward Harvey.

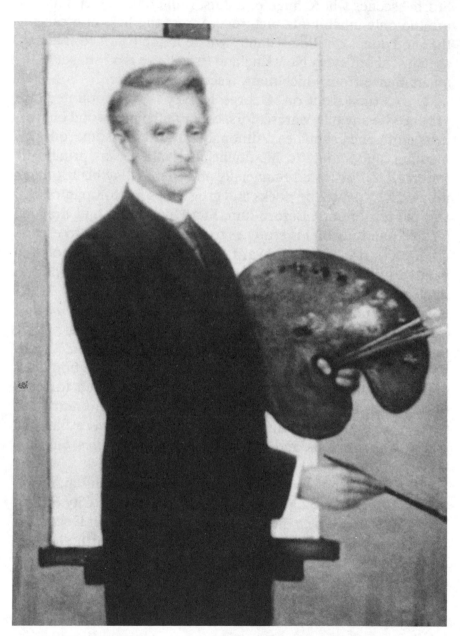

**SELF PORTRAIT**
*By HENRY HAMMOND AHL - Oil on Canvas, 50"x40"*
(Courtesy of the Newburyport Historical Association)

# Chapter Nineteen

## HENRY HAMMOND AHL

In American art traditions, there have been a number of families of distinguished artists; most often husband and wife. The Peals, Wyeths, Webers, and Weirs would be offered as examples of families of gifted individuals who expressed their creative talents by painting. A number of these families have to a greater or lesser degree been appreciated and acclaimed for their contributions. Other such as the Ennekings, Kaulas, Cranes, Paxtons, Ochtmans, and others are presently being reassessed as part of the growth of general public interest in American art. This is especially relevant for those painters of the later decades of the 19th and earlier decades of the 20th centuries. Henry Hammond Ahl, his wife Eleanor, and son Henry Curtis Ahl, have to date been relatively unappreciated as a significant family of American artists Each were encouraged and supported by the others, yet remained clearly distinguishable in the expression of their talents.

Henry Hammond Ahl was born in East Hartford, Connecticut, in 1869. As a child, Mr. Ahl demonstrated a passion for drawing by the age of 6. By 17, he had already shown competence in oils. Henry Hammmond Ahl was fortunate to be able

to travel to Europe on a number of occasions. He studied in the Royal Academy in Munich under Alexander Wagner and Franz Von Stuck. Peter Paul Ululler was his mentor in landscape painting. Mr. Ahl also studied with Gerome at the Ecole des Beaux Arts in Paris. After his first trip to Europe, he returned to Springfield, Mass. where he met Eleanor Isabella Curtis who was to be his wife.

After a tour of Europe, sketching and visiting galleries, Ahl returned to the United States and opened a studio in Washington, D.C. He became well known for his portraits of prominent figures such as Speaker Henderson and Senator Hoar of Massachusetts.

Following another trip to Europe, Mr. Ahl moved his studio to New York. He continued to paint and travel and following a trip to the British Isles, he moved to Boston. Sometime around 1920, Henry Hammond Ahl bought the Dr. John Clark house in Newbury, a 20 room landmark built around 1637. This was to be his home and studio for the rest of his life.

The career of Henry Hammond Ahl is much more artistically varied than most of his contemporaries. Although a very successful artist during his lifetime, he belonged to no school, colony, or movement; he left no legacy of pupils or followers save his only child, Henry Curtis Ahl.

During his time in Springfield, Mr. Ahl painted landscapes that reflected his training in Munich but with certain characteristics of the Barbizon mood. He displayed also the inspiration of Rosseau and Corot. At approximately the same time he began depicting religious themes in the manner of Rubens and Tiepolo, receiving acclaim for his Americanized version of *The Madonna of the Clouds*.

From his studio in the Corcoran Building in Washington, he executed his most important portraits of well known political figures of his day in an academic style. However, the single painting that received greatest public notice was *In the Shadow of the Cross* which the lay public and the newswires gave the description "the miracle painting". A conventional figure of

Christ stands clearly relieved against a blue and white sky when the work is illuminated. If the room is made dark, a figure bearing the cross stands out against a field of light". Mr. Ahl maintained that the phenomenon was not by conscious design. Because of the effect this work had on the public, it went on national tour in 1899 and was displayed at the St. Louis World's Fair of 1904. Henry Hammond Ahl was described as "famous by age 30".

From approximately 1900-1910, Mr. Ahl entered into his first tonal period in which he utilized translucent color to depict radiant sunsets or forest interior scenes. His particular "tonalist methods" was characteristically unique with a great deal of Barbizon flavor and a keen interest in the nature depicted, especially the regal oaks of eastern Massachusetts around Newburyport.

From 1911-1915, Mr. Ahl turned to religious themes and executed murals and massive depictions of the cross which were used as altar pieces, stations of the cross, and to decorate churches in Boston and Providence. Mr. Ahl's 12' X 20' *Crucifixion* in the Church of the Blessed Sacrament in Boston and his fourteen stations of the cross in Hartford won him great public acclaim throughout the Northeast. He discontinued this work after falling from a scaffold and receiving significant injuries.

From 1915 into the 1920's, Mr. Ahl's intensified interest in landscape coincided with his growing expertise in horticulture. He became an authority on the magnificent live oaks that were abundant in the Byfield, Rowley, Newburyport area where he came to live. As a landscape artist, Henry Hammond Ahl had the versatility of talent to embrace tonalism, the Barbizon mood, and impressionism. He also executed numerous works of historical places, homes, and taverns which were given copyright and received widespread public distribution. A number of commercial firms used these prints for their calendars and holiday greeting cards that were sent to customers.

Periodically, Mr. Ahl would have exhibitions at Doll and Richards or the Vose Gallery in Boston. Often included would

be a rendering of "The Ancient Oak" probably his most highly respected subject by critics and art historians. An example is contained in this collection. This particular painting was copyrighted in 1921. Henry H. Ahl's landscapes of haystacks on the salt marshes are rendered in a manner emphasizing color to produce form; which embraced the most characteristic elements of impressionism. In the 1930's and 1940's, Mr. Ahl began to receive great recognition in Europe being included in *Who's Who in the World of Art*, the *International Blue Book* and the *World Biographical Dictionary*. Numerous articles appeared in newspapers both in America and Europe, especially France.

Mr. Ahl was made a member of the Salmagundi Club, the Boston Art Society, the Copley Society, and the Artists' Professional League. In recognition of his interest in horticulture and preservation, he was elected to the Archeological Society of America, the Society for the Preservation of New England Antiquities, the American Tree Association, the American Forestry Association, and Phi Gamma Mu.

Henry Hammond Ahl continued to paint in his studio in the magnificent house shared with his artist wife and son until his death in 1953. Although there were a series of articles in local newspapers at the time of his death, little note was taken by the general public or in the art world of the passing of one of America's most versatile artists.

**Selected Paintings by Henry Hammond Ahl:**

- *Self-Portrait*, 50x40 oil on canvas (Newburyport Historical Association)
- *The Old Oak*, 25x30, oil on canvas
- *House in the Mist*, 25x30, oil on canvas
- *The Salt Marshes*, 25x30, oil on canvas
- *Sunset*, 10x14, oil on panel
- *Merry Christmas*, 8x10, oil on canvas
- *The Oak*, 8x10 pencil

- *Vermont Landscape*, 8x10 oil on canvas
- Near Bass Rocks, 12x16, oil on panel

Note:        This chapter was written and contributed by Professor A. Everette James, Jr. ScM, JD, MD, Chairman of Dept. of Radiology at the Vanderbilt University School of Medicine, Nashville, Tenn.
He is a collector of American Impressionism.
He is author of:
"The Cowan Collection" Antiques, November, 1980
"Women Artists: Their Role In American Impressionism"
Collecting American Impressionism"
Radiographic Analysis of Paintings:
Film/Screen Combinations, Magnification, Low Kilovoltage, and Xeroradiography"

# BIBLIOGRAPHY AND GENERAL SOURCES

Among the best sources for background information on some of the artists included in this publication were family and friends and associates of the artists themselves. This included family members of H.R. Burdick, G. Castano, E. Harvey, W.F. Paskell, W.P. Phelps, D. Santry, and H. Spiers..

Art dealers who in the course of their business activities had contact with various artists and who very generously shared their remembrances included; J. Additon, T. Gilbert Brouillette, John Castano, Charles Childs, Edward Cloran, and Robert C. Vose, Sr.

Others, experts in their special sphere of the art world, included; Alfred Harrison, author and Director of the North Point Gallery in San Francisco, Professor William B. Hoyt of Cape Ann (Rockport), Mass., Dr. Frederick Innes of Boston,Mass., and Kenneth Van Vechten Parks of Catskill, N.Y.

**Other publications and institutions include but were not limited to the following:**

*American Art Annual* (1932) Biographical Directory of
    American Painters & Sculptors, reprint by
    A.C.Schmidt Fine Arts, N.J.
Annisquam Historical Society, Annisquam, Mass.
Bacon, Edwin M.*King,s Dictionary of Boston*, Moses
    King, Pub.,Cambridge, Mass.,1883.
*Bierstadt Exhibition Catalog*, 1858.
*Boston Almanac and Business Directory.*, Pub. Sampson,
    Murdock & Co., Boston, Mass.(1889 & 1891)
Boston Art Club, Exhibition Catalogs (1875-1931).

*Boston Athenaeum Art Index of 1863, 1878,* etc..

Boston Globe, Nov.27, 1902, (Review of W.L. Dean's
    Studio Show.)

Boston Globe, obit. (H.R. Burdick) Sept. 18, 1942.

Boston Herald, obit. (H.R. Burdick) Sept.18, 1942.

Boston Journal, Morning Edition, January 19, 1884 "The
    Fine Arts" (Review of Boston Art Club's 29th
    Exhibition)

Boston Museum of Fine Arts, Boston, Mass.

Boston Public Library.

The Bostonian Society.

St. Botolph Club, Catalog, Spring Exhibition (1886),
    Boston, Mass.

Bowles, Ella, *Let Me Show You New Hampshire* (New York,
    1938)

H.R. Burdick, *The Ideals of Art* (privately
    printed).(1935)

California Museum Archives (Oakland, Stanford and Santa
    Cruz.

Campbell, Catherine H. *New Hampshire Scenery*
    (Dictionary of 19th Century Artists) , Pub. Phoenix
    Publishing, Canaan, N.H. 1985.

Cape Ann Historical Association, Cape Ann, Mass.

*Charitable Mechanic Association Catalog, Fifteenth
    Exhibition (1884),* Boston, Mass.

Champney, Benjamin.,*Sixty Years' Memories of Art and
    Artists,* (privately printed), Woburn,Mass.,1900.

J. Eastman Chase's Gallery, Boston, Mass., C.E.L. Green
    Exhibition Catalogs, 1882, Feb.1887, Mar.1888,
    Apr.1889, and Feb. 1891.

Clements & Hutton., *Artists of the 19th Century,*
    Houghton, Mifflin & Co., Boston, Mass. 1884.

Cloran Art Store, Boston Mass.,Records of 1930.

Cowles Art School, Boston, Mass., Brochure (1889)

Dedham Historical Society, Dedham, Mass.

DeSoissons, S.C., A Parisian Critic,s Notes of Boston
    Artists (1894) Excerpt.

*Dictionary of American Biography*, N.Y., Charles
    Scribner & Sons.,1958.
Essex County Artists Association Catalogs,1865 and
    1910.
Fielding, Mantle.,*Dictionary of American Painters,
    Sculptors, and Engravers.*,Apollo Books,
    Poughkeepsie, N.Y., Rev.by G.V. Spitz, 1983.
Hurd, Charles E., A Painter of Monadnock, *The New
    England Magazine* (Nov.1897.)
Jordan Art Gallery, Boston, Mass., Catalog, *Fourth
    Exhibition of Oil and Water Colors by New England
    Artists*, (1897).
Leonard & Co.,Auction Catalog, (May 1883, April 5,
    1911)
Public Libraries in:Boston,Mass., Franconia, N.H., and
    Conway, N.H..
Mallett, D.T. *Mallett's Index of Artists* (1935)
    reprint, and Supplement, Pub.N.Y., Peter Smith
    1948.
Massachusetts State Archives.
National Academy of Design (listings of 1878, 1880 &
    1893.)
*New York Historical Society Listing of Artists in
    America* by Groce & Wallace (1860).
Noyes & Blakeslee Exhibition Catalogs, (1877 and May
    1880) Boston, Mass.
Paskell, William F. Journal (Dec.1884 to Dec.1885)
    Boston, Mass.
Philadelphia Centennial Exposition Catalog, 1876.
Robinson, Frank T., *Living New England Artists* (1888)
    Boston,Mass..
Smith, R. C. *Biographical Index of American Artists*,
    Pub. Olana Gallery, N.Y.(1929)
Sugar Hill Historical Museum, Sugar Hill, N.H.
Sullivan Brothers and Libbie Galleries, Boston,Mass.,
    Exhibits of April 26, 1881 and April 1883.
*U.S. Art Directory*, 1882-1884.

Wiggin, J.B., *The [Poor] Wild Artist in Boston*, Publ.
  J.B. Wiggin, Boston,Mass.1888.
Williams & Everett, Boston, Mass., Catalog, May
  Exhibitions; July 26,1875, June,1876, Aug.9,1876,
  and 1880.
Young, William, *A Dictionary of American Artists,*
  *Sculptors and Engravers*, publ. W. Young & Co.,
  Cambridge, Mass. 1968.

# INDEX OF ARTISTS

*(NOTE: See also the Index of American Artists in App.A)*

*Numbers refer to Chapters, [ ] Artist's own Chapter*

# APPENDIX A

## THE FIFTEENTH EXHIBITION OF THE MASSACHUSETTS CHARITABLE MECHANIC ASSOCIATION

### • 1884 •

A glance, even briefly, through this catalogue reveals a great deal of the art activity of the era. Artists from all over the country sent paintings hoping to be selected for this annual exhibition. The New York and Philadelphia men vied with the Boston entrants. The show was held in the Mechanic's Building on Huntington Avenue a few blocks up from Copley Square in Boston. It was always well attended and prestigious in all its fields. An excellent description of this show is found in the Paskell Journal. The old building was torn down some years ago and all the records and memorabilia including some fine paintings that had been purchased by the Association through the years went into storage. Unfortunately the warehouse burned and everything was lost. This catalogue can be considered important for that reason alone.

Many paintings were entered and amounted to several hundred each year. The local artists always felt that the selections jury were biased in favor of the out of town artists. The exhibition policies caused not only controversy, but downright

bitterness. This was fairly true of all shows in any city. The Boston men felt that too many invitations were sent to artists of sure fire reputation. Once accepted an artist had to deal with the hanging committee who could hide his picture up near the ceiling or in an obscure corner. This may have been the reason for so many large paintings. Hide this if you can; and they did. It was the custom to have a florist come and drape laurel ropes and garlands around the pictures and one saw more greenery than pigment. The walls in the small rooms were just too crowded with pictures. Still the public acclaimed the shows and the attendance increased each year.

All the paintings were for sale and it is interesting to note the catalogue prices. Some of those works would bring the same relative price today but many would command a tenfold increase in today's market. A select few became masterpieces and their creators household names.

We have reproduced portions of the 1884 MCMA Catalogue on the following pages; specifically the listings for the American artists in oil and watercolor.

MASSACHUSETTS CHARITABLE MECHANIC ASSOCIATION
CATALOGUE
Of The
DEPARTMENT OF FINE ARTS

Fifteenth Exhibition

Third Edition

BOSTON

PUBLISHED BY THE ASSOCIATION
1884

CATALOGUE

OIL PAINTINGS BY AMERICAN ARTISTS

Room 1.

Owner

1 PHOEBE JENKS.........Boston
Portrait of a Lady.                    A.W.Wright
2 JOHN J. ENNEKING.......Hyde Park,Mass.
The Coming Storm. Near the Old Greenwood
Homestead, Hyde Park, Mass. $450.
3 CARL GUTHERZ.........St. Louis
A Seasoned Cup.
4 THOMAS HICKS,N.A.......New York
Priscilla.
5 F.H. SAFFORD.........Cambridge
Sunset near Josselin, Brittany.$100.
6 FREDERICK W. KOST......Clifton, N.Y.
Springtime at Garrettson's Staten Island.$350.
7 I.H. CALIGA (STIEFEL).....Boston
Study of Man in Prayer. $250.
8 NEWBOLD H. TROTTER......Philadelphia
Pheasant Shooting. $200.
9 FRANK M. BOGGS.........Paris
Trafalgar Square,November,'83. $1000.
10 FRANK M. BOGGS........Paris
Old House on Canal,Dordrecht,Holland. $600.
11 C.C. BRENNER.........Louisville
A Midsummer Afternoon. $500.
12 D.W. TRYON..........New York
A New England Road. $250.
13 ELIZABETH BOOTT........Boston
Mabel. $150.
14 F.K.M. REHN..........New York
Coming Storm. $400. M. Ream
15 M.F.H. DeHAAS,N.A.......New York
After a Blow. Montauk Point. $1000.
16 CHARLES SPRAGUE PEARCE.....Paris
La Priere. For Sale.
17 S. EMIL CÁRLSEN........Paris
Peonies.                    Noyes & Blakeslee
18 ANNIE C. SHAW.........Chicago
Summer. $500.
19 W.D. STRATTON.........Boston
Apple Trees in Spring Time. $250.
20 L.L. WILLIAMS.........Paris
Good Comrades. $600.
21 HARRY CHASE, A.N.A.......New York
Arrived In. $400.
22 KRUSEMAN VAN ELTEN,N.A......New York
Late Afternoon in the Woods. $500.
23 WM.L.PICKNELL.........Paris
Cote de Ipswich. $1500.
24 GEORGE WHARTON EDWARDS......Paris
Retour de la Peche. $1000.
25 A.M. WHITE..........Boston

228

Oranges. $50.
26 JAMES P. KELLY.........Philadelphia
Whetting the Scythe. $250.
27 LUCIA S. BLISS.........Boston
Roses. $50.
28 J.M. STONE............Boston
Study, Head. $300.
29 JULIAN SCOTT, A.N.A.......New York
A Sortie,Petresburg,1864. $150. T.A. Wilmurt
30 M.J. HEADE............New York
Sunset in Florida. $200.
31 HUBERT HERKOMER........London
Portrait.                    George Hensched
32 J.H. DOLPH,A.N.A........New York
Setter Dogs. $350.
33 F.D. MILLET,A.N.A........New York
Regina Convivii. $1250.
34 E.L. DURAND...........New York
Reading Robinson Crusoe. $175
35 J.H. TWACHTMAN..........Cincinnati
On the River Maas,Holland. $250.
36 JAMES P. KELLY.........Philadelphia
Three Score and Ten. $200.
37 ANNA P. DIXWELL.........Boston
Old House, Richmond. $75.
38 PETER ROOS............Champaign,Ill.
Rab.                         Chas.Barron
39 BRUCE CRANE............New York
A Lowland View.$100.          Nathan Ullman
40 CHAS.A. WALKER..........Boston
Among the Hemlocks. Winter at Saxonville $100.
41 CHARLES VILLIERS........Boston
Miss Nellie Grant
42 F.F. APPLEQUIST.........Beachmont,Mass.
The Listless Fisher. $125.
43 ALFRED ORDWAY..........Boston
Pepita. $500.
44 N.W. McLEAN............Boston
Evening Landscape. $35.
45 C.C. COLEMAN...........Rome
Lady of 15th Century.         L.A. Wright
46 F.A.BRIDGMAN..........Paris
Woman of Constantinople.      C.W. Norton
47 I.M.GAUGENGIGL.........Boston
Dolce far Niente.             C.W. Norton
48 I.M.GAUGENGIGL.........Boston
In the Boudoir.               C.W. Norton
49 W.M. CHASE...........New York
Court Jester.                 C.W. Norton
50 GEORGE FULLER(deceased)......
The Dunce.                    S.D. Warren
51 E.L. WEEKS...........Paris
Crossing the Desert.          C.W. Norton
52 S.EMIL CARLSEN.........Paris
Peonies.                      F.G. Macomber
53 WM. HART............New York
Landscape and Cattle.         L.A. Wright
54 F.D.WILLIAMS..........Paris

The Heights of Sainte Marguerite.$600.
55 SAMUEL GUILD.........Boston
Still Life.                          James Guild
56 J.WELLS CHAMPNEY,A.N.A.....New York
Melissa. $750.
57 F.A. BRIDGMAN,N.A.......Paris
"What shall I sing?"(Int.Cairo Cafe).$1400.
                                    Noyes & Blakeslee
58 W.H. HILLIARD.........Boston
Otter Cliffs.$300.              Noyes & Blakeslee
59 L.M. WILES..........La Roy,N.Y.
Anne Hathaway's Cottage.$200.
60 ELIZABETH BOOTT........Boston
Daddy Jim. $60.
61 D.F. HANSBROUCK........New York
November Afternoon in the Catskills.$125.
62 J.C. NICOLL,A.N.A.......New York
On Marblehead Neck. $300.
63 RUDOLPH F. BUNNER.......New York
Near the Beach. $100.
64 NATHAN ULLMAN.........New York
Old House,Adirondack Mountains.$75.
65 H.R. BURDICK.........Boston
Portrait,Gen.C.B.Norton.
66 R.W. VAN BOSKERCK.......New York
Old Red Mills,Bergen Co.,N.Y.$300.
67 EDGAR PARKER.........Boston
Portrait.                    John Smith,Andover
68 W.H. HILLIARD.........Boston
Village of Geisen.$400.          Noyes & Blakeslee
69 J.FOXCROFT COLE........Boston
The Abbajona River,Winchester,Mass.$300.
70 WM.T.RICHARDS.........New York
Clearing off. $550.
71 C.H. TURNER..........Boston
The Member from Cranberry Centre.$250.
72 W.B. BAIRD..........Paris
Near the Farm. $60.
73 M. REAM............New York
Melons. $350.
74 E.T. BILLINGS.........Boston
Portrait-George Fuller.
75 W. GEDNEY BUNCE........New York
Drifting. $225.
76 ELLEN M. CARPENTER......Boston
Roses. $100.
77 J.HARVEY YOUNG.........Boston
Portrait.                    Mrs.Oliver Ditson
78 GEORGE L. BROWN........Malden,Mass.
Grand Canal,Venice(near Noon).$1200.
79 N.T.LEGANGER.........Boston
Happy Hours. $1000.
80 CLINTON OGILVIE,A.N.A.....New York
Near Vichy,France. $150.
81 E.F. ANDREWS.........Washington
Waterloo and Sedan. $300.
82 WESLEY WEBBER.........Boston
View on the Cobbossee Stream,Me.

83 L.L.WILLIAMS. . . . . . . . .Paris
Three Thieves. $500.
84 C.T. PHELAN.. . . . . . . . .New York
Landscape and Goats. $400.
85 CHAS.A.WALKER.. . . . . . . .Boston
A Summer Afternoon,Campton,N.H.$150.
86 I.H.CALIGA(STIEFEL).. . . . . .Boston
Consolation. $450.
87 ALFRED ORDWAY.. . . . . . . .Boston
On Wakefield Pond. $200.
88 E.L. SMYTH. . . . . . . . . .Hartford
One of Nature's By-ways.$125.
89 ELLEN M. CARPENTER. . . . . .Boston
Old Mill in Southboro. $150.
90 GEORGE HETZELL. . . . . . . .Pittsburg
Fruit. $350.
91 OTIS S. WEBER.. . . . . . . . Boston
The Signal. $600.
92 JOHN J. ENNEKING. . . . . . .Hyde Park,Mass.
Cloudy Day,Greenwood Pool,Hyde Park,Mass.$800.
93 A.C. THACHER. . . . . . . . .New York
Yellow Roses. $75.
94 J.C.NICOLL,A.N.A. . . . . . .New York
A Bit of Straitsmouth Island,Mass.$300.
95 ALFRED ORDWAY.. . . . . . . .Boston
In West Roxbury Park. $300.
96 F.CHILDE HASSAM.. . . . . . .Boston
Landscape-Early Summer $350.
97 CHAS.H. DAVIS.. . . . . . . .Paris
Old Ground. $200.
98 M.J. HEADE. . . . . . . . . .New York
Sunset,Passamaquoddy Bay.$350.
99 E.SUTTON. . . . . . . . . . .Mont Eagle,Tenn.
Roses. $150.
100 M.F.H.DeHAAS,N.A. . . . . . .New York
Early Morning, Sag Harbor.$250.
101 ELLEN M. CARPENTER. . . . . .Boston
Portrait. $75.
102 W.M.HUNT(deceased). . . . . .
Reverie.                     Joseph Burnett
103 DAVID NEAL. . . . . . . . . .Munich
Portrait.                    G.F. Macomber
104 ARMAND DUMARESQ.. . . . . . .
The Geneva Conference.       E.D. Jordan
105 ANNIE T.BURT. . . . . . . . .Providence
Fruit Piece. $200.
106 CLARA S. HOWE.. . . . . . . .Philadelphia
Lobster. $45.
107 GEO.A.WENTWORTH.. . . . . . .Boston
Cow Lowing. $100.
108 W.P.PHELPS. . . . . . . . .Lowell
Blackberrying.View in Dublin,N.H.$400.
109 CHESTER LOOMIS. . . . . . . .Paris
A Cup of Tea.$225.            Noyes & Blakeslee
110 CLINTON OGILVIE,A.N.A.. . . . .New York
Summer at Anteuil,France.$125.
111 A.T.BRICHER,A.N.A.. . . . . .New York
Cliffs on Appledore Island.$450.  Nathan Ullman

231

112 FREDERICK W. KOST........Clifton,N.Y.
Winter, Normandy. $100.
113 S.W. WHITMAN.........Boston
The Song.                        S.D. Warren
114 F.D.WILLIAMS.........Paris
The End of the Day. $250.
115 F.SCHUCHARDT,Jr........New York
Christmas Eve. $250.
116 JOSEPH LYMAN,Jr........New York
On Star Island-Isles of Shoals
117 F.K.M.REHN.........New York
Little Good Harbor Beach,Cape Ann.$100.
118 W.GEDNEY BUNCE.........New York
Fishing-Boats on the Lagoon.$325.
119 F.D.MILLET,A.N.A........New York
A Toilette. $500.
120 A.F.TAIT,N.A.........New York
A Happy Family at Home. $200.
121 J. APPLETON BROWN........Boston
A Country Road. $450.
122 HENRY MOSLER.........St.Cloud,France
The Village Clockmaker.$3000.    Noyes & Blakeslee
123 JULIUS L. STEWART........Paris
Honey-Moon.                    Cornelius Vanderbilt
124 JAMES G. TYLER.........Providence
After a Tempest. $500.
125 FRANK FOWLER.........New York
In the Spring Time. $150.
126 E.SUTTON...........Mont Eagle,Tenn.
Little Boy Jamie. $150.
127 E.I.DURAND..........New York
The Little Juggler. $150.
128 J. FOXCROFT COLE........Boston
Spring. $450.
129 JAMES D. SWORD.........Philadelphia
Early Industry. $150.
130 W.GEDNEY BUNCE.........New York
A Gray Day,Venice. $75.
131 W.S. MACEY..........New York
Scene on Taunton River. $350.
132 CHESTER LOOMIS.........Paris
Ennuis de Voyage.$450.              Noyes & Blakeslee
133 THOS.B.CRAIG.........Philadelphia
A Jersey Byway. $150.
134 CHARLES RUSSELL LOOMIS.....Hartford
Girl and Globe. $200.
135 WILLIS S. ADAMS........Florence,Italy
Venetian Rag Picker. $200.
136 MARGARET W. LESLEY.......Philadelphia
Rosebuds. $500.
137 GEORGE W.MAYNARD,A.N.A.....New York
Reflection. $200.
138 C.E.L.GREEN..........Boston
Jeffries Point,Swampscott,Mass.$300.
139 RUGER DONOHO..........Paris
The Mount $800.                    Noyes & Blakeslee
140 JAMES B. SWORD.........Philadelphia
Evening. $600.

141 CHAS.H. WOODBURY. . . . . . . .Lynn,Mass.
Condemned. $150.
142 A. BIERSTADT,N.A. . . . . . . .New York
Old Faithful Geyser. $5000.
143 ELIZABETH BOOTT.. . . . . . . .Boston
Sheep Pasture. $100.
144 ALLISTER SUMNER JONES . . . . .Boston
Solitude. $150.
145 LOUIS SCHULTZE. . . . . . . . .St. Louis
The Hunter's Return. $500.
146 ARTHUR QUARTLEY,A.N.A.. . . . .New York
Rugged Maine. $700.
147 W.F. HALSALL. . . . . . . . .Boston
Stormy Day. $500.
148 J.ALDEN WEIR. . . . . . . . .New York
Roses. $125.
149 WALTER BLACKMAN.. . . . . . .Paris
Peasant Girl. $150.
150 CHARLES M. DEWEY. . . . . . .New York
Moonlight. $50.
151 BERTHA VON HILLERN. . . . . .Boston
Evening on the River,Indiana.$35.
152 GEORGE W. MAYNARD,A.N.A.. . . .New York
A Winter Reverie. $300.
153 ROBERT W. VONNOH. . . . . . .Boston
Portrait.                        Mrs.Frank Maynes
154 THOMAS ROBINSON.. . . . . . .Providence
Cattle and Landscape. $600.
155 L.D.ELDRED. . . . . . . . . .Boston
Surf-beaten Rocks. $300.
156 John J. Soren.. . . . . . . .Boston
Mount Mansfield,Vt.
157 ELIZABETH F.BONSALL . . . . .Philadelphia
The Work Hour. $150.
158 BURR H. NICHOLLS. . . . . . .New York
Water Carrier,Venice. $200.
159 WALTER F. LANSIL. . . . . . .Boston
The Veteran of the Heroic Fleet.$600.
160 E.F. WOODWORTH. . . . . . . .Boston
On the Coast. $75.
161 J.H.WITT. . . . . . . . . . .New York
Going for a Row. $800. M. Ream
162 J.F. CROPSEY,N.A. . . . . . .New York
Mount Washington from the Conway Valley.$1000.
163 GEORGE INNESS,Jr. . . . . . .New York
The Meet.                        S.D.Warren
164 ELLIE R. JENKINS. . . . . . .Boston
Colosseum. $100.
165 ELLIOT DAINGERFIELD . . . . .New York
The Fool's Joke.$100.            Nathan Ullman
166 A.BORRIS. . . . . . . . . . .Boston
Polish Grain Boat. $200.
167 MARION H. BARNES. . . . . . .Boston
Portrait.                        J.C.Watson
168 PHOEBE JENKS. . . . . . . . .Boston
The Gipsy.                       Willard White
169 CHARLES H. MILLER,N.A.. . . . .New York
Bouquet of Oaks,Stewart's Pond,Jamaica,L.I.$300.

170 RHODA HOLMES NICHOLLS.. . . . .New York
Primavera Venezia. $200.
171 WALTER SATTERLEE,A.N.A. . . . .New York
The Two Roses. $500.
172 GEO.L. BROWN. . . . . . . . .Boston
View of Subiaco,among the Appenines.For Sale.
173 JAMES B.SWORD . . . . . . . .Philadelphia
If---. $500.
174 S.C. HUSKINS. . . . . . . . .Lynn,Mass.
The Old Lewis House, Lynn.$75.
175 JULIAN RIX. . . . . . . . . .Patterson,N.J.
A Clifton Meadou. $250.
176 FRANZ lENBACH.. . . . . . . .Munich
Portait of Dr. Dallinger.      George Henschel
177 S.W.GRIGGS. . . . . . . . . .Boston
Waiting for Breakfast. $100.
178 T. DEFREES. . . . . . . . . .Boston
Just before Sunset,Grand Canal.$250.
179 SUSIE ENGLAND.. . . . . . . .New York
A Serious Case. $400.
180 W.SCOTT LEIGHTON. . . . . . .Boston
Spring Ploughing.$200.      Noyes & Blakeslee
181 ROBERT W. VONNOH. . . . . . .Boston
Portrait-John P. Conway. For Sale.
182 J.JAY BARBER. . . . . . . . .Columbus
Down by the Marshy Shore.
183 P.E. ROTHERMEI. . . . . . . .New York
Hypatia.
184 JULIUS L. STEWART.. . . . . .Paris
Reverie.$450.      Noyes & Blakeslee
185 ARTHUR QUARTLEY,A.N.A.. . . .New York
A Summer Morning. $3000.
186 W.F. PASKELL. . . . . . . . .Boston
Sunset - Sketch $45.
187 J.H. DOLPH,A.N.A. . . . . . .New York
Deacon Smith's Hat. $125.
188 W.B. BAIRD. . . . . . . . . .Paris
A Family Group. $35.
189 E.M. BANNISTER. . . . . . . .Providence
A New England Hillside. $800.
190 WESLEY WEBBER . . . . . . . .Boston
Low Tide,Boothbay,Me
191 D.W. TRYON. . . . . . . . . .New York
April in France. $200.
192 DE SCOTT EVEANS.. . . . . . .Cleveland
Poetry Poll.
193 M. DeFOREST BOLMER. . . . . .New York
The Moorland Path. $350.
194 J. APPLETON BROWN.. . . . . .Boston
The Sea. $750.
195 HENRY SANDHAM.. . . . . . . .Boston
A Bicycle Party.      Col.Albert A.Pope
196 CHAS.A. WALKER. . . . . . . .Boston
Rhododendrons. $175.
197 RUFUS S. MERRILL. . . . . . .Boston
Home of the Red-Tailed Hawk.$500.
198 R.SWAIN GIFFORD,N.A.. . . . .New York
A Country Home. $1500.

199 J.H. WITT.. . . . . . . . . .New York
At the Sea Shore.$400.          M.Ream
200 R.W.VAN BOSKERCK. . . . . . .New York
A Summer Landscape. $90.
201 J.FOXCROFT COLE.. . . . . . .Boston
Pastoral Scene in Normandy.$1200.
202 ELLEN DAY HALE. . . . . . . .Boston
An Old Retainer. $250.
203 C.MORGAN McILHENNY. . . . . .New York
Gray Summer Noon.
204 F. CHILDE HASSAM. . . . . . .Boston
Some Old Houses,Nantucket.$300.
205 J.M. STONE. . . . . . . . .Boston
Reminiscence of Battle of Newberne,N.C.$350.
206 J.ALDEN WEIR. . . . . . . .New York
Flowers. $250.
207 BURR H. NICHOLLS. . . . . . .New York
Sunny Hours. $350.
208 J.W. ALEXANDER. . . . . . . .New York
Mr. Jefferson as Bob Acres.$2000.
209 OTTO GRUNDMANN. . . . . . . .Boston
Portrait.
210 WALTER L. DEAN. . . . . . . .Boston
Low Tide. Scheveningen.
211 WALTER L. DEAN. . . . . . . .Boston
Market Boat. Capri.
212 WALTER L. DEAN. . . . . . . .Boston
At the Fountain. Capri.

WATERS, Etc,

ROOM 8

Owner

1 CHARLES A.WALKER........Boston
The Meadow Pool.(Monotype)$100.
2 CHARLES A.WALKER........Boston
Surf at Nahant.(Monotype).$100.
3 CHARLES A.WALKER........Boston
Landscape and Cattle.(Monotype).$150.
4 CHARLES A.WALKER........Boston
Twilight.(Monotype). $75.
5 CHARLES A.WALKER........Boston
The Meadow Pasture.(Monotype).$87.50.
6 CHARLES A.WALKER........Boston
Landscape.(Monotype). $75.
7 CHARLES A.WALKER........Boston
Surf at Nahant.(monotype).$125.
8 CHARLES A.WALKER........Boston
Revere beach.(Monotype).$75.
9 CHARLES A.WALKER........Boston
Midsummer.(Monotype). $75.
10 CHARLES A.WALKER........Boston
Winter Twilight,Saxonville,(Monotype).$90.
11 CHARLES A.WALKER........Boston
The Brook.(Monotype). $25.
12 CHARLES A.WALKER........Boston
The Pasture Road.(Monotype).$25.
13 J.H. TWACHTMAN........Cincinnati
Venetian Scene. $40.
14 FRANK MYRICK.........Boston
Interior of Fish-Oil House.$25.
15 AGNES S. WHITING........Reading,Mass.
Easter Lillies.                    Mrs.C.E.Damon
16 ELIZABETH CHADBOURNE......Boston
Nasturtium. $15.
17 WM. WALTON..........New York
Belinda. $150.
18 L.B. FIELD..........Boston
Pansies. $25.
19 LOUIS K.HARLOW........Boston
Surf at Nantucket. $25.
20 R.M. BAILEY,Jr........Boston
Sketch. $50.
21 J.H. TWACHTMAN........Cincinnati
View in Venice. $40.
22 FANNY W. TEWKSBURY......Newtonville,Mass.
A Rocky Slope. $12.
23 WALTER SATTERLEE,A.N.A....New York
Puck. $50.
24 S.M. BARSTOW.........Brooklyn
Lily Pond.Bethel,Me. $30.
25 ELIZABETH N. LITTLE.......Auburndale,Mass.
A Few Thoughts. $25.
26 AGNES D. ABBATT........New York
Roses. $45.
27 SARAH M. VOSE.........Hyde Park,Mass.

Fruit. $20.
28 ELIZABETH CHADBOURNE......Boston
Trout Brook,Maine. $30.
29 M.C.W.REID..........New Rochelle,N.Y.
Roses. $15.
30 S.W.HAGGERTY.........Boston
The Old Doorway.
31 J.H. TWACHTMAN........Cincinnati
Venetian Scene. $35.
32 H.S.TALBOT..........Boston
Cliffs at Star Island,Isles of Shoals.$30.
33 G.H.McCORD,A.N.A.......Morristown,N.J.
Moonlight on a Canal $95.
34 HELEN S. FARLEY........Boston
Basket of Birds' Eggs. $35.
35 MARY E. JOSLYN........Boston
Street in Concarneau,France.$25.
36 MARY E.JOSLYN.........Boston
Interior of St.Etienne du Mont,Paris.$35.
37 ALBERT H. MUNSELL........Boston
Pilot-Boat chasing a Steamer.
38 F.T.STUART..........Boston
Study of Roses. $15.
39 G.H.McCORD,A.N.A.......Morristown,N.J.
Early Candlelight. $75.
40 W.F. PASKELL.........Boston
Mountain Brook. $20.
41 L.B. HUMPHREY.........Boston
Landscape at Osterville.$30.
42 J.H. TWACHTMAN........Cincinnati
Venice. $35.
43 J.H. TWACHTMAN........Cincinnati
Venetian Scene. $25.
44 CHARLES E. DANA........Philadelphia
LaPremiere Pose. $150.
45 GEO.E.MORRIS.........Lawrence,Mass.
Symplocarpus. $30.
46 J.H. TWACHTMAN........Cincinnati
Holland Village. $50.
47 WALTER McEWEN.........Boston
Sylvia.
48 R.M. BAILEY,Jr........Boston
Old Newburyport. $50.
49 E.L.S. ADAMS.........Chicago
Don Roderigo. $75.
50 F.CHILDE HASSAM........Boston
A Gray Morning.San Giorgio,Venice.$75.
51 M.G.WHEELOCK.........Boston
Landscape.                      Joseph Burnell
52 H.W.RANGER..........New York
In French Canada. $150.
53 B.F. NUTTING.........Boston
A New England Farm. Indian Summer.$10.
54 CLARA M. COLCORD.......Swampscott,Mass.
Portrait Sketch.                B.W. Redfern
55 FANNY W. TEWKSBURY......Newtonville,Mass.
Afterglow. $25.
56 F.HOPKINSON SMITH.......New York

"For men may come and men may go,
But I go on forever."
57 J.ALDEN WEIR.........New York
Puritan Girl. $750.
58 F.CHILDE HASSAM........Boston
A Gondolier,Venice. $100.
59 G.H. McCORD,A.N.A........Morristown,N.J.
April Day. $125.
60 S.P.R.TRISCOTT........Boston
Evening,Arichat,Cape Breton.$75.
61 L.B.HUMPHREY.........Boston
Figure. $25.
62 J.M.FALCONER.........Brooklyn
Scottish Misty Morning. $130.
63 EMILY PERCY MANN.......Boston
Roses. $20.
64 LUCIA S. BLISS........Boston
Birches. $25.
65 J.H. TWACHTMAN........Cincinnati
A Scottish Moor. $30.
66 CHAS. WESLEY SANDERSON.....Boston
Moss Glen,Adirondacks. $90.
67 WALTER SATTERLEE,A.N.A.....New York
Two Sides of a Convent Wall.$250.
68 GEO. E. MORRIS........Lawrence,Mass.
Lemonade. $35.
69 ELIZABETH CHADBOURNE......Boston
Study of Pansies. $40.
70 CARLTON T. CHAPMAN......New York
Shifting Sand at Coffin's Beach.Cape Ann.$30.
71 CHAS. WESLEY SANDERSON.....Boston
Lake Dunmore, Vt. $300.
72 ROGER TAPPAN.........Haverhill,Mass.
A June Morning.
73 WM. WALTON..........New York
The Dance. $50.
74 FANNY W. TEWKSBURY......Newtonville,Mass.
Buttonwood and Willows. $20.
75 F.De B. RICHARDS.......Philadelphia
Old Mill, Sea Isle City, N.J. $75.
76 BYRON ALBEE..........Boston
The Old Pasture. $30.
77 HELEN A. PRESSEY.......Winchester,Mass.
Roses. $20.
78 AGNES D.ABBATT........New York
In Lobster Lane, Magnolia,Mass.$175.
79 SARAH M. VOSE..........Hyde Park,Mass.
Poppies. $50.
80 BERTHA VON HILLERN......Boston
A Bit of Strasburg, Va. $20.
81 SARAH EDEN SMITH.......Salem,Mass.
Spa-na-da-ka.Arickaree Girl.$20.
82 A.E.C. SPENCER........Cambridgeport,Mass.
Portrait                          J.H.Wells
83 S.B. ALEXANDER........Boston
Miss Daisy.
84 E.E. PAGE..........Boston
Trout Brook.

85 NELLIE E. BROWNE. . . . . . .Boston
Terrier Dog. $20.
86 A.E.C. SPENCER. . . . . . . .Cambridgeport,Mass.
Portrait.                               Dr.E.E.Spencer
87 MARIA J.C.BECKET. . . . . . .Boston
Sketch of Oaks. $15.
88 KRUSEMAN VAN ELTEN,N.A. . . . .New York
Going to Pasture. $100.
89 SARAH EDEN SMITH. . . . . . .Salem,Mass.
Aunt Nancy. $18.
90 ROGER TAPPAN. . . . . . . . .Haverhill,Mass.
Jackson Falls.
91 FRANK HENDRY. . . . . . . . .Boston
Shore Sebago Lake. $20.
92 LUCIA S. BLISS. . . . . . . .Boston
Study. $15.
93 LUCIA S. BLISS. . . . . . . .Boston
Study. $15.
94 ELIZABETH N. LITTLE.. . . . .Auburndale,Mass.
Cherry Blossoms. $20.
95 MARY E. JOSLYN. . . . . . . .Boston
Mountain Laurel. $20.
96 J.M.FALCONER. . . . . . . . .Brooklyn
Farm Yard, East Hampton, L.I.$30.
97 W.F. PASKELL. . . . . . . . .Boston
Road to Pasture. $18.
98 HELEN M. KNOWLTON.. . . . . .Boston
Study of a Head. $75.
99 NELLIE E. BROWNE. . . . . . .Boston
Angola Cat. $20.
100 F.O.C.DARLEY,N.A. . . . . . .Delaware
Leisure.$30.                        R.Dudensing & Son
101 PERCIVAL DELUCE.. . . . . . .New York
Caelia. $30.
102 W.L.SHEPPARD. . . . . . . . .Richmond,Va.
Some Peach Blossoms. $3.
103 AGNES D.ABBATT. . . . . . . .New York
Looking toward Manchester, Mass.$25.
104 A.E.C. SPENCER. . . . . . . .Cambridgeport,Mass.
Portrait.                           Dr.E.E.Spencer
105 S.M. BARSTOW. . . . . . . . .Brooklyn
Ferns near Laurel House,Catskill,N.Y.$75.
106 G.H.McCORD,A.N.A. . . . . . .Morristown,N.J.
Brook near Mendham,N.J. $75.
107 GEO.J.LA CROIX. . . . . . . .Boston
American Falls,Niagara. $18.
108 GEORGE W.MAYNARD,A.N.A. . . . .New York
Autumn. $40.
109 F.O.C.DARLEY,N.A. . . . . . .Delaware
Toil.$30.                            R.Dudensing & Son
110 ANNA P. DIXWELL.. . . . . . .Boston
Empire. $30.
111 J.C.NICOLL,A.N.A. . . . . . .New York
"Her day is almost o'er."$150.
112 ROGER TAPPAN. . . . . . . . .Haverhill,Mass.
Old Houses,Boston.
113 HENRY HOLMES. . . . . . . . .Boston
A May Day.

114 MISS VINSON.. . . . . . . . .Boston
Golden Rod.
115 CLARA M. COLCORD. . . . . . .Swampscott,Mass.
Wilson's Point,Swampscott.$12.
116 COLIN C.COOPER,Jr.. . . . . . .Philadelphia
Stone Alley, Nantucket, Mass.$20.
117 DAVID COX.. . . . . . . . . .London
Landscape.                         Joseph Burnett
118 S.R.BURLEIGH. . . . . . . . .Providence
The Curling of the Ringlet.$150.
119 HELEN A. PRESSEY. . . . . . .Winchester,Mass.
Asters. $25.
120 CHARLES E.DANA. . . . . . . .Philadelphia
In the Court of Heidelberg Castle.$75.
121 W.HAMILTON GIBSON.. . . . . . .New York
In the Meadows.
122 EMILY PERCY MANN. . . . . . .Boston
Peonies.                           Dr.Sophia C.Jones
123 COLIN C. COOPER,Jr. . . . . . .Philadelphia
Wharf at Nantucket. $20.
124 F.T.STUART. . . . . . . . . .Boston
Sketch of Old House at Scotch Plains,N.J.$25.
125 COLIN C. COOPER,Jr. . . . . . .Philadelphia
On the Wind. $25.
126 W.S. BUCKLIN. . . . . . . . .Red Bank,N.J.
"Get out of my path." $150.
127 LOUIS K.HARLOW. . . . . . . .Boston
Willows at Winthrop. $60.
128 F.WM.HARTWELL.. . . . . . . .Boston
A Path in the Woods. $30.
129 S.P.R.TRISCOTT. . . . . . . .Boston
Arichat,Cape Briton. $250.
130 WM. WALTON. . . . . . . . . .New York
St. Cecilia,Martyr. $200.
131 F.HOPKINSON SMITH.. . . . . .New York
Summer Morning in Venice.$300.
132 COLIN C. COOPER,Jr. . . . . . .Philadelphia
Beating Up. $25.
133 F.HOPKINSON SMITH.. . . . . .New York
Private~Apartments,Harlem Flats.
134 CARLTON T. CHAPMAN. . . . . .New York
Fishing Schooners off Gloucester.$35.
135 L.B. FIELD. . . . . . . . . .Boston
Roses. $40.
136 FRANK MYRICK. . . . . . . . .Boston
Fish House,Monhegan Island,Me.$25.
137 MARY E. JOSLYN. . . . . . . .Boston
Cavalier. $40.
138 W.HAMILTON GIBSON.. . . . . .New York
Blossom Time. $75.
139 CHARLES E.DANA. . . . . . . .Philadelphia
Street Scene in Cairo. $75.
140 HELEN A. PRESSEY. . . . . . .Winchester,Mass.
Dandelions. $15.
141 HOMER D. MARTIN,N.A.. . . . .New York
Coast Meadow.$40.                  T.A.Wilmurt
142 CHAS. WESLEY SANDERSON. . . . .Boston
Old and Young Growth. $75.

143 F.De B.RICHARDS........Philadelphia
At Anglesea,N.J. $75.
144 KRUSEMAN VAN ELTEN,N.A.....New York
The Mill Pond. $200.
145 FRANK MYRICK.........Boston
A Bit of Monhegan. $25.
146 WM.J. WHITTEMORE.......New York
Autumn near Brattleboro,Vt.$15.
147 B.F. NUTTING.........Boston
A New England Farm.- Gone West.$40.
148 EMILY PERCY MANN........Boston
Hollyhocks. $80.
149 F. HOPKINSON SMITH......New York
Old Well of the Alhambra.$150.
150 CLARA M. COLCORD.......Swampscott,Mass.
Portrait.
151 NELLIE LITTLEHALE........Stoneham,Mass.
Oleander of California. $7.
152 AGNES S. WHITING.......Reading,Mass.
Study of a Cabbage. $25.
153 NELLIE LITTLEHALE........Stoneham,Mass.
Wild Sunflower of Montana.$7.
154 GEO.N. CASS(deceased)......
Summer Afternoon.           L.M.Brainard

### INDEX -OIL PAINTINGS

### AMERICAN ARTISTS

#### Room 1

| | |
|---|---|
| Hilliard,W.H. | 58,68 |
| Howe,Clara S. | 106 |
| Hunt,W.M. | 102 |
| Huskins,S.C. | 174 |
| | |
| Inness,Geo.,Jr. | 163 |
| | |
| Jenks,Phoebe | 1,168 |
| Jenkins,Ellie R. | 164 |
| Jones,A.S. | 144 |
| | |
| Kelly,James P. | 26,36 |
| Kost,Frederick W. | 6,112 |
| | |
| Lansil,Walter F. | 159 |
| Leganger,N.T. | 79 |
| Leighton,W.Scott | 180 |
| Lesley,Margaret W. | 136 |
| Lenbach,Franz | 176 |
| Loomis,Chester | 109,132 |
| Loomis,Charles R. | 134 |
| Lyman,Joseph,Jr. | 116 |
| | |
| McIlhenny,C.Morgan | 203 |
| McLean,N.W. | 44 |
| Macey,W.S. | 131 |
| Maynard,Geo.W. | 137,152 |
| Merrill,Rufus S. | 197 |
| Miller,Charles H. | 169 |
| Millet,F.D. | 33,119 |
| Mosler,Henry | 122 |
| | |
| Neal,David | 103 |
| Nicholls,Burr H. | 158,207 |
| Nicholls,Rhoda Holmes | 170 |
| Nicoll,J.C. | 62,94 |
| | |
| Ogilvie,Clinton | 88,118 |
| Ordway,Alfred | 43,87,95 |
| | |
| Parker,Edgar | 67 |
| Paskell,W.F. | 186 |
| Pearce,Charles Sprague | 16 |
| Phelps,W.P. | 108 |
| Picknell,Wm.L. | 23 |

| | |
|---|---|
| Rix,Julian | 175 |
| Robinson,Thomas | 154 |
| Roos,Peter | 38 |
| Rothermel,P.E. | 183 |
| | |
| Safford,F.H. | 5 |
| Sandham,Henry | 195 |
| Satterlee,Walter | 171 |
| Schultze,L. | 145 |
| Schuchardt,F.Jr. | 115 |
| Scott,Julian | 29 |
| Shaw,Annie C. | 18 |
| Smyth,E.L. | 88 |
| Soren,John J. | 156 |
| Stewart,Julius L. | 123,184 |
| Stone,J.M. | 28,205 |
| Stratton,W.D. | 19 |
| Sutton,E. | 99,126 |
| Sword,James B. | 129,140,173 |
| | |
| Tait,A.F. | 120 |
| Thacher,A.C. | 93 |
| Trotter,Newbold H. | 8 |
| Tryon,D.W. | 12,191 |
| Turner,C.H. | 71 |
| Twachtman,J.H. | 35 |
| Tyler,James G. | 124 |
| | |
| Ullman,Nathan | 64 |
| | |
| Van Boskerck,R.W. | 66,200 |
| Van Elten,Kruseman | 22 |
| Villiers,Charles | 41 |
| Von Hillern,Bertha | 151 |
| Vonnoh,Robert W. | 153,181 |
| | |
| Walker,Chas.A. | 40,85,196 |
| Weber,Otis S. | 91 |
| Webber,Wesley | 82,190 |
| Weeks,E.L. | 51 |
| Weir,J.Alden | 148,206 |
| Wentworth,Geo.A. | 107 |
| White,A.M. | 25 |
| Wiles,L.M. | 59 |
| Williams,L.L. | 20,83 |
| Williams,F.D. | 54,114 |

# - *MCMA Catalogue* -

# APPENDIX B

## The Journal of William Frederick Paskell

• SELECTED SECTIONS •

### Boston, Wed. December 5, 1883

Today I saw the collection that I spoke of yesterday sold. They sold for smaller prices than I thought they would. Some of the heads were sold as low as 25. a piece, and none exceeded a dollar. But even these prices were too much for such rubbish. There were a few tolerable good copies of barnyard scenes knocked down at $4.00 and $5.00. One picture, a copy from an oil painting by Raphael was put up and sold for $4.00. This so affected the auctioneer that he declared with great emotion, "Gentlemen and ladies I have sold in thirty years experience, just 313 copies of that picture not one of them brought me less than $100. Alas!" Every time a picture was sold, some exclamation was uttered by the auctioneer about the poor taste of his audience.

### Sunday, December 9

Began a watercolor painting, 14 x 20. It is an autumn scene and I have a good chance for golden yellow and black and grey. It is a little bit of road and a few bare trees and a hill in the distance. 2 figures are coming up the road. In the afternoon I went sketching in Day's Woods and made a pencil sketch of a tree trunk. In the evening I went to Jamaica Pond and we had a row in a boat. It was a splendid moonlight night but extremely cold. A curious blue haze obscured the shores of the pond but the higher parts of the trees were seen quite plainly. The haze or mist seemed to cover the lower part of the shore like a veil. The water was very smooth and no wind could be felt.

**Monday, December 10**

Read a few chapters in "Modern Painters." More and more interesting.

**Tuesday, 11th**

This evening I found a suitable room for the club and we occupy it next week.

**Wed. 12th**

We had a meeting of the club at Miss Rogerson's house, to arrange a few matters and do a little drawing. We practiced some simple cubes and shading. Some of the novices do not like this plain simple work but want to paint immediately. They seemed to think it was childish to draw a cube and shade a square by means of hatching and crossing lines. But it is only by slow patience and long labor that we can hope to improve our ideas and add to our power.

**1884 January 1, Tuesday**

Varnished one of the pictures that I am going to send to

the Art Club Exhibition this month. I have just sent the schedules. H.O. Walker, one of the most successful portrait painters of this city, told me that the two pictures I am going to send are the best I have and he thinks there is no question about their admission on their merits. "However," says he, "place no dependence on the jury as influence, not merit, is the greatest factor in getting your work in. Do not be discouraged if they are returned, but be assured that there will be 50 worse ones there." DeBlois, Miss Bothe, and Juglariz all advise me to send them. This morning I made a charcoal drawing of the room and took it to Kimball, the editor of "The Artist," who liked it so much that he is going to reproduce it in his paper.

### Thurs. 3

At the room this evening with Reynolds and did a little modelling in terra cotta. We have decided not to have the young lady members and wrote them to that effect.

### Fri. 4

At the room in the evening and made a charcoal drawing. Gendrot has left us. Next to King I depended on him for keeping the club going. He however, prefers his social club to our drawing club. Poor taste for one who wants to be an artist.

### Tue 15

In the morning I went to take a lesson in watercolor from Mr. Sanderson. He is one of the most pleasant men I ever met with. He has a very entertaining way of talking. In the afternoon I worked at the room on two oil paintings. I hear that Mr. Juglariz is very sick. Mr. Winslow asked me today why I did not finish my pictures more. I said to him, "Do you think pictures are manufactured like chairs that every one must needs be polished and finished alike?" He said he thought that everything

should be minutely painted from nature and that if it was any particular place that not even a pebble should be omitted; he had always done so and always should. A very poor way to look at art, I thought. To do that way would be to bring down painting to the level of manufacturing. Painting is the interpretation of nature not the imitation. Gendrot's pictures came back from the Art Club today, not accepted. I hope mine are taken as they are the two best I have. One of them is a sunset sketch from nature. (a 15 minute sketch) and the other is "A Road in West Roxbury."

**Wed. 16**

At Mr. Sandersons' in the morning, painting.

**Thurs. 17**

My pictures are both accepted at the Art Club. I have received a ticket for the private view tomorrow and the reception in the evening.

**Friday 18**

Went to Sanderson's in the morning to paint in water colors. In the afternoon I went to the private view at the Art Club. Over 450 were sent to it but only 162 were taken. Mrs. Chadwick's large canvas "The Fisherman's Return" had a prominent place. It measures 10 feet by 12 feet, as near as you can judge. It does not look like a woman's work and indeed it is very probable that the master in Europe that she studies with had a great deal to do with its painting. Very cold in color and the sky was a dryness that is never seen by the seashore. Mr. Walker has two portraits. Fuller has a splendid portrait that shows more refinement in every way than any other picture in the gallery. His Art is justly called an "Art concealing Art." J. Francis Murphy has a landscape that occupies the same place,

perhaps excepting Enneking's among the landscapes that Fuller's does, among figures. Delicate, rich, and refined coloring. It is very poetical and sweet. Enneking's two pictures are hung on the same wall. The largest one is thought by some to be his best picture ever exhibited. One of my pictures, the largest, is skyed but the little one was hung on the line and the magic word, "Sold" was on it. I received $20.00 for it. I met one of Miss Bothe's pupils and she was talking with ? (a Mr. Dickinson)....
(next two pages partially missing...)

(Bottom of page only) ..(WFP commented on the exhibition and Dickinson disagreed on some point)..However the young lady confirmed my statement. She introduced me to him after this. He was Mr. Dickinson of the Journal. Mr. Enneking then came up and Mr. Dickinson ..(introduced WFP to Enneking who said to him)..

(Bottom of page only) "....remember to keep a reserve in everything" "Never make your colors so brilliant but what if you need it can be made more so." "Come to my studio to see me and bring some of your sketches for me to see." I felt quite elated to think that a man like Enneking would say this to my face, for I know that is apt to make you egotistical and conceited. A number of people congratulated me on my success and wished me good luck. I met Mr. Juglariz who has just recovered from sickness. He is ever so much better than when I saw him last. I am more successful than I thought I would be in regard to my pictures and must try hard to keep it up.

**Sat 19**

The "Journal" this morning contained a full account of the exhibition. Three columns were taken up by it and splendid notices were given to the young painters, Stewart, Woodbury, and myself.

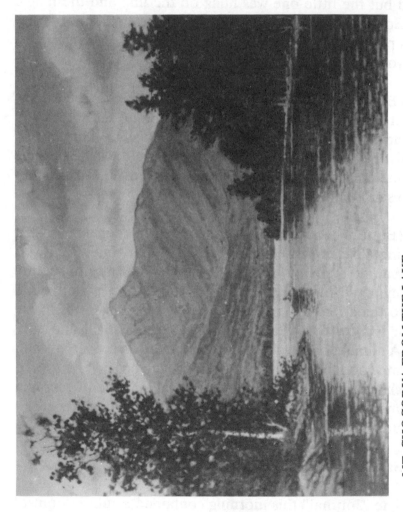

MT. CHOCORUA FROM THE LAKE
*By WILLIAM F. PASKELL - Oil on Canvas, 20"X24"*
(Private collector)

"An interesting feature of the landscapes exhibited is the work that some of our younger painters have sent to it. First among them as at once the newest and one of the most promising, is Mr. William F. Paskell, who has never exhibited any of his works before, yet both of whose contributions to the present display were accepted and hung. They are numbers 87 and 98, both modest in their intention and unaffected in their execution, yet showing an unusual talent, and a great quality of handling that suggests much that is admired in Michel and Rousseau. The painter is but 17 years of age and had little or no instruction in art, but the sign of genius is unmistakably upon him, and he shows unusual promise. One of his pictures was sold at once at yesterday's private viewing, and the other ought, by its merit, also to find a purchaser.

Mr. Woodbury, who has come to be regarded as a feature of all our exhibitions, is represented by two pictures, both very meritorious, and Mr. E.B. Stewart shows a finely painted wood interior."

*Boston Morning Journal*

### Saturday January 19, 1884

Encouragement like this is sufficient to let me see that I should keep on.

### Mon. 21

Went to see the exhibition with Jones and Gendrot in the evening. Met Mr. Eaton, who congratulated me and introduced me to some of his friends.

### Tues. 22

At the exhibition in the evening with Weinz and met Mr. Juglariz who seemed mighty pleased with my pictures.

**Jan. Fri. 25**

Worked on my large oil painting and finished it.

**Sun. 27**

Varnished my large picture and made a pen and ink sketch of it.

**February Fri. 1....to Sun. 10**

Worked on some small water colors all this time and finished my large one at Sandersons.

**Fri 22**

Washington's Birthday. Mr. Dickinson came to see my large picture. I have just finished and he thinks it is one of the best I have done. He is the art critic of the Journal. Mr. Engels also saw my sketches for the first time today and he thought I should keep on. He invited me out to see him.

**Sat 23**

Painted a small watercolor 4 x 5. Went to see Walker's exhibition. Went to see Mrs. Gardner Brewer who bought 2 of my water colors, sketches for $6.00 and gave me a letter of introduction to Mr. Crowinshield of the Art Museum.

**Sun 24**

Began the biggest watercolor I have attempted 19 x 26 "October Morning" Began a mountain sunset 10 x 14 in watercolor.

**Feb. Sat. 29**

Miss Bothe came to see my large painting and she says it is very fine in tone and harmony and she thinks it is well composed.

### March 1 Sunday

Out in the woods in the morning. Went to see Mr. Wagner in the afternoon and he advised me to study the figure.

### Mon 2

Began a new watercolor and laid in the first washes.

### Tues 3

Began a large oil painting (40 x 25) "Close of Day." It describes a roadway through a field and a group of trees on the right. The left foreground is occupied by a few bushes and a pool of water, and the distance is closed in by hills, twilight and a new moon.

### Wed 5

Worked on the same. Mr. Pitman is going to bring a friend to see my big picture who may buy it.

### Sat 8

Worked on a sunset (panel) that I began a few months since and finished it. Miss Bothe has asked Doll and Richards to exhibit my big painting and they have consented.

### March Sat 22

Made two pencil sketches in Day's Woods today and one yesterday. Up to see Mr. Graves at his studio in the morning.

**Mon 24**

Went sketching in the afternoon and painted a bit in water colors (a study of a pool of water with a stretch of field beyond, and a bright blue sky. Also painted a watercolor (6 x 9) of a little stream with the old willow near Willow Pond. The sky was cloudy with a few patches of blue seen through it. In the morning I worked on my big painting 20 x 30 and finished it. Made a pencil sketch today.

**March, Tues 25**

Finished the 6 x 9 picture that I began yesterday and then went sketching in oils. I made a study of an old willow near Willow Pond. In the afternoon I went sketching with watercolors and made a sketch of an old stone wall with an opening from which a pool of water flowed. Also made a 6 x 9 watercolor of a little stream with a group of trees and a small bridge in the middle distance. Also made three pencil sketches.

**Wed 26**

Painted a small 4 x 5 sunset. Too cloudy and rainy for sketching today. Began a small landscape in watercolor.

**Thurs**

Finished the 6 x 9 watercolor I began

**Tuesday**

In the city this afternoon and called on Mr. Graves. He was much pleased by my study of water & field.

**March Friday 28**

Made a sketch of an old willow tree in oils in the morning. Took 7 of my watercolor sketches and 2 oils to show Miss Balch who paints a great deal in watercolors. She was greatly pleased with them all and spoke quite well of them. In the evening I began two watercolor sketches of old willow stumps. I find that by taking a true but slight pencil sketch and by noting down the chief points of a scene by means of notes that you can produce a picture better in all respects than a mere composition.

**Sat 29**

Finished the two willows that I began last night. They have come better than I expected and one of them has a nice passage of light sky in it.

**March Sun 30**

Painted an oil painting 12 x 20 this afternoon and made a pretty good success. It describes a field on an autumn day. Sky cloudy with a light piece in the distance lighting up the landscape. A group of trees occupy the middle distance and a little stream of water flows around them into the foreground. In the evening I began a 6 x 9 watercolor, "Willow Tree, Brookline," from a pencil sketch. Could not go sketching today because of the weather. Yesterday I was sketching without any coat on and the weather was fine. All the snow was gone and it looked as though summer was near. This morning the wind was howling and there was a foot of snow on the ground and still snowing. Fine weather for sketching in your shirtsleeves.

**March Mon 31**

Painted at DeBlois today. Started a sunset on my 40 x 25 canvas. A group of trees take up the foreground, a piece of low flat weedy ground beyond this is a stretch of river and the far shore is just lit up by the last rays of the setting sun. Sky full of light.

**Tues. April 1**

At DeBlois painting today, working on my big canvas.

**Wed. 2**

Painting on a small watercolor of a willow and finished it. Sold a drawing (watercolor) to Mr. Eastman Chase and one to Mr. Pitman, $10.00

**Thurs. 3**

Began a 10 x 14 sunset in oils. Went to Gendrots in afternoon.

**April Fri 4**

At. Mr. Sandersons in the morning and worked on a watercolor that I am doing there. He says he thinks my pictures (2) that I have sent to the Art Club Watercolor Exhibition will be surely accepted. Mr. Chase and Dickinson express the same opinion. Worked on two watercolors at home in afternoon.

**Tues 8**

My pen and ink sketch that I sent to the exhibition is rejected but the watercolor is taken. I find out that only one third of those sent were accepted. Mr. Sanderson had one refused.

**Thurs 10**

Went to Mr. Sandersons to paint in watercolor.

**Fri 11**

Went to the private view this afternoon of the Art Club. Some fine things and a few poor ones. G. Smillie has 3 fine pictures full of air and sunshine. One of his, a large landscape is I think the best in the collection. Alden Weir has a fine figure piece "Puritan Girl." .W. Hamilton Gibson has some small pictures which show intense feeling for light and air. They are slight sketches but Nature is seen in them more than art. E.B. Stewart shows three black and white very correct in composition and values., but shows an incompleteness in parts. Little's "Ebb and Flow," is very much appreciated. Some of the oil monochromes are execrable. Hitchings was on the jury and that probably accounts for his 3 pictures being admitted. They display a vast amount of niggeling and are more like topographical drawings than pictures that appeal to our sense of the beautiful. Sanderson's pictures have nearly the same quality in execution but are more poetical in conception. There is any amount of good sketches by numerous artists. Ross Turner shows two pictures that are only in their first stages or would be if they were in other artists's hands. There are several "studio" pictures that have no particular value as works of art.

**Sat 12**

The morning papers contain full accounts of the exhibition and my picture was mentioned in the Post, Journal, and several others.

**Sun 13**

Went sketching with Andrews in the morning.

**Monday 14**

Went sketching in watercolor at Dorchester and walked there and back, 10 miles. Last week I painted a mountain scene, 10 x 14 a sunset and two sepia sketches.

**Tues 15**

Went to Sandersons to work on my watercolors.

**Wed. 16**

Began a sketch of an old willow at Willow Pond in water-color. Fishing has set in again and I went five nights within a week. I usually go about two hours before sunset as I find it the best time.

**Thurs 17**

Worked on the watercolor I began yesterday and finished it.

**Friday**

Painted a small watercolor in a low tone.

**Sat. 19**

Went to see Mr. Hatfield at Doll and Richards about my big picture. He is perfectly satisfied to let me exhibit it at his place. He says it is a very true picture but it is not bright enough to suit many. He told me to repress my inclination for grey effects and paint brighter bits. I don't think I will however.

**April Sun 20**

Painted on a 10 x 14 canvas, a green landscape with blue light sky but do not think it a success.

**Mon 21**

Began a 12 x 16 moonlight scene. I have succeeded pretty well with the sky.

**Tues  22**

Miss Bothe sold the watercolor that I painted Friday for $2.00 Began a 10 x 14 landscape of the same subject. Watercolor.

**Wed.  23**

Went to DeBlois to paint on my 20 x 30 landscape. Repainted the trees and gave them more strength and improved the foreground. Worked on my big 40 x 25 canvas also. Painted five hours.

**Thurs  24**

Worked at DeBlois 4 hours. Glazed the sky of my large canvas and made it warmer. Made the distance grayer. Put in some sheep and more detail. Changed the form of the tree and ground.

**Fri. 25 April**

Worked on my 12 x 16 painting and nearly completed it. In the afternoon I went sketching with Garceau at McCarty's ledge and began a 10 x 14 sketch in watercolor.

**Sunday 27**

Went sketching with Andrews.

**Mon. 28**

DeBlois's exhibition opens tomorrow evening and he had a varnishing day today. We had a great time. I have sent six contributions.

**Tues 29**

Went sketching in oils this morning and made a study of rocks. oil. In the evening was at Mr. De Blois's reception. Large crowd.

**Wed 30**

Worked at DeBlois on my large canvas.

**May 1st to 10th**

Worked wholly in oils this time. I went twice sketching with DeBlois. I have got a job from now till September coloring prints. It is not very nice or artistic work and it is niggling and not over well paid for but I have to do them as they bring in a few dollars a week and the painting brings in almost nothing. As it is I get from 2 to 3 days painting a week.

**Mon 26**

In the afternoon I made a watercolor study of an apple tree in Curtis's field.

**Tues 27**

Went sketching from nature in watercolors, made a study of burdock leaves, one of cloud and sketch from apple trees.

**Thurs 29**

Went sketching in watercolor. Made a sketch of an old bank with weeds and bush and light sky. Made a study of an immense mass of clouds, (cumulae) Made a pen and ink sketch in the afternoon of an idea for a picture. Made a pencil study of some trees.

WILLOW POND, BROOKLINE, MA.
*By WILLIAM F. PASKELL - (June 2, 1884), Pencil sketch*
(Courtesy of Olive Paskell Day)

**A TREE**
*By WILLIAM F. PASKELL - (June 4, 1884), Pencil sketch*
(Courtesy of Olive Paskell Day)

**TWO WHEELED CART**
*By WILLIAM F. PASKELL - (June 4, 1884), Pencil sketch*
(Courtesy of Olive Paskell Day)

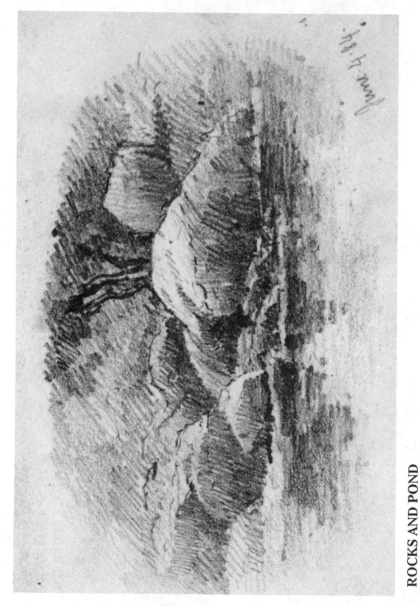

**ROCKS AND POND**
*By WILLIAM F. PASKELL - (June 4, 1884), Pencil sketch*
(Courtesy of Olive Paskell Day)

**Fri. 30**

Decoration Day.

**Sat. 31**

Painted a small sunset sketch of an effect that I saw last night.

**Monday June 2, 1884**

Went sketching in Brookline this afternoon and made a pencil sketch of some oaks.

**Tues 3**

In the city in the morning and worked on a 13 x 16 watercolor of a "June Day".

**Wed. 4**

Started out sketching this morning at 7 o'clock and returned at 4 in the afternoon. Made 3 small studies in watercolor and 3 pencil sketches.

**Thurs 5**

No painting today. Called on DeBlois this morning. We got arguing about art and he told me that I would never make a painter, unless I made more of a study of composition (that is the rules of it.) He believes in that system which never paints as you see but as you think it should be., changing and spoiling everything and preserving nothing; painting none of that mysterious detail of which Nature is so full and ignoring all natural laws. I told him that I did not believe the rules of art ever made a painter of real genius but only helped him to accomplish cer-

tain ends by a nearer road than usual. Only study from Nature can make a real artist and hard earnest study at that. DeBlois's paintings are all made upon rule as you can see by gazing at any of his works.

### Sat 21

In the city this morning. Called on Miss Bothe and found that she had sold a large watercolor that I had finished last week for $10.00. Bought some painting material and fishing tackle as I am going for five weeks to Conway, N.H. I expect to get a good deal of material for my painting this coming winter in the way of sketches and memoranda. Another thing that influences my going is that there is good trout fishing at that place. We start on the first.

### June Sun. 22

Made a small pencil sketch this afternoon in the woods. In the evening I saw a beautiful effect on Jamaica Pond. The pond was one unruffled sheet of water and everything was perfectly reflected in the water, but you could not see the places where the water began and the land stopped. Everything was full of mystery. A boat lay on the water in the foreground and its reflection seemed be part of it as you could not see where the boat stopped and the reflection began. The sky was very dark and subdued as it was an hour after sunset. Sky was full of long fantastic, motionless, wreaths of clouds that seemed to have no edge. (Pencil sketch drawn)

### Tuesday. (July) 1

Tomorrow we start for Conway.

### Wednesday 2, 1884

**SCHOONERS OFF THE ROCKS**
*By WILLIAM F. PASKELL - Watercolor, 9½x13¼"*
(Courtesy of Richard A. Bourne Co. Inc., Hyannisport, Ma.)

We started at 7.30 A.M. from the Eastern Depot and had a delightful ride in the cars to Conway where we arrived at 1.30 P.M. We passed through Newburyport, Ipswich, and Portsmouth, places that interested me very much. At Ipswich there (was) an antique looking building close by the depot that I would liked to have sketched very much, but the train only made a very brief stop. At Newburyport we got a beautiful view as we passed over the bridge the other side of the town. We could see the river and all the town and the sea beyond, all lighted up by the morning sun. (9.15 A.M.) A warm haze shrouded everything. At Conway, 125 miles from Boston we got into a team awaiting us and were driven to the farmhouse we were to stay, a distance of 15 miles. After going about 4 miles we had got right into the heart of the mountains and each turn we made presented some new beautiful phase of nature to our eyes. One of the best spots I saw was a view of Bear Mountain and the vast valley in front of it. I think that a picture of it will be one of the first things I will do when I return home. We stopped at a Farmhouse to get supper. The people there would not take anything for their hospitality and after staying there 2 hours we went on our way. While we were waiting for supper I went down to the river and caught a few chub one of them weighing 1 lbs. We started from this place at dusk to travel 6 miles over the mountains (Spruce Hill) to the Intervale. A strong breeze was blowing as we started and the half moon was 4 hours from setting. Only a few clouds were in the sky and the soft moonlight soon spread itself over the mountains and produced a most beautiful effect. I never spoke for the three whole hours it took to go the distance; so much was I interested in things around us. We arrived at Mr. Mayhews at 9.35 P.M. and went at once to bed as we were thoroughly tired out. We had taken 8 hours to go 15 miles stopping at every elevation to see the place.

**Monday 7**

We went to the Oliverian Brook today for a days fishing

and brought back 244 trout. This brook is even more beautiful than the river. The banks are lined with huge rocks and banks where the water made fearful devastations, carrying away huge trees from the soil and cutting new channels for itself every winter.

**Thursday 10**

Went up the Oliverean Brook and painted a 10 x 14 watercolor. I have a level portion of the brook in front with the strip of dry river beyond it, then there is the forest and in the distance I have drawn part of Whiteface.

**Monday 14**

Painted an oil color sketch on Swift River.

**Tues 15**

Painted a sketch in sepia of Mount Corrigan after rain. In the afternoon I went to Douglas Pond to fish.

**Wed. 16**

Rainy all day. Could do nothing except to make a few notcs of rain effects.

**Thurs. 17**

Painted a watercolor of the old mill house and made a pencil drawing of same.

**Fri 18**

Went pencil sketching in the morning and made 6 sketches. Raining in the afternoon.

**Sat 19**

Rainy all day

**Sunday 20**

Went to "Tom's camp" on Bear mountain. The road up the mountain was very picturesque and I enjoyed the walk very much. We caught 9 trout out of a brook nearby and to cook these 9 little things we lit a big log fire that burned for five hours then had to be put it out. I made a sketch of the old camp in watercolors. There is a beautiful little brook nearby the camp that had water like ice in it. The woods around it have some beautiful trees.

**Mon. 21**

Today I painted on my watercolor I began yesterday. Went fishing in the afternoon.

**Tues 22**

Made 3 pencil sketches of Mount Chocorua from Swift River and a watercolor of same

**Wed 23**

Went fishing in the morning and made 2 pencil sketches in the afternoon

**Thurs 24**

Raining all day. Painted on a watercolor in the house

**Fri 25**

**GLOUCESTER, MASSACHUSETTS**
*By WILLIAM F. PASKELL - (1890), Pencil sketch*
(Courtesy of Nancy Mace Fleming)

I went to paint Swift River Falls today but as soon as I got on the first wash, it began to rain.

**Sat 26**

Painting all morning: Reading in the afternoon

**Comments upon a hike thru the mountains**

We arrived at Shackfords the nearest farmhouse as it was getting dark and there found a hay team ready to convey us home. We quickly jumped on and soon arrived home. The ride seemed one of the most laughable I ever saw. If you sat on the rail you would feel as though your bones would rattle the life out of you, and if you tried to sit on the bottom of the wagon you would be jolted up, down, and all around. I tried to stand and persuaded myself that this was the best way when I felt a sudden irresistible desire to fall down. I then placed one hand on the rail and spread my feet out so that I could brace myself for the jolts. Just then someone hit me under the knee and I again fell down. At last I found out that the only proper manner to keep up was to keep dancing around as the others were doing. Just before we came to the house we gave sundry shouts and beautiful howls to be imitative of the cat, dog and other useful animals.

**Friday August 1**

Made a pencil sketch today and began a 10 x 14 water color sketch of Owl's Head Mountain. Today I went to see one of the grandest desolate scenes in these mountains. I mean the "Hurricane" on the sides of Passaconway and Potash. On this spot there reigns desolation supreme. Three years ago there stood the unbroken forest on the sides of these mountains. Huge maples, Pines and Spruce, some that stood 100 feet in height, but in the fall of 1882 the tornado tore down and uprooted every living thing for a distance of five miles in length and

one mile in width. You cannot see a living tree or bush for all this distance and there you can see those thousands and thousands of forest giants laying dead in the bright clear sunlight, their trunks riven and splintered, their roots torn from the ground and desolation and solitude meet the eye on every hand. And when we reflect and think on these things wrought by nature and her forces, who is there that says there is no God? "Wonderful and Terrible are Thy works, O Lord!"

### Saturday August 2

Today I and Mr. Mayhew went up the Oliverean Brook for a days fishing. The road lay for two miles thru a beautiful wood and then we struck the brook and began fishing down. I used flies most of the time and we caught 400 trout between us. The upper part of the little mountain stream is grand. The stream is full of huge boulders of granite with the water rushing and splashing between them. Then on each side rise banks of earth and granite, some of them rise 30 feet in height and these are crowned with magnificent pines and hemlocks. At one place is a number of falls and pools of the wildest king (trout ?) and we caught more good sized trout that at any other time.

### Sunday (Aug.) 3

Mr. Mayhew and I made the ascent of Mount Chocorua today. Our house is only about one mile from the foot of the mountain, and then it is five miles up the side of it. We started about 8 A.M. and soon struck into the logging road that goes half way up the mountain. The road has not been used for years and is all overgrown with vines, broke etc. and is rather hard to travel on as there are numbers of logs laid crossways to prevent the teams from sinking in the earth. The weather was all that could be wished. At one place the road goes up a very steep place and here the young maples formed a complete arch over the path and the sunlight coming down among the branches pre-

sented a most exquisite effect. After we left the road we went to see Champney Falls. There are two falls, one of them being fully sixty feet in height, and the other 15 or 20 feet. The large one is grand and imposing. We viewed the falls from below, in the gorge formed by the constant wear and tear of the stream. Here is a chamber, formed of granite walls 80 feet high and a space of 25 feet between them. The length of it is about 200 feet and up in the farthest part the stream makes the great leap. At this time of the year the stream is very small and when it reaches the bottom it is like rain. A most delightful sound is made by the water falling into the pool below. From the pool the brook passes down the gorge and out into the wood again where it is joined by the other stream. The sight of these granite walls made a great impression on me. How many ages must the water have been wearing out the channels? Who can tell when those granite walls were hewn out of one solid mass and left there as a testimonial to the power of that mountain torrent? How many years will this mountain child run on, tearing down, and building up? How long will that stream still sing the praises of the Almighty? Ask the brook as it springs from the top of that cliff and as it strikes the deep pool below. Listen to that song and I think you will hear the brook answer, "Forever.... Forever."

We stayed here for half an hour and then went on our way. We still had to climb the main peak which towered into the air two miles before us. The lower part of the mountain was covered with oak, maple and hemlock, but here on the high steep side the only tree seen was the spruce. The ground is covered with a velvety moss and decayed roots and often I would find myself up to my knees in some hole that appeared to be firm ground. We came across a windfall when near the top and although it was only about 75 yards across it, the job was very difficult. After leaving the spruce timber we got on the ledges of granite whose only vegetation was the little mountain blue berry whose fruit is rather bitter, and also a few raspberries We saw a plant known as the sweet plum whose leaves are a brilliant green

and whose bright scarlet berries presented a beautiful contrast. The skunk currant is also seen here. We now, after another five minutes of climbing, stood on the top of the middle peak. To the south of us lay the main peak which only looked 3 minutes walk, but was in reality 3/4 of a mile away. No pencil or pen could give one tithe of the beauties that lay before us.

On the north we could see Mount Washington and the Crawford and Pinkham Notches. (20 miles) The Waterville mountains lay in the western horizon together with Whiteface and Passaconway. To the south lay the hill country of Ossipee, Tamworth, Madison, and in the distance, behind these towns was a long bright silvery sheet of water, Lake Winnipesaukee, 18 miles away. The Moat Mountains and Bear Mountain reared their heads into the northern sky. This immense landscape laying for 30 miles on all sides of us, with its lakes and mountains, and clouds coming and going was the most impressive grand scene I have ever been able to see. The scene was too maplike to sketch so therefore I made 3 pencil sketches of rock on the mountain. We then ascended to the highest pinnacle or peak and saw the place where, as the legend says that Chocorua, the Indian Chief, jumped off and met his death on the rocks hundreds of feet below. After staying two hours on the summit we began the descent. The warm rosy afternoon light penetrated everything and lit the distant sides of the mountains with a delicate pink grey, leaving the shadows and portions of a greyish purple.

The road we travelled over was in all in a cool shadow and the vistas of woodland and hill were something grand. When near the foot we stopped to take a drink of the purest, coldest water from a beautiful little spring. The water gushed out of the ground between two granite boulders and then fell into a basin two feet below and then it flowed over another little fall and formed into a series of tiny rapids. The spring was surrounded by young maple trees and moosewood which made the place delightfully cool. Through one opening in the trees there came a ray of warm soft light that shone on the pool where the

fall struck it and the beautiful playing light and colors produced by it are indescribable. Not a stop could we take but new features presented themselves to see. About sundown we arrived at the house having been gone eleven hours; 5 hours to make the ascent and 4 hours coming down. These mountains with their mighty woods and streams are grand.

**Thursday 21**

Came home today.

**Sept. 2 Tues**

Made a watercolor sketch at Jamaica Pond 9 x 12. Finished the 10 x 14 study of trees I began at Long Island. In the evening I made a pencil sketch of Mount Chocorua from one of its spurs.

**Wed. 3**

Began a 9 x 12 watercolor of Grotto Glen and laid in nearly all the color.

**Thurs 4**

Finished the watercolor I began yesterday and made a drawing of Mount Corrigan.

**Friday 5 to Tues 30th**

Have painted all this time from nature and sketched. Have made five finished oil paintings and began 4 more. Have painted 10 finished watercolors and began 4 more. Made many rough color memoranda and about 3 charcoal drawings and 10 pencil sketches.

**Boston  October  Sat  4**

Went to see Miss Bothe who bought a small palette knife
sketch for $2.00 and a little oil painting 8 x 12, for $5.00. They
are both very rich in color and yet subdued and gray. Two of the
best things I have yet done.

**Sunday  5**

Went sketching with Gendrot in waterolor.

**Mon  6**

Painting at home all day today. Began a pencil drawing
of the Waterville Mountains at sunset

**Tues  (Oct.)7, (1884)**

This morning I painted in both oil and watercolor on two
of my unfinished paintings. In the afternoon I went with Allen-
dorff to the Mechanic's Fair. The lower floor is occupied by
machinery and here we saw the electric railway, the brick mak-
ing machines, and a number of new inventions. The next floor is
occupied with all manner of jewelry and furniture. On the next
floor are the art galleries. First the foreign gallery, the American
Gallery, the watercolor gallery, and the Prang gallery where a
fine exhibit is made. Then comes the heliotype gallery. The pho-
tograph, Normal Art School, and Gravell School of Design gal-
leries are on the other side of the American Gallery. The for-
eign gallery is filled with fine examples of the leading masters of
Europe. One of the finest, if not the very finest in the whole
room is Bougereau' "Fraternal Affection." The color is delicate
and fine and the expression on the faces is excellent. Lefebvre
has a good picture, "Salome, the Daughter of Herodias." The
finest landscape in the gallery is by Jules Dupre, "Evening" It is
painted with the spirit and boldness, not the boldness of the ig-

norant, but that of the master guided by nature and judgement. The color is very harmonious and rich. In the foreground are a few rocks and a pool of water, the distance is all forest and bush. The sky is a strong one full of light and air; large clouds are sweeping across the heavens, showing very dark against the light sky. It is one of those pictures that make you seem to be out-doors with the trees rustling, the wind blowing, and the last rays of the sun shedding their warmth over everything. No finicking and patching and niggeling here, but a story told us in a manly and straightforward way.

Daubigny is represented by a small landscape, "Sunset on.... River," very delicate and simple. Gerome has a picture called an "Eastern Beauty." In the American gallery are about 210 pictures. Enneking has a large landscape. It describes a low marshy piece of ground in front with a pool of water and a woody piece of landscape behind it. On the right hand you can see up over the hill into the distance. The sky is broadly and finely painted with, what seems to me, a fine knowledge of effect and a cloud form. It is the work of a man who enters thought-fully into the feeling of nature. The force of the wind is shown by the bending of the trees and the water is finely rendered. Cropsey has a large view of Mount Washington from the Con-way Valley. I think that is fine work with the rich pure color in it, the only drawback to me seems to be the absence of grey and neutral tints to some extent. Green has a nice piece of color in his large picture. The whole is painted with the knife and is handled in a masterly manner. Bogg's "Trafalgar Square" is a huge landscape (about 72 by 50) painted in a way so broad in fact that you must retire some 10 yards before the picture is seen properly. A fine feeling for the peculiar moisture and muggy atmosphere of the great city is shown throughout the work.

The picture pleases very few casual observers but to those who care to examine and study it a great deal is seen. Vonnoh shows two of his portraits one of them being finer than the other, both in color and in handling, is therefore hung where its good qualities are not seen. This is a regular rule of the hang-

ing committee. Gaugengigl has two of his fine little works exhibited, but I think that an artist of his caliber should have ambition to attempt something that will appeal to the heart and mind of the spectators, attempt at least to show some lesson. But here we will see a young painter of undoubted genius and he gives us a figure sitting in a chair, with a polished floor, and fine drapery back of her. He calls it, "In The Boudoir." What an inspiring work! What emotion is shown in that face gazing into nothing! How the heart is affected by the bright polish on the floor! Oh, yes, by all means go on painting works that are mere studies of a figure with a little bit of silk, a little bit of polish, a little bit of drapery, a little pink, a little green and all the colors of the rainbow; niggle over it until every little bit can bear no more niggeling, then call it, "In The Boudoir," "In the Studio," or in anything you please, but do not by any means tell any story in your work.

The old masters, I think, did not sacrifice anything to the mechanical part of a picture but rather sacrificed their detail to help the idea they wished expressed. Their painting was part of their being and life, the one being meaningless without the other. They painted the people that were around them on every side. They were ignorant of the modern furniture picture and such works are no more works of high art than an Irish hut is like a palace. The trouble with all the moderns is this, they admire the means more than the end. They look more at paint as paint than at what the paint means. Van Elton, Weber, and a number of American painters have all good works exhibited. Woodbury, the young painter has a picture called "Condemned," a group of old vessels. It is very grey in tone and does not seem to be as strong a picture as he exhibited at the Art Club. Perhaps the light, which is miserable, is responsible for this. My little picture is hung just below the line and has a fair light. It is a small sunset sketch. Miss Jenks has a miserable portrait, and one of her meaningless genre pictures, "The Gypsy Girl." Now I always thought a gypsy girl was very tanned up being with a peculiar wildness in her nature, but Miss Jenks gives us a girl with a face of waxy white and no expression whatever.

The watercolor gallery has about 200 pictures and among them are some fine things. Smillie, Sanderson, and some of the best talent of the country are represented. F. Hopkinson Smith has a large picture, "The Song of the Brook." It is a work that shows immense work and is one of those things that only a man conversant with nature can produce. Sanderson has 2 pictures here. The gallery is not so important as the main one. Two of my pictures are hung here, "The Mountain Brook," and the "Road to Pasture." One of them is hung on the line and one just below it. A work that attracts much attention is young Bartlett's statuette of "John Brown."

**Wed  (Oct.)8....to Sat. 11**

Worked all this time on oil paintings indoors.

**Sun  12**

Out in the woods all afternoon and made a pencil sketch.

**Mon  13**

Began a pencil sketch of the Waterville Mountains at sunset and made a sketch in oils at Willow pond 12 x 18.

**Tues  14**

Painted another small oils sketch at Willow Pond. (erasure) came home to day from Maine,

**Wed  15  1884**

Began a small panel painting in oils. Finished the pencil drawings I began Monday. Began a small sunset in oils for Weinz.

**Thurs 18**

In the city to see Miss Bothe and had a long talk with her about my painting. I told her that if I sold enough pictures to keep me that I should be enabled to keep on and work otherwise I must give it up. I know not what else I should do for a living and certainly think to give up without first making every effort to succeed is wrong. Art is a thing that needs your whole life and mind to be given to its service and no man who is not willing to sacrifice all he has to keep at it is not able to produce those works that are the offerings at the altar of nature; that show that nature has yielded her secrets to one who holds communion with her in all her moods.

**Fri (Oct.) 17**

In the city again today. Took in 3 more paintings to show. In the afternoon I went sketching with Heil in watercolor.

**Sat 18**

In the morning I finished a 12 x 18 picture that I call, Autumn Day." I have succeeded in it much better than I have expected. In the afternoon I went to Day's Woods and began a watercolor study of cedars. Made some memos of the sunset as to color and effect.

**Sunday**

Painted on a 12 x 18 painting, "Morning in the White Mountains, Albany, N.H." and finished it. Began a large water-color, "Cloudy Day at Albany, N.H."

**Mon 20**

In the city to see Mrs. Hunter about paying me for my

picture. Couldn't see her. In the afternoon painting on a large watercolor.

**Tues 21**

In the morning I began a small oil painting, "Sunset." In the afternoon I went painting but was not very successful. Coming home I saw an effect that struck me in the Grotto Glen and began a 12 x 18 painting of it.

**Mon 22**

In the afternoon I went sketching in oils and began a 12 x 18 in Day's Woods. The woods are now wearing their last bright tints and the breezes blowing from all directions scattered thousands upon thousands of leaves at every blast. The hectic flush that precedes death is now visible and soon the forest will be deserted by man and all living things.

**Thurs 23**

In the afternoon worked on the 2 oil paintings that I am doing from nature.

**Fri. 24**

In the city in the morning to see Mrs. Hunter who paid me and bought a panel picture for $4.00

**Sun 26**

Started for a day's walk and went 10 miles. I stopped to examine a number of scenes and made 14 pencil sketches and memorandums. The trees are leafless now with the exception of a few oaks and their leaves are a dull red. As far as the eye can reach the hills are clothed in the most exquisite and delicate grey

and purple, varied in one or two spots at every short interval by a suggestion of orange or yellow or red.

**Mon to Sat. Nov. 1**

Painted on my 12 x 18 autumn scene in Day's Woods and brought it nearly to a finish. Painted a small panel oil painting that I sold for 4.00 and sold a 12 x 18 "Moonlight among the White Mountains," for 8.00. Began a picture on the 16 x 12 canvas that I had another one on "Solitude," and rubbed in the whole of it. I intend to call it, "Before A Storm in the White Mountains." The sky will be very cold and grey. On Friday I called on Mr. Patterson who gave me an order for pictures as follows,

**Oct 31**

| | |
|---|---|
| 3 pr Paintings 6 x 9 at 5.00 | 15.00 |
| 3 pr Paintings 12 x 18 at 5.00 | 15.00 |
| 5 Watercolors 6 x 8 at 2.00 | 10.00 |
| TOTAL | 40.00 |

"...to be paid for when done."

I also sold him my "View in Newton After Rain," large watercolor for 4.00 and 2 small watercolors for 2.00. The prices he gives are very small indeed but they are better than having to leave the paintings as I should be obliged to do if I could sell nothing.

**Saturday**

I worked on my 12 x 18, Autumn in Day's Woods." and almost finished it. Painted a little on the 16 x 24 mountain picture.

**Sunday  Nov. 2**

Home all day. All good composition must have the foundation of its parts in Nature. The whole may be imaginary as to arrangement but the same principals and laws that are seen in Nature must be shown here also in every form of cloud and leaves.

**Monday  Nov.  3, 1884**

Very unwell. Only painted 3 hours and began a 12 x 18 picture, "A Valley in West Roxbury." I have placed the horizon very high in this picture it being only 3 inches from the top.

**Tues  4 and Wed 5**

Very unwell both days no painting or work of any kind.

**Thurs  (Nov.)  6**

Better. able to paint 5 hours on my 12 x 18 and a little one 4 x 7.

**Fri.**

Painted all day and nearly finished the Valley scene and worked on a water color of a sunset.

**Sat.  8**

Finished the valley scene and introduced a figure. Started another called "October Day." Began a small pencil drawing, "The Parker Hill Sand Banks from Day's Woods."

**Nov.  Sun.  9**

Out pencil sketching and made 4 sketches. In the evening I be-

gan drawing with Van Brown washes and brown ink drawing, a combination that is very effective. Called on Gendrot with Knox.

**Monday 10**

In the city in the morning. In the afternoon I worked on the water color began Thurs. Worked on the drawings. (pencil and ink) and finished both.

**Sat 29**

Have worked all the week on copying 3 watercolors alike for Mr. Patterson and have began a 16 x 21 oil painting of "Valley at the Foot of Whiteface." I have tried to show the valley while under the grey sky when the morning sun floods the valley with a misty luminous light. If the picture turns out as good as I expect, I will send it for my contribution to the Art Club exhibition that opens on Jan. 16. The other pictures that I will send will probably be the "Misty Morning After Rain," and another sketch.

**Sun 30**

Went for a short walk today in the woods. Nature must ever form the foundation for all art.

**Dec 1 to 6 Sat**

Painted two more panels for Mr. Patterson this week. I feel that the work I have done for him is worth twice as much as he gives me. But then it is better than nothing. Began a 12 x 18 painting "Before a Storm," in oils and worked on the 14 x 21 painting.

**Sunday 7**

Went for a walk in the woods and was fully repaid by a fine

sunset. Long masses of grey cloud warmed and lit at their under edges by the sun formed with the delicate yellow of the sky; a most beautiful arrangement of color.

## Jan. 7.(1885)

Today I sent three works to the Art Club Exhibition and expect to see them returned, rejected.

## Jan 8 Thurs

Began another water color of the same subject as I sold to Mr. Patterson for a mere song. I mean the "After Rain, Newton," He wishes me to paint him 3 more for the same price.

## Jan. 9

Worked all morning in oil. Called on Miss Bothe who gave me an order for a painting 18 x 24 for 15.00.

## Sat. Jan 10

Called on Patterson and he has served me meanly. He ordered 22 pictures from me at a price that scarcely paid for the materials and after filling the contract he refuses to take half of the pictures. If they catch you once its their fault, catch you twice, its your fault. He told me he expects to sell my pictures for about 10 times as much as he gave for them in a few years. However I am going to have no more contracts with Mr. P.

## Mon. 12

Painted all day in oils. "The Afternoon Haze," is rejected.

## Tues 13

Went to see Miss Brewer, sold her 33.00 worth of watercolors. viz. "Grotto Glen," "Sketch at Jamaica Pond," "Study of An Apple Tree," and "View Near Moultonboro."

**Wed 14**

The Art Club, after accepting my two pictures, refuse to hang them, so I am shut out. Painted on my large 25 x 40 oil painting and worked on a sunset and a watercolor.

**Thurs 15**

Painted on a 12 x 18 canvas and on the largest picture.

**Fri. Jan. 16**

Painted on my large 40 x 25 picture, "Close of Day," and a 12 x 18 one. In the afternoon I went to the Art Club private view. The exhibition is very poor and Boston Artists are almost entirely shut out. Out of 121 exhibitors only 34 are Boston men. Mancini's "Standard Bearer," is abominable in almost every way. The execution of it is blustering and crude, the color is a complete discord and the painter seems to be moved by no deep feeling or character. Some of the pictures are mere copies of better works, notable Pierce's "View with Sheep," which is a poor imitation of the style of Jacques. Micksell shows an enigma that is labeled "King Olaf's Ships." It is useless to go on showing the different details of the exhibition; Suffice to say that it shows a wonderful amount of rubbish; a number of fair works and a few good ones. Gaugengigl has a fine work, "Un Champ du Battaille" and Woodbury has a large landscape showing a gully in a saltmarsh where the tide has worn away the earth and left it exposed to the sun. In the middle distance is a number of haycocks and a few men at work. The sky is very finely painted and is full of a glowing light that pervades the whole thing. The club has purchased this work and I think it has done a good thing.

Woodbury is deserving of it. Enneking has a somber November landscape that is not quite up to his usual work. It is very impressive but has an artificial look about it that makes one feel that it is an unhealthy feeling for texture and gloom rather than genuine poetry that inspires the artist. Stites, "Upland Ranch," bought by the club, is an interesting thing. Tomkins, "Mother and Child," also bought by the club is very fine and thought by some to be the best picture here but Turner's "Courtship of Miles Standish," is certainly the most important. There is one picture called "Last Look," and the first look is likely to be the last look. Stewart has one sketch that is altogether too broad and painty to be fit to be exhibited as a picture and a large view of "Mount Monadnock," that is very poetic in conception and strongly painted with the exception of the foreground. It is a work on the whole that shows that poetry in painting is not dead yet. The exhibition shows a lot of New York and Philadelphia work and I think that it is disgraceful to the art club to kick out so many local artists and admit those from other cities. Fri. 30.... Painted on Patterson's watercolor pictures all morning. In the afternoon I went to see Miss Bothe who is going to make some arrangements for an exhibition for me in March.

**Sat. (Jan.) 31**

Painted a 12 x 18 moonrise and nearly finished it. Touched up Patterson's picture a little.

**Mon (Mar.) 2 to Sat 7**

Working all week on various works. Have decided to hire a room and have an exhibition. I have got one wall in my Father's place (8 Bromfield St) to show the pictures for the present. The critics of the Journal, Advertiser, and Post are coming to see them and give me a little notice to help call attention to the show I will have later.

**Sunday 8**

Cold, windy, and snowy.

**Monday 9**

In the city in the morning and called on Miss Bothe and Mr. C.E.L. Green and gave him a sepia drawing of West Roxbury Park that I painted.

**Tues 10**

Painted all day on the picture "After A Storm, N.H." and Patterson's watercolor.

**Wed. 11**

Called on Miss Bothe and Mr. Green. In the afternoon I worked on Mr. P's picture.

**Thurs 12**

Finished P's picture and glad of it as it is the 4th one of the same subject. Finished Miss Bothe 's commission and started a bright sunset. A composition with a river in the foreground and a part of a city and a bridge in the middle distance the sun is setting in gold and crimson behind the building and melts in the sky and distance are lost in a blue haze of distance.

**Fri and Sat**

Worked on small panel picture, "Sunset," and began a 5 x 7 brown drawing, "Sunset in Day's woods, and worked on the storm picture.

**Sunday 15**

In the afternoon I called on Flohr (?) and had a talk on art with him.

**Mon. 16**

Worked all morning on my different watercolors, touching them up and finished the small panel I began Saturday

**Fri 20**

Called on Miss Bothe and had a talk with her on the exhibition I hold next month. I thought at first of trying to get the use of Doll and Richards gallery but it was impossible to pay the price and hope to succeed in making enough money to take me through the summer. And then they thought that it was not just the thing for a young artist to show his work to the public until he had about five years study. They do not think how he is to live in the meantime. Mr. Williams told me that time honored anecdote of how Michelangelo filled a room with enough paper with drawings before he felt satisfied that he had mastered the art. These are the replies that you get when you try to dispose any work to these art dealers. Art dealers only in name for they know only those works that will sell to an ignorant public. Ask them about the finer qualities of art, feeling, truth, expression, effect, color, composition, drawing, and those parts of a picture that are the very life of it, and they gaze at you in astonishment. The only quality they recognize in art is this one; salability,if it does not possess this one quality its other merits are as nothing. They ask the artist to come down to the level of an ignorant public and do not try to lift the public to that of the artist. The public should be taught the difference between that poor work that is only a showy gaudy mass of chrome, green, blue, red and varnish and that work that is true art. True art has a far nobler mission than to please the eye; its mission is to enable our love for nature; it speaks to our mind through our sight and as such should be honored. Let us say with Goethe, "Happy indeed is he

who early knows what art is. I will hire a room for a month and have a place where I can paint while my exhibition is going on.

### Sat. (Mar.) 21

Began a 12 x 18 painting, "Before a Storm." Finished the stormy mountain scene 18 x 24.

### Mon, 23

In the afternoon I went to see Miss Bothe and have hired a room in the same building with her for my exhibition. In the evening I made a small pen and ink sketch.

### Tues 24

Made a pen and ink sketch of my watercolor that I painted for the Art Club Catalog. Went sketching from Nature and in the evening went to the Evening Drawing School exhibition with a couple of friends.

### Wed 25

In the city all morning and made another drawing on Bristol board for the catalog as the first one does not suit me. The picture I have sent to the exhibition that opens on April 10th is the one that I think my most successful one, "After Rain, Newton." It is a little different from the one I sold to Mr. Patterson. In the afternoon I painted on the 12 x 18 oil painting began Saturday.

### Wed. April 1st

The month of wind and rain. Today I began moving into my place in the city, (13 Franklin St.) where I will have my exhibition. It is two Rooms from Miss Bothe . Called on McLean and DeBlois.

**Thursday 2**

Fast Day. No work today.

**Fri 3**

Had the rest of my things moved into my studio today. I will have to open on the 9th to the public. Painted on the "Chocorua" this afternoon.

**Sat 4**

Painted all day on "Chocorua," and advanced it a great deal. Heil painted here in the morning I am going to show two of his sketches along with mine. He has got talent for drawing that is surprising and cannot but help doing something in years to come. McLean may also show a couple.

**Sun**

Beautiful Spring Day! Everything is sparkling with light and much with life. I will not be able to work outdoors until the end of the month because of the exhibition.

**Mon 6**

Hanging pictures in my studio today. Have got about 60 to show. Now for the selling. If I succeed, all right, and if not... well, we will not anticipate.

**Tues 7**

Painted on a 12 x 18 , "Summer Night," but did not accomplish much.

**Wed 8**

Occupied all morning, puttering around, writing and addressing circulars and running about. Called on Green and had quite a talk with him, Worked on the "Chocorua," and succeeded in improving it. Miss Bothe thinks it far ahead of anything I have done. It is certainly practical as far as I can carry it and the subject is original both in composition and effect. But it still falls far short of the great original, that impressed me so much, as far below as the wooded valleys are below its granite peak, and echo perhaps of its wonderful effect but a very faint one. Still if it stirs some of the finer feelings it has accomplished something.

**Thurs 9**

Have postponed the opening until Monday. Have had my Art Club pictures refused. Employed all day in numbering the pictures and writing catalogs.

**Friday (Apr.) 10**

Had a number of visitors today.... No Sales. Worked on the Chocorua and have nearly finished it. The foreground is a little empty and flat as yet. Worked on a water color (July Day) 7 x 10 and laid in the first washes.

**Sat 11**

Varnished the "Chocorua," today and it brought it out wonderfully Worked on my small watercolor and began a 12 x 18 oil "Autumn Afternoon." The "Boston Journal," this morning contained a small criticism on my pictures and spoke well of them. Mr. Downes, the critic of The Advertiser came today and was extremely pleased with the exhibition. The Transcript critic came also....... No sales.

**Mon. 13**

Today I worked on my 12 x 8 picture began Saturday and began another same size. Sunset. Worked on water color. No matter how much we may be depressed there is always a reviving, refreshing influence in outdoor nature that tend to elevate us and lift us above the mere rush and worry of life. It fills us with hope and spirit. He who is destitute of hope is poor indeed. When that leaves only one thing takes its place; despair, blacker than the deepest night. He who gives his soul over to the keeping of this foul friend is a coward through and through. He seeks to hide from God and his fellow man.

**Tues 14**

Had 8 visitors Sold a watercolor, "Moonrise," for $5.00 to Miss Bothe . The Advertiser says of my big picture,

"One of the largest of his pictures is a view of Mount Chocorua at sunrise, in which the effect of the first flush of dawn over and beyond the mountain peak, with the mist and shadows of the night still hovering in the woods and valley beneath is conveyed with remarkable success."

The Journal says:

There are large landscapes with beautiful skies, and soft toned foliage and exquisite feeling; and small pictures with just a glimpse of sunset or twilight which are like poems in their delicate beauty."

**April Mon 15**

Had 11 visitors; sold 1 watercolor to Miss Seaver of Northboro for $4.00. Worked on the two 12 x 8 paintings and finished one.

**Thurs 16**

Had 10 visitors.... No sales...

**Friday and Saturday**

had 21 visitors....... no sales.... Poor prospect of even pay-ing my expenses. The newspapers have given me notices. I have sent out 200 circulars and the artists have sent people, and what result? two watercolors sold and one sepia.... 10.00.... This is enough to disgust the most credulous and shows how hard it is for a young painter to even get recognized.

**Sun 19**

Out in the woods all day. Beautiful warm weather. Went to see Gendrot tonight who sails for France on May 2nd. His Father is going to give up work and go back to his native land, so that his son may study Art. Oh! How I wish I could have a chance such as that and may he improve it to the utmost.

**Mon. 20**

4 visitors..... no sales.... Painted a 12 x 18, "After a Rainy Day" and a watercolor 6 x 9 "July Day," I worked on the "Chocorua" and took out a light group of trees in the fore-ground... improved it a good deal. Gendrot came to the house tonight and we had a good social time till midnight when he bid the family good by for the last time.

**Tues 21**

Had 3 visitors today.... no sales.... Painted on a 12 x 18 "Summer Night," and a "Meadows in West Roxbury," a 12 x 9 "Chilly Day," a small oil sketch, "Twilight," and a pen and ink drawing of the "Whiteface" picture.

**Wed. 22**

No visitors and no sales....

**Thurs 23**

Mr. McLean came to see me and bought a small sketch, 1.00. Finished a 12 x 18 "Summer Clouds." very successful in water and sky.

**Fri.**

Mr. Jacob Wagner today purchased a small sketch for 2.00. No other visitors. Worked on the "Oliverian," watercolor and a small oil sketch "Fading Light."

**Saturday (Apr.) 25....**

No visitors except Miss Eichberg who will certainly buy something. The exhibition which I close today has been a failure. I see the uselessness of any longer trying to get a living at painting just at present. It is always the same old tale of nobody wishing to buy anything. They all wish you good luck but even that would not be given if it cost a cent. It is a shame that work like art should meet with such return when a man that digs dirt in the ditch gets a better living. Monday 4.... Moved out of my place and find the exhibition has left me in debt. I have left 12 pictures in Miss Bothe 's studio for the present, that is the best of them. Miss Harrington bought the small 12 x 8 picture to give Miss B. It is called, "An Autumn Afternoon," and to say the least it is one of my best.

**Tues 5**

Out sketching from Nature.

**Wed 6**

Went to Chelsea to give a lesson to Mrs. Gilbert in watercolor and began a small one, "Monadnock" from a sketch.

**Thurs, Fri, Sat.**

Worked on watercolor various sizes and Sun 10.... went with Knox sketching and painted a study of Apple Trees and a palette knife of a bank of sand which is one of my strongest outdoor bits. Tues. painted 12 x 8 oil, "Sunset on the Charles," and gave Garceau a lesson, busy day.

**Wed Thurs Fri.**

Gave lessons to Garceau and Mrs. Gilbert and finished "Monadnock".

**Fri. May 15**

I called on Miss Bothe to show her a few sketches. She was very pleased with the palette knife study. The Transcript spoke very well of my Art Museum of picture. It says;

> "The small number of landscapes is their only point of weakness. As a whole it is marked by great evenness and that of a high degree. Enneking, Foxcroft Cole, and Murphy, stand as usual first and with them this time, C.E. L. Green, and Monks; perhaps also William Paskell and Waugh."

I do not know how my little picture entitles me to stand with these men, who are represented by large and important works.

"Close of a Rainy Day," by W. Paskell is better than it seems. As a picture it is wholly good although the sky seems a bit painty."

The Journal says:

"Mr. W. Paskell shows a very poetic little picture called "The Close of A Rainy Day," The clouds are breaking where the sun has about gone down and rays of soft light touch the trees through the moist atmosphere. It is broadly painted and is charming throughout."

These paper criticisms are of course to be taken at a certain discount but they are very stimulating to say the least to a young person.

**May Sat. 16... Finished the watercolor sunset in the**

morning and in the afternoon went to see W. Mitchell of Malden and began a 10 x 14 watercolor from nature.

**Sun**

...went sketching in oils and made a 8 x 12 of Slack's Pond, Day's Woods and also made a sketch near Brookline of the Sunset.

**Mon.**

Worked on the 10 x 14 water color I began Sat. Began a small sepia drawing and a water color 5 x 10. In the afternoon worked in city.

**Tues 19**

Worked in the city all day for my Father. Called on Green. He liked the palette knife study and the sunset but found fault with the others as being too yellow.

**Wed 20**

Painted on a water color in the city during the morning. In the afternoon I painted a study from nature. It was pouring with rain and had to sit beneath a cedar to do my sketching.

**Thurs 21**

In the morning made a study of the Glen and in the afternoon went to the city to work for my Father. Called on Miss Bothe .

**Fri**

Worked at shop in the morning. In the afternoon Garceau went with me to Slack's Pond to take a lesson and painted a study of young birches and elms at Slacks Pond..

**Sat. 23**

Worked at shop all day and called on Green in the P.M. He liked the small sunset study, 7 x 10 (Brookline) so well that he offered me one of his pictures for it. The picture he gave me is a beautiful thing, full of light and air and poetry. I also gave him another little one for smaller one of his.

Wedn. (Jun.) 17 In the morning went to the city where I repainted a lot and part of the background of Miss Bothe picture that was at the Art Museum Exhibition. It had been injured in some way or other. Also painted a small sketch in oils.

**Thur. 18**

Painted a study of rocks and trees in Days Woods. 12 x 18 sketching with Garceau in the afternoon in water colors.

**Fri. 19**

Painted in water color in the city. Worked on the large sketch of Jamaica Pond.

**Sat. 20**

Painted a small water color copy of one I had for Patterson. Also sold him 3 other small sketches, and the "Newton" picture that was rejected at the Art Club. Called on Miss Bothe in the afternoon to see about going to Framingham where she has got me a pupil. Looking at the later sketches I have alone she said that everything I painted now seemed to be one advance over the last.

One sketch pleased Miss Bothe . It describes a broken piece of ground with a group of dark trees beyond it and a blue sky with a few white clouds. It is certainly the most successful bit of painting as far as light, pure white light, is concerned that I have done.

**Sun. 21**

Out in the woods all day.

**Mon. 22**

Painted on a 12 x 8 canvas in the morning and went sketching with Garceau in the afternoon in water color.

**Tues. 23**

Today I have been in the city all day and painted a 6 x 9

water color for Patterson. Called on Miss Bothe in the afternoon.

### Wedn. 24

In the morning I went to West Roxbury Park to paint an 18 x 24 from nature and did 3 hours work on it. In the afternoon I went sketching in water color with Garceau and began a study of brook and trees near Willow Pond.

### Mon (July) 13 to Sat. 18

Sketching with pupils all week except Thurs and Sat. Painted four studies from nature in oils and began a water color 10 x 14 of "Meadows at Forest Hills." Went to Mendon Wen. On Saturday I worked on the 18 x 24 painting that I began last month and made a number of changes in it.

### July Sun. 19

Went to Wellington with Mr. Morse and painted a 13 x 9 study from nature.

### Mon. 20

Went to Wellington with Mrs. Morse and made a study of willows in oils. In the afternoon I worked on the sketch that I painted at Mendon last week. Toned it down and made it grey.

### Tue. 21

Went sketching with Mrs. M. again and painted a study a willow stump. In the afternoon I went sketching with Garceau in water color.

### Wedn. 22

Went to Mendon and gave Miss George and Miss Douglass a lesson. I painted a 12 x 9 study from nature.

**Thursday July 23, 1885**

In the city at studio all day. Worked on large water color and touched (up) my last study from nature. Today, died Gen. U.S. Grant, the preserver of the Union. Within a few hours of his death all businesses began to drape their stores and warehouses.

**Fri. 31**

Worked with Garceau at the house on the water color we began.

**Sat. Aug 1**

Went to Mendon today and painted a study of an apple trees and house with Miss Geary. Went to Wellington and gave Mr. Morse a lesson in oils. Tomorrow I go to Amherst, N.H. for two weeks to paint with Mrs. Morse.

**Sun.,Amherst, N.H.**

I started on the Lowell Road at 7.30 and arrived at Amherst Sta. at 9.45. From thence Mr. Morse drove me to Lake Baboosic, a distance of five miles over a beautiful winding road. After going down to the lake, a beautiful sheet of clear water amid wooded hills, and then had dinner. Mrs. Morse and I painted a study of a large mountain, lying to the north of us. The evening was spent very pleasantly in instructing me into the mysteries of draw poker.

**Tues (Aug.) 4**

Painted indoors because the rain fell in torrents, but in the afternoon out on the lake for a row. We also climbed a small hill from the top of which could be seen a number of mountains lying in the west, some twenty miles distant. The chief peak I should judge was Monadnock. It is a very impressive looking mass, but too far distant to make a good subject for a picture. At twilight we were on the lake again rowing.

**Wed. Thur. Fri**

Fishing and painting. Out on the lake each day Began a watercolor of an old dilapidated chimney. Three of us sketched at the far end of the lake.

**Sat. 8**

Today we went to the upper end of the lake and while 3 of us sketched, the remainder of the party were playing poker. I began a pencil drawing of a point of land with a round topped hill behind it.

**Sun. 9**

I finished the water color study and in the afternoon I went on an excursion in a rowboat up the lake, from the house I went to Poker Point so named for us and after a half hour rest I went to the extreme end and explored a little placid stream that flows from the lake. Sun.... I was out on the lake with Mr. McConnell and Mr. Rhoades. In the after(noon) I began an 8 x 12 study from nature.

**Mon. 17**

Finished Mr. Morse's picture that I have given him. View from house, of lake and hill beyond. 12 x 20.

**Tues  18**

The granges of the county had a picnic here today and we had more fun than enough in watching their giant and homely ways and activities. But say what we will, it is they support the rest and by them we live. Among all the hundreds present it was hard to find any best contented faces. Hard work, tool and age were there, but not despair. God Bless them and prosper them.

**Wedn. 19**

Sketching today.

**Thursday**

Came home today.

**Thurs  (Sept.) 10**

Painted a small watercolor. Went in the city in the afternoon to see Miss Bothe who has sold one of the panel paintings to Mrs. Candler.

**Fri 11**

Painted a thome.

**Sat.  12**

In the city in the afternoon to help Miss Bothe prepare her studio.

**Sun. 13**

Nothing done today.

**Monday 14**

Went to Newton with Heil, made 2 studies (or rather impressions) in watercolor and pencil sketches and walked 15 miles, had a delightful time.

**Tue 15**

Painted a 10 x 14 watercolor (near Newton) and started another one 11 x 9 Study in Days Woods.

**Wed. 16**

Finished the 11 x 9 picture and a 10 x 7 picture I began Monday. Painted a panel picture 6 x 8 and laid in a 14 x 22 oil "September Morn in Roxbury."

**Thur**

At Weinz's in the morning and began a 11 x 9 water color and a 10 x 14 one also. The first is a little bit of country road and the other is a subjected suggested to me by the shore of Jamaica Pond. In the afternoon I went into the city to find that Mrs. Candler wants me to give her a lesson every day for the rest of the summer and autumn. I have decided to take a studio in the city as I will then have a place to be found and where I can have my pupils come to paint.

**Fri. 18**

Painted an oil painting a short while and began two small panel paintings. After I went to Weinz's and worked on my two watercolors there.

**Sat.19**

Worked on same.

**Sun.20**

Nothing done.

**Mon. 21**

Worked on my watercolors at Weinz's home and went sketching in Day's Woods with Garceau in the afternoon.

**Tues 29**

At Mrs. Candler's in the morning and made a sketch of a brook near "Willow Pond." How delicious are the autumn days with their cloudless skies and soft misty light enveloping the hills within its pearly grasp. What joy to unfold these glories of nature if only for a moment. Poor I am, and poor I may remain, but I would not leave this for all else that is, Life is to love all these things and feel with them and as far as your power allows to interpret them.

You feel the joy of creation, of vitality, of all that lives. As well deprive the dove of the air, the fish of its element, and the stag of its mountain forests as to keep the healthy mind alive in a studio with its rules and laws.

**Wedn (Oct.) 7 & Thur. 8**

Painting at home. Fri and Sat.... At Mrs. Candlers and painted a 12 x 16 sketch for her of a favorite view from her studio window.

**Sun 11**

Worked on one of Allendorff's pictures. I have got a

pretty fair suggestion of afternoon light warm and glowing on the buildings looking toward the East, but the foreground is almost hopeless.

**Mon. 12**

Today I began a sunset, 20 x 30 and just rubbed it in. I finished a panel and a 9 x 12 Watercolor, "Sunset. Today there was a fire in Miss Bothe 's studio and her large picture, "The Thief," and several others were ruined. My "Chocorua," is a wreck owing to the chemicals that were thrown on it. It is a sad blow to me as I had just sold it for 40.00 to Miss Freeman of Wellesley. However she will take it as soon as it is repainted.

**Tues 13**

I painted the sky of my sunset and will have to glaze it with cadmium to make it warmer. Finished the 2nd commission today.

**Wed 14**

This morning I started a 20 x 30 oil painting of the same subject as the sketch that is now at the Art Club. The Transcript says of the Exhibition;

William Paskell's glowing, golden study is brilliantly good, pure sunlight. The clouds simply and even carelessly done with admirable character.

The large picture to my eye, is going to be better than the sketch, the sky being very brilliant and spacious and then it has a purity of color which I have never struck before.

**Thurs (Oct.) 15**

Called at Mrs. Candlers today where I saw Miss Bothe . In the afternoon I went into the city and called on Mr. Wagner, who has got some wonderful things this summer, notably a sunrise on the sea shore and a fine study of trees and water.

**Fri 16**

Began repainting the "Chocorua," and feel though it will lack the solemnity it had before, it will be more delicate and have more vitality. Worked on it all day.

**Sat. 27**

Glazed the sky of the sunset with codmium and madder and succeeded in getting more glow and warsutte in it. Worked on the "Chocorua" all day. When this is done and out of the way I think that I will attempt a larger one.

**Sun. 18**

Went sketching with Mr. Morse and made a watercolor of the glen. Slowly, slowly these days of Autumn pass away. Beautiful they are beyond description but mingled with this is a sadness that goes through you. It is the old, old story, "dust thou art, to dust return"

**Mon. 19**

Finished the Chocorua today and also finished the sunset.

**Tue. 20**

At Mrs. Candlers today and finished the sketch I was making for her.

**Wed. 21**

In the city today to see Miss Bothe and she thinks that the "Chocorua," is far better than before. She is sure that Miss Freeman will accept it....(last entry is dated Dec.14, 1885)

## END OF JOURNAL

### William F. Paskell
*Oil Paintings and Sketches*
*(from his records kept in 1887)*

| NUMBER | TITLE | SIZE |
|---|---|---|
| | **Pencil Drawings and Black and White** | |
| 63 | *Sunset* | 4x5 |
| 64 | *Fields at Dorchester* | 7x5 |
| 65 | *Sunset at Dedham* | 4x5 |
| 67 | *(no 66) Twilight* | 4x5 |
| 68 | *Country Road* | 5x7 |
| 69 | *Sunset at Dorchester* | 6x9 |
| | **Water Color Drawings and Sketches** | |
| 298 | *Before the Snows in September* | 7x12 |
| 299 | *Autumn Sunset from Nature* | 7x10 |
| 300 | *Moonrise, Day's Woods* | 9x12 |
| 301 | *Sketch at Roxbury* | 5x8 |
| 302 | *On the Meadows (S)* | 5x7 |
| 304 | *no 303 Twilight (D)* | 4x6 |
| 305 | *July Day, Albany, N.H.* | 4x5 |
| 306 | *Moonrise in Summer* | 4x5 |
| 307 | *A Roxbury Road* | 5x7 |

| | | |
|---|---|---|
| 308 | *Sunset at Roxbury (D)* | 5x8 |
| 309 | *Sketch (D)* | 6x4 |
| 310 | *Sketch* | 7x5 |
| 311 | *Summer Morning Misty (S)* | 7x12 |
| 312 | *Cloudy Day at Roslindale (S)* | 6x9 |
| 313 | *Sketch* | 5x7 |
| 314 | *Moonrise (S)* | 4x5 |
| 315 | *Summer Day (S)* | 4x5 |
| 316 | *Twilight* | 5x8 |
| 317 | *Pasture Land at West Roxbury* | 5x7 |
| 318 | *Meadows at Roslindale* | 5x8 |
| 319 | *Meadowland (S) Sold* | 12x18 |
| 320 | *Grey Day Jamaica Plain;Sold* | 7x10 |
| 321 | *Grey Day on an English Heath;Sold* | 7x10 |
| 322 | *Sketch from Memory* | 10x14 |
| 323 | *Composition* | 18x32 |
| 324 | *Composition* | 19x16 |
| 325 | *Composition* | 10x14 |
| 326 | *After Rain* | 12x18 |
| 327 | *Sketch Among the Pines from Nature* | 7x5 |
| 328 | *Sketch On Parker Hill* | 6x9 |
| 329 | *Composition (S)* | 6x7 |
| 330 | *Composition (S)* | 7x5 |
| 331 | *Composition (S)* | 4x5 |
| 332 | *Composition (S)* | 4x5 |
| 333 | *Composition (S)* | 5x7 |
| 334 | *Sketch at West Roxbury* | 6x9 |
| 335 | *Sketch at West Roxbury* | 6x9 |
| 336 | *Summer Afternoon, Parker Hill (S)* | 12x9 |

| | | |
|---|---|---|
| 337 | *Willow Pond, Roxbury (S)* | 12x9 |
| 338 | *Grotto Glen (S)* | 12x9 |
| 339 | *Sketch at Point Allerton* | 12x9 |
| 340 | *Sketch at Nantasket* | 10x14 |
| 341 | *Grey Day in Roxbury Fields (S)* | 10x14 |
| 342 | *Grey Day on Concord River* | 10x14 |
| 343 | *Jamaica Pond* | 10x14 |
| 344 | *Shore of Jamaica Pond* | |
| 345 | *Study at Brookline.* | |
| 346 | *A Roxbury Road.* | |
| 347 | *Grotto Glen, Day's Woods.* | |
| 348 | *Study of Oaks* | |
| 349 | *Meadows at Readville* | 12x18 |
| 350 | *Sketch on Parker Hill* | 10x14 |
| 351 | *Approach of a Storm* | 6x4 |
| 352 | *Brookline Swamp* | 10x14 |
| 353 | *Composition* | 5x7 |
| 354 | *Willow Pond, Roxbury* | 7x10 |
| 355 | *Sketch* | 6x9 |
| 356 | *Commission* | 7x10 |
| 357 | *Composition* | 8x12 |
| 450 | *After Sunset* | 8x12 |
| 451 | *Moonrise* | 7x10 |
| 452 | *After a Snowstorm* | 6x9 |
| 453 | *Meadows at Dorchester* | 6x9 |
| 454 | *Twilight* | 9x12 |
| 455 | *Winter Twilight After Snow* | 12x20 |
| 456 | *Sunset at West Roxbury* | 12x18 |
| 457 | *Close of Day* | 22x28 |

| 458 | *Road at West Roxbury Sunset* | 12x9 |
|---|---|---|
| 459 | *Sunset, Parker Hill* | 6x9 |
| 460 | *Sunset, Parker Hill* | 6x9 |
| 461 | *The Pond at Twilight* | 5x8 |
| 462 | *Commission (Mr. C.)* | 44x26 |
| 463 | *Commission (Mr. C.)* | 27x26 |
| 464 | *Commission (Mr. C.)* | 27x20 |
| 465 | *Sketch, Old House at Roxbury* | 20x12 |
| 467 | *Sketch, Old House at Roxbury* | 12x18 |
| 468 | *Sketch "Sheds"* | 12x16 |
| 469 | *Sketch "Sheds"* | 10x14 |
| 470 | *Sketch Doorway at Roxbury* | 10x14 |
| 471 | *Sketch Doorway at Roxbury* | 7x10 |
| 472 | *Sketch Old House at Roxbury* | 8x12 |
| 473 | *Sketch Old Buildings at Roxbury* | 8x12 |
| 474 | *Sketch Old Buildings at Roxbury* | 8x12 |
| 476 | *Cloudy Spring Day* | 12x8 |
| 476 | *Swampy Ground at Brookline* | 12x18 |
| 477 | *Old Buildings at Roxbury* | 8x12 |
| 478 | *Old Barn at Roxbury* | 10x14 |
| 479 | *Day's Woods, April Afternoon* | 9x13 |
| 480 | *From Day Street* | 9x12 |
| 481 | *April Morn, Day's Woods* | 7x10 |
| 482 | *Meadows at Roxbury* | 12x18 |
| 483 | *July Day* | 12x18 |
| 484 | *On Parker Hillside* | 12x18 |
| 485 | *At Huntington Park* | 22x16 |
| 486 | *At Back Bay, Wasteland* | 22x?(torn) |
| 487 | *Sketch Sunset on the fields at Newton* | 12x8 |

| 488 | *Oil August Day, Day's Woods* | 30x40 |
|---|---|---|
| 489 | *Sketch April Day at Roxbury* | 12x9 |
| 490 | *Sketch At Marblehead* | 10x14 |
| 491 | *Sketch at Roxbury, Waste Land* | 8x14 |
| 492 | *Sketch Parker Hill, April Day* | 8x12 |
| 493 | *At Hungtington Park Sketch* | 8x12 |
| 494 | *Sketch Dorchester* | 10x14 |
| 495 | *Sketch Near Roxbury* | 10x14 |
| 496 | *Sketch at Readville Meadows* | 8x12 |
| 497 | *Sketch Neponset River Readville* | 8x12 |
| 498 | *Sketch at Readville Meadows* | 8x12 |
| 499 | *Sketch at Readville Meadows,Neponset River* | 8x12 |
| 500 | *Sketch Roxbury Road, September Day* | 8x12 |
| 501 | *Sketch After Rain, Sketch at Roxbury* | 8x12 |
| 502 | *Rainy Day sketch at West Roxbury* | 7x10 |
| 503 | *September Day sketch at Roxbury* | 10x14 |
| 504 | *Willow Pond Pathway* | 30x20 |
| 505 | *Spring Day sketch at Roxbury* | 30x20 |
| 506 | *Brookline Swamp* | 22x28 |
| 507 | *Sunset* | 22x30 |
| 508 | *Sketch in Day's Woods* | 9x13 |
| 509 | *Sketch from Nature* | 9x12 |
| 510 | ***missing**** | |
| 511 | *Sketch from Nature Roslindale* | 12x18 |
| 512 | *Sketch from Nature, The New Road Buzzey (Bussey) Park* | 12x18 |
| 513 | *Sketch from Nature Shore of Willow Pond* | 16x19 |
| 514 | *Sketch from Nature,Fields at Jamaica Plain* | 14x10 |

| 515 | *(The Same)* | 10x14 |
|-----|--------------|-------|
| 516 | *Grey Day, Study at Jamaica* | 10x14 |
| 517 | *Study from Nature, Oaks at Jamaica* | 12x8 |
| 518 | *Study from Nature, Fields at Jamaica* | 12x8 |
| 519 | *Study from Nature, Fields at Jamaica* | 12x8 |
| 520 | *Sunset at Jamaica Plain* | 12x8 |
| 521 | *Study of Sand Bank at Jamaica Plain* | 12x8 |
| 521 | *Study at Jamaica Plain, Grey Day* | 10x14 |
| 522 | *Grey Day at Jamaica Plain* | 12x8 |
| 524 | *Sketch in Day's Woods* | 10x14 |
| 525 | *Sketch in Day's Woods* | 10x14 |
| 526 | *Study of Elms, Jamaica Plain* | 9x12 |
| 527 | *Study at Jamaica Plain, after Rain* | 8x12 |
| 528 | *Twilight at Jamaica Plain* | 8x12 |
| 529 | *A Back Road Jamaica Plain* | 10x14 |
| 530 | *Study at Jamaica Plain* | 10x14 |
| 531 | *Sun, setting in Fog, Jamaica Plain* | 8x12 |
| 532 | *Composition, After Rain* | ????? |

## END OF LISTING